FORBIDDEN HOLLYWOOD

THE PRE-CODE ERA
(1930–1934)

WHEN SIN RULED THE MOVIES

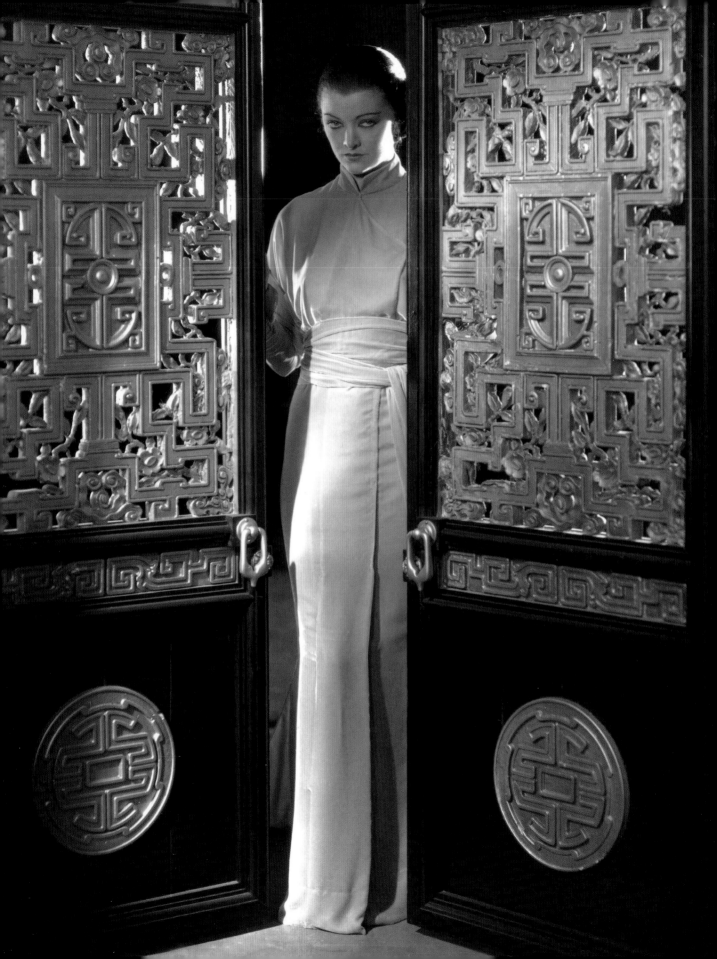

FORBIDDEN HOLLYWOOD

THE PRE-CODE ERA
(1930–1934)

WHEN SIN RULED THE MOVIES

MARK A. VIEIRA

RUNNING PRESS
PHILADELPHIA

TO THE MEMORY OF MY PARENTS.

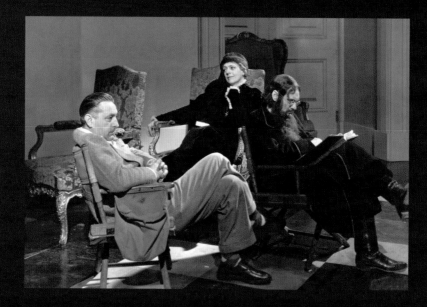

FRONT END PAPERS: A set reference still from Robert Z. Leonard's *Five and Ten*.

PAGE 2: Myrna Loy personifies forbidden Hollywood in Charles Brabin's *The Mask of Fu Manchu*. Photograph by Clarence Sinclair Bull.

THIS PAGE: John, Ethel, and Lionel Barrymore take a break from filming Richard Boleslavsky's *Rasputin and the Empress*. Photograph courtesy of Bill Nelson

BACK END PAPERS: A set reference still from Richard Boleslavsky's *Hollywood Party* (1934).

Running Press
Hachette Book Group
1290 Avenue of the Americas, New York, NY 10104
www.runningpress.com
@Running_Press

Printed in China

First Edition: April 2019

Published by Running Press, an imprint of Perseus Books, LLC, a subsidiary of Hachette Book Group, Inc. The Running Press name and logo is a trademark of the Hachette Book Group.

The Hachette Speakers Bureau provides a wide range of authors for speaking events. To find out more, go to www.hachettespeakersbureau.com or call (866) 376-6591.

The publisher is not responsible for websites (or their content) that are not owned by the publisher.

Print book cover and interior design by Jenna McBride.

Library of Congress Control Number: 2018959092

ISBNs: 978-0-7624-6677-1 (hardcover),
978-0-7624-6675-7 (ebook)

1010

10 9 8 7 6 5 4 3 2

CONTENTS

INTRODUCTION

What is *pre-Code*? Pre-Code is not a film genre like the western or the musical. It is a retrospective discovery, like film noir or screwball comedy. Unlike noir or screwball, though, it lasted only a few years. When Mae West made *She Done Him Wrong*, she had no idea she was making a pre-Code movie. She thought she was making a movie about her favorite subject, sex. The pre-Code tag came later, when someone realized that these films shared a time, a place, and an attitude. But what does pre-Code mean, really? What was the Code? What was "forbidden"?

Pre-Code refers to the four-year period before the Production Code was strengthened and enforced. There had been a Code since 1930, but the studios negotiated with it, bypassed it, or just plain ignored it. The movies of this period make viewers exclaim, "I didn't think they could say that in old movies!" A collection of eye-opening films constitute pre-Code.

In 1929, the film industry had just made the transition from silent cinema to sound films. Talking pictures brought a new candor, but some people were put off by it. A consortium of clubwomen, churchmen, and politicians assailed the industry, decrying off-color dialogue, stories of seduction, and scantily clad actresses. Local censors could not cut talking pictures yet, because the Vitaphone process used a separate disk, rather than a soundtrack at the edge of the film. With no one to stop them, screenwriters made their dialogue spicier. Complaints increased to the point at which legislators stepped in, and federal censorship looked like a possibility. This would have meant the end of the studio system, so the industry agreed to self-regulation and drafted a list of guidelines. This code would prohibit violence, profanity, and illegal drugs; allusions to "white slavery," miscegenation, or sexual perversion; nudity, provocative dancing, or lustful kissing; and suggestions of sexual congress, illicit or otherwise.

In March 1930, representatives of every studio signed the agreement. This "Production Code" should have kept forbidden elements off the screen, but the Great Depression arrived, emptying theaters. To lure patrons back, producers began to violate the agreement. Actresses flaunted their charms and flouted the Code. "Sin and succeed!" wrote *Variety* when reviewing a film in 1931. "Three cheers for sin!" wrote *Liberty* magazine when deriding the Code in 1933. By spring 1934, prohibited elements were no longer

James Gleason, Frederick Sullivan, Bert Roach, and Bradley Page enjoy pre-Code photos in Erle C. Kenton's *Search for Beauty*.

the issue. The character of the Hollywood film had changed. Films like *Search for Beauty* and *The Scarlet Empress* did not merely include suggestive scenes; these films were *about* sex. Their plots hinged on seduction. They showed naked women and even naked men. Though some of these films were exploitative, many of them were legitimate works of art. Hollywood was offering mature thought to an audience that was ready for it—and supporting it.

In that same spring, a grassroots movement sprang up in the Midwest. "Purify Hollywood or destroy Hollywood!" was the war cry. "Immoral" movies were the targets. When protests and boycotts caused the box office to drop and bankers to withdraw support, the industry surrendered and let a tough censor named Joseph I. Breen reconstitute the Code. In July of that year, it became the law of the land, and there was a Production Code Administration to enforce it. This time the studios cooperated, allowing Breen to regulate film content. "Pre-Code" films should really be called "pre-Breen."

These are the facts of pre-Code Hollywood. The story behind it is monumental, because it deals with a struggle for power. The stakes were high: the billion-dollar market for America's sixth-largest industry. The market was mostly Protestant. The industry was mostly Jewish-run. Yet a Midwest Catholic minority gained control.

This is the story of *Forbidden Hollywood*. The images throughout these pages show why the conflict arose in the first place. Hollywood's attitude toward sex was counter to Catholic doctrine of the day, which taught that sex was for married people and should not be discussed or shown, least of all in a place as public as a movie theater. Theaters came to be viewed as incipient brothels, corrupting everyone who entered them. Even the posters displayed outside their lobbies were scandalous, tainting the environment. Children were thought to be imperiled. Catholics saw the soul of a nation in danger, and they acted.

Fredric March and Elissa Landi in Cecil B. DeMille's *The Sign of the Cross*.

The "forbidden" aspect of pre-Code is the retroactive treatment accorded films of the early '30s. Many of them were in circulation when the new Code took effect. The Breen Office yanked these films back to Hollywood and forbade the studios to reissue them. If a film had been a success and merited reissue, Breen removed any element that the Code had just outlawed by having a studio editor cut the offending footage from the master negative. This crude process was applied to films like *Animal Crackers*, *The Public Enemy*, and *A Farewell to Arms*. Films judged too racy, like *She Done Him Wrong* and *Red Dust*, were denied reissue seals entirely. They became forbidden.

From all available evidence, the term "pre-Code" was first applied by a repertory film programmer named Bruce Goldstein in the late 1980s. Since then, there have been festivals, laser discs, videotapes, DVDs, blu-rays, and streaming devoted to the genre. There have been scores of books related to the subject. My 1999 book *Sin in Soft Focus* was the first to present an accurate, accessible chronology of the pre-Code era, but it is out of print. Information about pre-Code on the internet is often inaccurate. I would like to correct some misconceptions:

◇— Silent films are *not* pre-Code films.
◇— *Not* every pre-Code film was a low-budget shocker—but made with integrity and artistry. Many pre-Code films had big stars, big directors, and big budgets; these helped them defy the Code.
◇— The pre-Code censor was the Studio Relations Committee (SRC), part of the Motion Picture Producers and Distributors of America, Inc. (MPPDA)—*not* the Hays Office, or part of the

Motion Picture Producers of America, Inc. (MPPA), which did not exist until the 1960s.

◇— Joseph Breen was *not* a lifelong anti-Semite.

In the twenty-first century, when you can see just about anything you choose to see, you may find it difficult to understand why the images in this book and the scenes described here could have offended anyone, even ninety years ago. Will Hays, the sententious bureaucrat who monitored Hollywood conduct before and during the Code period, was fond of the expression "right-thinking." When backed against the wall, he said: "We simply must not allow the production of a picture which will offend every right-thinking person who sees it." Who was this "right-thinking" person? What made thinking right or wrong? Questions like this were swept aside when certain films offended certain people, and those people were not apathetic.

The American population in 1929 was 122.7 million. Ninety million were moviegoers, but then as now, the tastes of those patrons varied greatly from location to location. Film fans in Manhattan enjoyed sophisticated dramas; fans in upstate New York disliked them. Likewise, homespun stories did well in regional theaters but not in urban picture palaces. It followed that community standards differed greatly from the big cities to the small towns. "Damn" and "hell" were rarely spoken on the screen, of course, but there was even a hubbub over this sentence: "I'm going to have a baby." Some audiences found it too raw. "There must be a sweeter phrase for motherhood in pictures," wrote a Colorado exhibitor. "Let's get above the level of the cow having a calf." Other audiences found such attitudes risible.

The challenge for a manufacturer is to create a product that will sell everywhere. What if that product is a fantasy? When the fantasy of one community is the obscenity of another, the filmmaker's challenge becomes the censor's problem. This led to a four-year struggle.

My goal in writing *Forbidden Hollywood* is to tell the story of the pre-Code era by taking you there. We will eavesdrop on conferences between producers and writers, read nervous telegrams from executives to censors, and listen to conversations between censors and directors, where artistic decisions meant shifts in power—and money—when one-third of a nation was desperate. We will see how these decisions were so artfully wrought as to fool some of the people just long enough to get films into theaters. We will read what theater managers thought of such craftiness. We will read letters from a variety of fans as they, depending on community standards, applauded creativity or condemned crassness.

We will see why these films brought about the 1934 Production Code:

The Trial of Mary Dugan	*Red-Headed Woman*
	Call Her Savage
The Cock-Eyed World	*Island of Lost Souls*
The Divorcee	*The Sign of the Cross*
Hell's Angels	*She Done Him Wrong*
Little Caesar	*So This Is Africa*
The Public Enemy	*Baby Face*
Dracula	*The Story of Temple Drake*
Frankenstein	
A Free Soul	*Convention City*
Possessed	*Queen Christina*
Scarface	*Tarzan and His Mate*

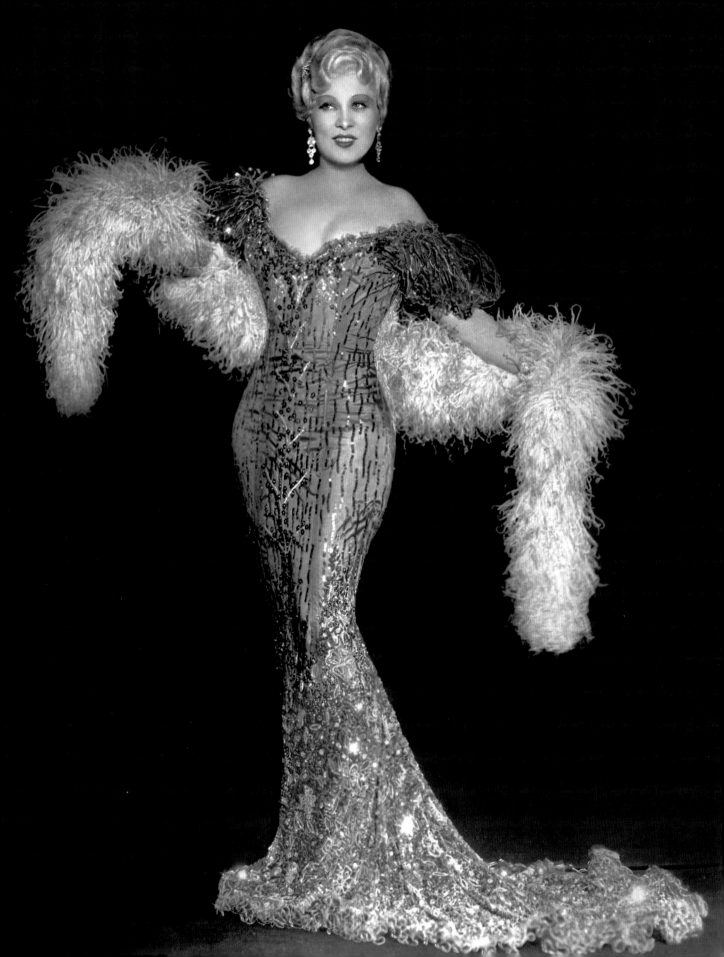

These films can be singled out from hundreds of other "problem films" because they meet these criteria.

◇— They were adapted from proscribed books or plays.
◇— They were attacked by the press.
◇— They were heavily cut by the state or local boards.
◇— They were banned in states, territories, or entire countries.
◇— They were condemned by the Catholic press and by the Legion of Decency.

Reading *Forbidden Hollywood*, you will learn the truth about these films. You will look at a particular pre-Code title and learn how a scene in it was regarded by a writer, a director, a Code administrator, a critic, an audience—and even a theater manager, who in the small towns, had a personal relationship with his patrons. If those patrons were offended by a film they saw in his theater, they were uncomfortable when they were leaving the theater. They looked down. They looked away. They did not want to confront the manager. But he knew. And even though he had not made the film in question, he felt responsible. He was showing it. Stories like these convey the history of pre-Code Hollywood in a new way. Film history should never be written without a human context.

Fortunately for us, there is ample documentation of the pre-Code context, even if some of the voices sound odd after nearly a century. Ninety years from now, our reactions to *She Done Him Wrong* may sound odd, too. This film engendered strong reactions in 1933, and it still does. *Forbidden Hollywood* will honor those reactions. Whether we find them peculiar or enlightened, we are fortunate to hear them. They give us a broader, deeper, clearer sense of the era than we have had. They help us understand why there was a fight to control the movies, why it ended as it did, and what survived.

MARK A. VIEIRA
August 1, 2018

OPPOSITE: "Having decided to be thorough, Mae West goes the limit," wrote Alma Whitaker in the *Los Angeles Times*. "None of your refined, lean, sinuous sophisticates like Norma Shearer's *Strangers May Kiss* or the Garbo-Dietrich line for her. When she is portraying a 'bad woman,' she's sumptuously, voluptuously, riotously bad, and she revels in complete vulgarity."

FOLLOWING PAGE: If one star embodied the giddy abandon of 1920s Hollywood, it was Mae Murray, seen here in Christy Cabanne's *The Masked Bride*.

PART

———

THE ROARING TWENTIES

———

ONE

NEW GODS AND NEW RULES

n 1920, Hollywood was synonymous with the American film industry. It was entertaining forty million Americans a week and achieving mythical status. The country needed myths. It was recovering from World War I and an influenza epidemic. F. Scott Fitzgerald saw "all Gods dead, all wars fought, all faiths in man shaken." To escape this nihilism, young people sat in darkened auditoriums and watched thirty-foot images solve life's problems in an hour. This was reassuring. It was also transporting. "You had only to see the faces of people coming out of a theater to know," wrote the *New Republic*. "They had been to the altar of all the old gods of human nature." For many, there were new gods, too—movie stars.

The stars of 1920 included William S. Hart, Lillian Gish, Roscoe ("Fatty") Arbuckle, Mabel Normand, Wallace Reid, Gloria Swanson, Douglas Fairbanks, Mary Pickford, and Charles Chaplin. Transfigured by luminous photography and animated by an innate charisma, these stars assumed the power of idols. But some idols have feet of clay.

Beginning in 1920, there was a series of scandals. The first was the poisoning death of Olive Thomas, a star who was married to Jack Pickford, Mary's brother.

The second, in 1921, was the death of a minor actress named Virginia Rappé. Roscoe Arbuckle was tried for manslaughter in her death amid press coverage that hinted at unnatural sex practices. The third scandal, in 1922, was the murder of director William Desmond Taylor. Again, there was speculation about Hollywood's private life, and two stars were harmed by association: Mabel Normand and Mary Miles Minter. The fourth scandal was the death of matinee idol Wallace Reid in January 1923. In this case, the cause was known; Reid's wife, actress Dorothy Davenport, acknowledged his struggle with morphine addiction.

Newspapers, both dailies and tabloids, seized on these events, sneering that Hollywood was not so much a magical place as a hotbed of vice. Arbuckle, Taylor, and Reid had worked for Famous Players–Lasky, which distributed their films as Paramount Productions, so Paramount was the obvious target. This prosperous combine had been merged only four years earlier, when Adolph Zukor saw how Jesse L. Lasky, Samuel Goldwyn, and Cecil B. DeMille had turned an unpaved suburb called Hollywood into a production hub. "Hollywood had built its big names," recalled DeMille. "Anything we did was news, and it was

titillating news if scandalmongers could hint that there was a fire of corruption consuming Hollywood's vitals. With the Arbuckle and Taylor affairs as a basis, pulpits thundered a lurid conception of Hollywood as a citadel of sin. The entire industry was tarred with a brush wielded in broad strokes. It was necessary to do something."

The film companies were vulnerable. Zukor's Paramount was a vertically structured monopoly, borrowing money from financiers to manufacture feature films, which it distributed with its own exchanges, and exhibited in its own theaters. It also forced independent exhibitors to buy blocks of films, using the product of one star to push lesser material. If there were proof of antitrust violation, bankers like Halsey, Stuart & Company could withhold credit.

Federal censorship was looming, too, and the studios had no legal safeguard. The first censoring body was founded in 1907 in Chicago, followed by New York in 1909. The studios fought back, taking one case to the highest court in the land.

In 1915 the Supreme Court ruled in *Mutual Film Corp. v. Industrial Commission of Ohio* that moving pictures were not protected by the First Amendment. "The exhibition of moving pictures is a business, pure and simple," read the decision, "originated and conducted for profit like other spectacles, and not to be regarded as part of the press of the country or as organs of public opinion within the meaning of freedom of speech." Moving pictures were merchandise; thus, the court upheld the right of prior censorship, and more censor boards opened.

The most punitive were the seven state boards, which oversaw entire regions. In January 1922, Massachusetts voted in the eighth board, and editorials urged federal censorship at that board. A referendum was scheduled. One by one, thirty-seven states introduced bills to establish censor boards. If the Massachusetts referendum passed, every state would have a board, and each board would be a tool for the federal government. A nationalized film industry was the obvious goal. The industry needed trade protection.

There existed an organization called the National Association of the Motion Picture Industry (NAMPI). Its members moved to recruit a spokesman, a politician whose conservative affiliations and sterling image would affirm the industry's integrity. They found their man in Will H. Hays. He was the postmaster general, a Presbyterian elder, and had managed the Republican convention to elect Warren G. Harding. NAMPI offered Hays a yearly salary of

In 1922, Will Hays became the head of the newly formed Motion Picture Producers and Distributors of America, Inc. (MPPDA). Photograph by Underwood & Underwood, courtesy of Bison Archives.

NEW GODS AND NEW RULES

$115,000. On March 5, 1922, he left the post office and became the "czar" of the movies. On March 11, the industry incorporated the Motion Picture Producers and Distributors of America, Inc. (MPPDA). It opened an office at 469 Fifth Avenue in New York, and Hays promptly launched a campaign against the Massachusetts referendum, repeating the strategy he had used to elect Harding—propaganda films and bribery. Massachusetts rejected the referendum, and no new boards appeared.

Reasoning that federal censorship would not be needed if the studios behaved, Hays urged self-regulation. He approached unfriendly groups like the International Federation of Catholic Alumnae (IFCA), the General Federation of Women's Clubs, and the Boy Scouts, and asked them to join his Department of Public Relations. Although he was a distinguished Protestant, he could not recruit American Protestants; the population was not centralized. American Catholics were, so he solicited support from the National Catholic Welfare Council. In 1924 he published a "Formula," which slowed the purchase of disreputable plays and novels. He saw to it that Rita McGoldrick of the IFCA used her weekly radio broadcast to both rate new films and praise his improvement of them. There was much to improve.

Hollywood films reflected the culture of the "Roaring Twenties." Two constitutional amendments had gotten the decade rolling; the Eighteenth, which outlawed alcohol, and the Nineteenth, which gave women the vote. Each year saw changes in manners and morals. Prohibition on the one hand and prosperity on the other created an "Era of Wonderful Nonsense." There were fads, tabloids, golf, cigarettes, speakeasies, bootleg gin, dancing, and "petting." There was a sense that Victorian strictures were being loosened by a new code. "The code had been born in disillusionment," wrote Frederick Lewis Allen in his 1931 book *Only Yesterday*. "Yet beneath the talk of a new era, the disillusionment persisted. And so the saxophones wailed and the gin-flask went its rounds and the dancers made their treadmill circuit with half-closed eyes, and the outside world, merciless and insane, was shut away for a restless night."

Nowhere was the outside world shut out more firmly than in the velvet darkness of a movie palace, where films like *The Golden Bed*, *Flaming Youth*, and *The Plastic Age* kept it at bay. If films were able to make salient comments, it was because they were ever more excellent. The silent cinema was coming of age, and it frequently dealt with subject matter suited to mature audiences.

Film Booking Office's *Human Wreckage* (1923) featured graphic scenes of drug use. Goldwyn Pictures' *Three Weeks* (1923) had scenes of drunkenness and debauchery in a Ruritanian palace. Metro-Goldwyn-Mayer's *Ben-Hur* (1925) had nude scenes, and its male star posed nude for publicity portraits. M-G-M's *The Big Parade* (1925) had an intertitle that read: "God damn them all!" M-G-M's *The Callahans and the Murphys* (1927) had a scene in which an Irish-American matriarch and her sewer-digger son guess the race of an abandoned infant. "Maybe it's a Jew baby," suggests her son. Mrs. Callahan looks under the baby's diaper, then declares, "It ain't a Jew baby!" An orgy scene in Paramount's *The Wedding March* (1928) hinted at "inverted sex practices" with a brief flash of one man kissing another during a drinking bout.

In 1927 Cecil B. DeMille asked Father Daniel Lord, the Jesuit editor of the Catholic youth magazine the *Queen's Work*, to join a minister and a rabbi as advisor on *The King of Kings*. Lord was appalled by the typical studio product. "There was little artistry and less entertainment in these films," wrote Lord. "Plots were puerile, thought content was less than zero, and scenes of 'romance' had all the sophistication of a back-alley seduction."

Even producers felt that things were getting out of hand. In 1926 Robert H. Cochrane, Universal Pictures' vice president, wrote to Will Hays, complaining about the production heads at the two biggest studios. "Unless Paramount can curb the natural lasciviousness of Bennie Schulberg," wrote Cochran, "and unless Metro can tone down Irving Thalberg (who, though fine in other respects, has a leaning toward the suggestive because of his showmanship), there is going to be a lot of dirty pictures during the coming season."

In January 1927, Hays opened a West Coast branch of the MPPDA at 6331 Hollywood Boulevard and installed a public relations department. This department's job was to consult with producers (then called "supervisors") and eliminate censorable elements from scenarios before they could be filmed. To head this department, Hays appointed Jason S. Joy, who had served as a colonel in the US Army General Staff before becoming executive secretary of the American Red Cross in 1920. He had been the MPPDA's director of public relations since 1922, but his arrival in Hollywood made him the face of the Hays Office, since Hays was usually in at the MPPDA in New York or at his law practice in Indiana. Joy's department inspected fifteen scenarios a month and submitted

recommendations. Most supervisors ignored him, and, predictably, their films fell victim to the censor boards.

There were ninety local boards and eight state boards: Florida, Kansas, Maryland, Massachusetts, New York, Ohio, Pennsylvania, and Virginia. Many state censors were civil servants who had happened onto a good thing. They were paid $200 a month by the state to watch movies all day and then cut them, reedit them, and even write new intertitles, with no regard for continuity or aesthetics. Paying censor fees was viewed as an unpleasant but necessary cost of doing business, so the creation of censorable scenes continued.

In May 1927, Hays convened a committee of studio executives to address the issue. Irving G. Thalberg, vice president in charge of production at M-G-M, joined Sol Wurtzel of the William Fox Company, and E. H. Allen of Paramount, and the three executives wrote a set of guidelines called the "Don'ts and Be Carefuls." In September, the MPPDA adopted it, and Hays created a "Studio Relations Committee" (SRC) to implement it. Jason Joy now had a way to review both scenarios and finished films. In October, when the Federal Trade Commission approved the "Don'ts and Be Carefuls," the film industry could boast of self-regulation.

Then, before Jason Joy could say "don't" or even "be careful," someone else spoke. On October 6, 1927, a film called *The Jazz Singer* was premiered by Warner Bros., one of the smaller companies. For the first time in a feature film, dialogue was spoken on the screen. "Wait a minute," said Al Jolson. "Wait a minute. You ain't heard nothin' yet." A Broadway audience gasped and then shouted. Talking pictures had arrived.

THE CENSORS

In 1928 only a handful of theaters were equipped with Vitaphone technology, and the industry could not decide if *The Jazz Singer* was a novelty or the portent of a revolution. In the spring, Warner Bros. released talking short subjects and part-talking features. In the summer the company released the first full-length sound feature, *Lights of New York*. A film that had cost $23,000 grossed $1.2 million. Never mind that the critics dismissed it. It talked. From then on, if a mediocre film had only one reel with sound in it, it did better than the best silent film. Fans' letters to *Photoplay* magazine indicated a preference for silents, but the box office told the tale. Even performers were fascinated. "There was a scene where I opened an envelope with a card inside," recalled Bessie Love. "After reading it, I ripped it in half. When we heard the sound of the card being torn, we were surprised and excited. It was all still such a novelty, hearing the noises one made on the screen." Within weeks, theaters began wiring for sound, and studios, both in Hollywood and New York, began building soundstages.

The new technology did not allow for camera movement. The camera was trapped in a soundproof booth, and, until the noise of the camera mechanism could be silenced, talking films would be static, like photographed stage plays. The studios looked eastward. "Proved stage successes were in high favor," William Hamilton Cline wrote in the *Los Angeles Times*. "These properties, once adapted (and deodorized, be it said), were the backbone of the talkies." Scenario writers, especially women, were suddenly deemed incapable of adapting "superior" stage material. Only legitimate playwrights were qualified to adapt plays. Thus began a literary land rush.

"The transcontinental trains were packed with Broadway writers summoned to save the talking pictures with clever dialogue," wrote Daniel Lord. "Instead they brought low, crude, and filthy things. Plots were narrowed down to seduction and murder and illegitimate children and immoral women and rapacious men. Silent smut had been bad. Vocal smut cried to the censors for vengeance."

OPPOSITE: In John Griffith Wray's *Human Wreckage*, Bessie Love injects herself with morphine while Dorothy Davenport cares for her infant. Davenport produced the film to honor her recently deceased husband, Wallace Reid.

At this point dialogue could not be censored. Most film companies were using Vitaphone's sound-on-disc technology, and there was no way to slice one groove from a sixteen-inch acetate disc. Nor could the offensive dialogue be kept out of the script in the first place. Jason Joy was reviewing a token number of scripts per month, but he had no authority to change scenarios, and his well-meaning suggestions were often met with grim stares; supervisors did not need a censor telling them how to write. The "Don'ts and Be Carefuls" did not say what to put into a film, only what to keep out of it, and they were vague about that. The SRC was a promising idea, but not a perfect one. Twenty percent of the supervisors acknowledged it. The rest bypassed it and endured the consequences.

The state censor boards were tough. They charged the studios $3 per thousand feet and $5 for each rewritten (and refilmed) intertitle. In 1928 the New York Board cut four thousand scenes from six hundred films. The Chicago Board cut six thousand scenes. The Virginia Board reported receipts of $27,624.75. "Business steadily increases," read the annual report. "Never before in the history of censorship has the volume of business been so great."

Censor boards were costing the industry $3.5 million a year in review fees, salaries, and mutilated prints. "A film might have a thousand feet cut out of it in Pennsylvania, and another five hundred in New York," wrote Daniel Lord. "The Ohio censors, notoriously exacting, would throw out whole scenes. A set of cuts made in a single state could cost a film company thou-

OPPOSITE: Censored silent films included Robert Z. Leonard's *Bright Lights* (1925) and Fred Niblo's *Ben-Hur* (1925).

sands of dollars—to reorder, to put back, to resplice, all to satisfy digressing tastes. The film print got to look like a ribbon that had been hacked by a child's shears."

What would account for these digressing tastes? Of the eighteen thousand theaters in America, 63 percent were in towns of less than 100,000, so the majority of American theaters were small-town or rural. This segment of the population led a different life than the urban segment, with divergent educational levels, religious beliefs, and social customs. Eighty percent of American movie houses were independent, but the theater chains were concentrated in big cities, where a five-thousand-seat movie palace could recoup a film's cost in a week. The big-city audience was more accepting of sophisticated fare than the regional audience, which preferred straightforward narratives.

The situation was complicated by which company owned how many theaters. Universal had 100 theaters, Loews had 200, RKO 250, Warner Bros. 850, Fox 900, and Paramount 1,500. Fox and Paramount had extensive holdings in the South and Midwest, so it behooved them to make films for those markets. When they strayed into "sophisticated" material, they heard gripes from exhibitors and moviegoers.

There is a journalistic legend that says one angry letter represents one hundred angry people who did not take the time to write. There is another version that says a hundred angry letters must be received before one angry letter is published. A study reported in 2001 by the *Journal of Criminal Justice and Popular Culture* confirmed that letters to the editor are a reliable measure of public opinion. In 1928 *Photoplay* encouraged its readers to write in, offering cash prizes for quality correspondence.

In early 1929, Will Hays installed Jason Joy and the Studio Relations Committee in the recently opened Louis B. Mayer Building, 5504 Hollywood Boulevard, at Western Avenue.

"In my town fifty-five out of a hundred people believe that motion pictures are sinful," wrote John Burke of Adams, Massachusetts. "They say pictures will make fools and bandits of our children." Burke did not specify how he arrived at his figures, and his letter won nothing.

"The average movie producer has the modern boys and girls all wrong," wrote Mary Walsh of Santa Fe, New Mexico. "In *Our Dancing Daughters*, Joan Crawford was a hot toddy, but she wasn't carrying our banner. We're not a pack of drinking, smoking, petting-party hounds that sneak home in the wee hours after a night of whoopee." Mary Walsh won $5 for her letter.

"If a producer made a picture showing the modern generation as we really are, he'd be exiled," wrote Elizabeth Norvell of Tuscola, Illinois. "Joan Crawford's pictures do not exaggerate us one bit. They even sugar-coat us slightly. We do drink, smoke, and pet, and we do sneak home in the wee hours. I am only sixteen, and I have never seen a moving picture which shows us moderns as bad as we are." Elizabeth Norvell also won $5.

Seeking to protect this generation (and earn revenue), the censors went after good films and bad, mutilating the last of the silent films, masterworks like *Sunrise*, *The Crowd*, *Our Dancing Daughters*, *The Patriot*, and *The Docks of New York*. Kansas was a "dry" state, so the Kansas state censor board cut drinking scenes. The Ohio board cut anything that might harm "impressionable" minds. In *The Magnificent Flirt*, an old man tells his nephew to look out the window; the old man sees a girl exercising in her underwear, but the boy sees a biplane's stunts. The old man says: "I show you a beautiful young woman, and you look at an airplane—you pervert!" John Leroy Clifton, an Ohio censor, refilmed the intertitle in order to delete the last word. After viewing D. W. Griffith's *Drums of Love*, which featured Don Alvarado, Clifton issued this order: "Cut scenes showing hero in tight trousers bowing and standing at top of stairway."

The impact of this censorship was not only felt by the studios in damaged prints and exorbitant fees; it was felt by audiences. When a brand-new print is cut and then spliced, there occurs a slight jump when the splice goes through the projector gate. This was obvious to most audience members, especially if it occurred when things were "getting good." Audiences could tell that they were being deprived of images and ideas for which they had paid at the box office.

OPPOSITE, CLOCKWISE FROM TOP LEFT: A seduction scene between Margaret Livingston and George O'Brien in F. W. Murnau's 1927 masterpiece *Sunrise* was cut by local censors. ◆ W. S. Van Dyke's *White Shadows in the South Seas*. ◆ "In *Our Dancing Daughters*, Joan Crawford was a hot toddy, but she wasn't carrying our banner," wrote a fan. "...We're more the chic, sophisticated type with enough sense to come home while it's still dark, get into bed, and dream about Greta Garbo and John Gilbert."

"Who are these censors, anyhow?" wrote James B. Cain of Chicago. "These positions are held by conservative, reclusive spinsters and egotistic, narrow-minded old bachelors. Are they judges of art? How are they qualified to regulate our morals?"

"Someday this censorship privilege will be given to persons who can resist the urge to use their scissors," wrote Ronald Dallas Reagin of Hugoton, Kansas. "Their formula is to count three and slash, no matter what is taking place."

"The attitude of the censor is essentially sadistic," wrote Floye Gilbert of Oakdale, California. "What he cannot enjoy, he is determined that no one else shall. Of course he pleads on 'moral grounds.' But since when have we become obligated to frame our moral standards to another's specifications?"

Morris L. Ernst was a civil libertarian. Pare Lorentz was a budding filmmaker and critic. In their 1930 book *Censored: The Private Life of the Movie*, they made a thorough study of censorship in the twenties. They were outraged at the cuts made in F. W. Murnau's *Sunrise* (1927). "The man who could look upon this movie and find even one scene suggestive is a man who could spend eight hours looking at two-for-a-nickel art magazines and then burn a Raphael nude. He could read Elinor Glyn all night and then demand that Theodore Dreiser be put in solitary confinement." It was this capricious, costly mutilation that had to be stopped.

The MPPDA was increasingly known as the "Hays Office," both in Hollywood and New York. (Will Hays made no effort to correct this.) In early 1929 Jason Joy and the Studio Relations Committee moved to the newly opened Louis B. Mayer Building

at 5504 Hollywood Boulevard. Located at the bustling corner of Hollywood Boulevard and Western Avenue, the handsome building also housed Central Casting and the Association of Motion Picture Producers (AMPP), a West Coast division of the MPPDA.

Cecil B. DeMille was the current president of the AMPP, and Mayer was a board member. The balconies of his building were decorated by architect S. Charles Lee with bas-reliefs of nude men and women making films. These figures were not a gesture of defiance to the Hays Office; they were a neoclassical convention.

Jason Joy hailed from Montana. After his stints in the Army and the Red Cross, he was even-tempered, deliberate, thoughtful. He would not attack a film because it dealt with adult issues. He more often found a way to express its complex morality without shocking anyone. According to censor Jack Vizzard, who worked with him years later, Joy was "a big, good-looking man, but bland, almost a milquetoast. But he must have had a core of steel. He tried to maintain the integrity of the Code, and at the same time, he could be almost obsequious, trying to please everyone."

Joy and his staff of four worked in Suite 408, consulting with supervisors from the eight major companies each week, helping them modify their nascent projects so the censor boards would pass them. The SRC facilities included a screening room where Joy could view finished films. Too often, he saw that he had been ignored. A film might include lines he had never seen because the actors had chosen to "ad lib." And, as long as there were Vitaphone discs, nothing could be cut. This situation made for some heated correspondence in 1929.

THE TRIAL OF MARY DUGAN

In 1929 Chicago's population was 50 percent Roman Catholic. Acting as chief advisor to the Chicago Censor Board was Father FitzGeorge Dinneen, the Jesuit pastor of St. Ignatius, a North Side church. In July he raised a ruckus over a film that the SRC had duly passed for exhibition. The animosity between this priest, the censor board, and the SRC was so potentially troublesome that Hays dispatched his chief legal counsel, Charles P. Pettijohn, to Chicago. In so doing, Hays set in motion the genesis of the 1930 Production Code.

The film that started the ruckus was an unlikely one, with an unlikely star. Norma Shearer was one of the top ten moneymakers of 1928. The aristocratic young Canadian had been a star since 1925, a year after the merger that created Metro-Goldwyn-Mayer. She was married to Irving Thalberg, the young executive who had made her a star. Thalberg was in his own category, a soft-spoken, cerebral producer who read books for pleasure, not because the studio might want to film them. He was a visionary, one of the few producers who was equally adept at handling financial matters and making creative decisions, and, in less than a decade he had become the sage of the system.

Working with management genius Louis B. Mayer, he had made M-G-M the most successful studio on the planet. Thalberg's exalted status was a factor when Will Hays invited him to collaborate on the "Don'ts and Be Carefuls."

Thalberg's 1929 challenge was to catch up to Paramount and Warner Bros. in the talkie market. This meant guiding Metro's vaunted stars, one by one, from silent technique to sound technique. Few of them had stage experience. Why, then, was Thalberg's third sound film a literal adaptation of a stage play? "The great quality that made motion pictures a success was realism," Thalberg told the *Los Angeles Times* in 1928 "Now voice has been added to pictures, making them just that much more intimate and real." He had chosen a grimly realistic play.

Bayard Veiller's *The Trial of Mary Dugan* had been a Broadway hit for Ann Harding and was still touring when Thalberg bought it. "This was one that Irving and I had seen in New York," recalled Shearer. "The adaptation would be unusual for the screen in that it takes place (except for a brief prologue) entirely in the courtroom where Mary Dugan is on trial for her life." Since M-G-M was all about stars, Thalberg must have

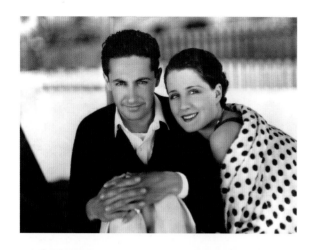

had someone in mind when he bought the play, but it was apparently not his wife. Shearer had been playing sincere, cheerful working girls. "Who could imagine me playing a chorus girl accused of murder?" she recalled. "Irving said that the change from the light comedies I had been doing to heavy drama was too drastic. And besides, I had no stage experience."

Thalberg hired Veiller to both adapt his play and direct it. "I talked with Thalberg over the telephone about what he wanted," wrote Veiller. "I was to minimize the fact that Mary Dugan had been the mistress of a man, but aside from that, we felt that for this experiment we could disregard most of the censorship rules." Veiller had been at M-G-M only a short while when he was accosted by a young woman. "I met him crossing the lot one day," said Shearer. "I told him how much I admired his play and would he give me a chance to read the part for him. So off we went, to a dark, dusty corner of an empty stage." Having convinced the playwright, Shearer rehearsed with him for a week, and then gave a staged reading on a standing courtroom set for Thalberg, Mayer, and a group of producers and their wives. After the applause died down, Thalberg told her she had the part.

On December 1, 1928, Shearer was dressed in a negligee for the first scene in the film. "I broke the sound barrier with a blood-curdling scream," she

Norma Shearer and Irving Thalberg were Hollywood's golden couple when they posed for this November 1928 portrait. ◆ In 1929, every M-G-M talking picture used a sixteen-inch acetate disc, not a soundtrack. ◆ An enlarged photograph of Norma Shearer in a bloodstained nightgown in Bayard Veiller's *The Trial of Mary Dugan* was too much for the Chicago censors in 1929. The ensuing political controversy led to the 1930 Production Code.

recalled. "Half naked and trembling, I was discovered in a darkened room, staring at the floor where a man lay dead."

Shearer's scenes on the witness stand were the high point of the script, but Thalberg was not pleased. "You didn't play it this way when you performed in front of that audience," he told her. "Then, when you had to confess your illicit relationship with this older man, you felt shame and pity, not for yourself, but for how much your shabby tale might hurt your brother. Now you are feeling pity for yourself. Tomorrow we start these scenes over. See that you play it with this thought in mind—with this feeling. Then the audience will care whether you are proven innocent or guilty."

The Trial of Mary Dugan was released in March 1929. "For Norma Shearer, the picture is a vindication and a triumph," wrote *Los Angeles Times* critic Norbert Lusk. "She emerges as an actress of greater individuality than she ever revealed in silent pictures." A. M. Sherwood Jr. wrote in *Outlook and Independent*: "Norma Shearer, the waxy, ephemeral beauty of light romances, invests Bayard Veiller's skillful lines with a tragic power that frankly astounded this observer. No cheap histrionics for her—no spurious assumption of virtue." *The Trial of Mary Dugan* grossed $1.4 million, vindicating everyone but the censors.

"The Chicago police have pounced on *The Trial of Mary Dugan*," wrote the *Outlook* in July. "It seems that Mary 'led a sinister life,' and the censors 'don't think that sort of thing should be advertised on the screen.' It would never do to let Chicago learn that there are such things as immoralities. The first thing you know, there might be a spot or two on the city's immaculate crime record." The snide comment was a pointed reference to the shocking crime that had occurred five months earlier, the so-called "St. Valentine's Day Massacre," in which seven gangsters were lined up against a garage wall by their rivals and executed with submachine guns.

There was an unexpected twist to the *Mary Dugan* situation, as reported in *Variety*: "This one drew plenty of free publicity when the Chicago Censor Board classified it as for adults only, then banned it entirely, and finally gave it a clean ticket when newspapers and city officials intervened. Gives you an idea how the board functions."

How the board functioned was very much on the mind of Father FitzGeorge Dinneen when he strolled down State Street and saw giant images on the Roosevelt Theatre heralding *The Trial of Mary Dugan*. He assumed that an alderman had been bribed by a film exchange to let the film open. "I'm going to teach some people in this town a lesson," said Dinneen. "I'll stop these filthy motion pictures from coming into my parish if we have to clean out every alderman on the North Side!" Ultimately he and his Chicago compatriots would accomplish much more than that.

THE COCK-EYED WORLD

Nineteen twenty-nine was a boom year for Hollywood. The industry reported profits of more than $54 million (roughly $19 billion in 2019 dollars). By the fall, the studios had stopped making silent films. Ever the trailblazer, William Fox had to his credit the Movietone sound-on-film process, widescreen movies, and a massive complex called Movietone City. In October 1929 he released an am-

bitious talkie, *The Cock-Eyed World*. This was the sequel to 1926's *What Price Glory?* which had made folk heroes of two rambunctious marines, Flagg (Victor McLaglen) and Quirt (Edmund Lowe). Having disposed of World War I in the silent film, director Raoul Walsh now had these rough-and-tumble characters ransack the audible world for female companionship.

"An appreciative first-night audience at Grauman's Chinese rocked with laughter and heartily applauded," wrote Louella Parsons in the *Los Angeles Examiner*. "You may rest assured the suggestive scenes made possible by dialogue didn't escape these critical first-nighters." Nor did the scenes escape the Kansas censors, who marched into the offices of Governor Clyde William Reed. "I gathered the impression that the picture would not be permitted in Kansas," Reed wrote to head censor Emma Viets. Then he learned that she could not cut dialogue from the film—because of the disc. Embarrassing incidents followed.

"My son is between sixteen and seventeen," wrote William H. McCarnish of Kansas. "He wanted to see

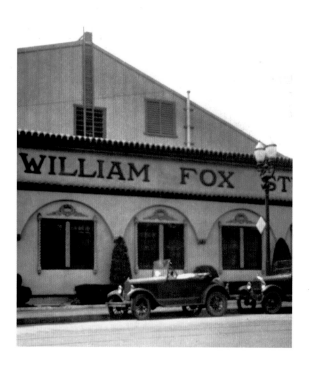

Located at Sunset Boulevard and Western Avenue, the William Fox Studio was one of two immense plants owned by the acquisitive mogul. Photograph by J. C. Vieira, 1929.

The Cock-Eyed World, because he has heard so much about it, and it has drawn such crowds. His mother also has heard much about it from other mothers. She said he ought not to go because the picture does not depict discipline or teach loyalty or patriotism. The prominent theme is that married women receive these marines with open arms in their bedrooms."

Marlen Pew, a trade editor, made the mistake of taking his children, and he endured "the humiliation of sitting through *The Cock-Eyed World* in the presence of a crowd of boys and girls of my family circle." A Nebraska exhibitor warned his colleagues: "If you have spent years trying to convince your better class of patronage that the movies are not as bad as the reformers say they are, then don't play this one. It is rough and vulgar from the first squawk."

How bad could it be?

The Cock-Eyed World had dirty songs, racist slurs, and caricatures (bestial Russians, dopey Swedes, nervous Jews, effeminate Central Americans), horizontal love scenes, a heroine who is obviously wearing no panties, and dialogue straight out of a locker room.

"Her old lady came home! I had to *get it* on the run."

"I'm bringing you the *lay* of the land."

"Son of a *bitch*!" was clearly mouthed by Quirt in one scene.

The film's references to social diseases were unprecedented. Flagg: "I bet you twenty bucks I can make her!" Quirt: "That's a bet. I been itching seven years to get your dough." Flagg: "You been *itching* for seven years, but don't blame it on me!" Quirt: "Why, the minute she saw me, Charmaine gave you the gate." Flagg: "And what she gave *you* was *plenty*!!!"

"Of all the bloated messes, this is the limit," wrote

Victor McLaglen and Lili Damita in a scene from Raoul Walsh's *The Cock-Eyed World.*

J. S. Walker, a theater owner in Grand Prairie, Texas. "Some exhibitors say this is 'hot.' No, this is not 'hot.' It is just stupid. It is not even good enough to be called 'vulgar.'" Harry Warner wrote to Will Hays: "Anyone employed by our company who would send a picture like that into our office, with the slang, vulgarity, and insinuations, would never work for us another day, even if it was my own brother."

Few theater owners were complaining. "The best hard-boiled picture ever made," wrote Golden, Colorado. "The public wants this kind. So make them hot." "Played it to packed houses through a ten-day engagement," wrote Binghamton, New York. "Everybody thought they were going to hear and see something racy," wrote McMinnville, Oregon. "Many were disappointed as they thought it would be rougher than it was," wrote Greenleaf, Kansas. *The Cock-Eyed World* brought Fox Film a staggering gross of $2.6 million, and it demonstrated that talking pictures could be offensive in ways that silent films never could.

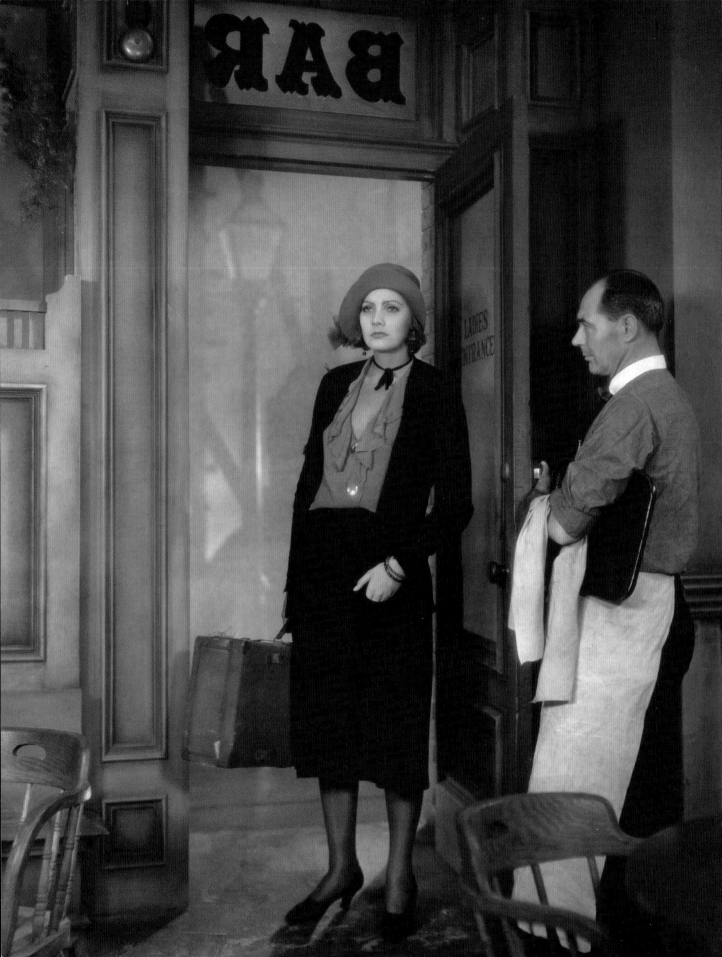

PART

———

1930

———

TWO

THE REAL PRE-CODE FILMS

Dialogue gave the talkies a literal, immediate quality. In *Sunnyside Up*, Marjorie White asks Janet Gaynor: "Then what the *hell* are you crying for?" In *Not So Dumb*, William Holden declares: "You know I don't give a *damn* about pictures!" In *The Voice of the City*, detective (and director) Willard Mack barks at a suspect whom he calls a "snowbird" (a cocaine addict): "Shoot *that* in your arm, hop. Either arm."

In 1929 the studios made 489 films, yet submitted only 203 scripts to the SRC. It managed to review 323 finished films; too many of them would become censor fodder. Even with the increased profits of sound films, companies could not afford a ruined product, nor could they afford the ill will that spawned the 1928 Brookhart Bill, which intended to outlaw block-booking (the practice that forced exhibitors to accept unwanted films in order to get the ones they wanted). Will Hays managed to defeat the bill but could not still the voices of disapproval.

One loud voice was that of Martin Quigley, a Catholic layperson who published the *Exhibitors Herald World* from Chicago. His magazine had formerly been called *Exhibitors Herald* and would soon become *Motion Picture Herald*, but whatever it was called, everyone in the industry read it. "Martin Quigley was an institution around here, because of his magazine," recalled censor Geoffrey Shurlock. "And because he *made* himself an institution. He was also a worrier about morals and decency." In 1929 Quigley upbraided the industry for not solving the problem at its source, the studio. He warned that if films were not made uniformly acceptable to the public and to the government, the industry would lose block-booking—and gain federal censorship.

In September 1929, Charles P. Pettijohn arrived in Chicago. To deal with Dinneen's righteous indignation, Pettijohn met with Cardinal George W. Mundelein, who was one of the most powerful prelates in America. Mundelein played golf weekly with Harold L. Stuart, the founder of Halsey, Stuart & Company, one of the banks underwriting Hollywood's conversion to sound. Pettijohn was a Protestant married to a Catholic, raising his children as Catholics. He suggested that the cardinal could call the shots if the censor boards were shut down. Dinneen suspected a plot to weaken the board system and warned Mundelein away from Pettijohn.

Will Hays was of no help in this situation. The best he could do was offer one of his pious dictums. "This industry," he said, "must have toward that sacred thing, the mind of a child, toward that clean virgin thing, the same care about the impressions made upon it that the best clergyman or the most inspired teacher of youth would have."

Pettijohn's overtures led Dinneen to speak with Martin Quigley. The censor and the publisher agreed that the industry needed a more detailed and specific version of the "Don'ts and Be Carefuls." It needed more than a formula to order the manufacture of "decent" moving pictures. It literally needed a "code."

In October, Dinneen and Quigley invited Daniel Lord to join their brainstorming sessions. They also invited one Joseph Ignatius Breen, a militantly devout Catholic and a father of six who was working as a public relations man for the Peabody Coal Company. While Breen listened, Quigley made notes, and Lord began to draft a document.

In years to come, Daniel Lord would refer to 1929 as "pre-Code." This designation was, of course, accurate, even if no one knew what it meant. The films of this period—spiked with "damn," "hell," and undressed chorus girls—were a distinct type of film, different from the transgressive wildness that was to come. Jason Joy notwithstanding, there was no code, so there was a giddy spontaneity to these films. There was also a slight unease. The country was still working hard and playing harder, but there was a sense that something was ending. Yes, the silent era had just ended with *The Kiss*, the last silent film for both Greta Garbo and M-G-M. Yes, the decade was ending. But something else was ending as well.

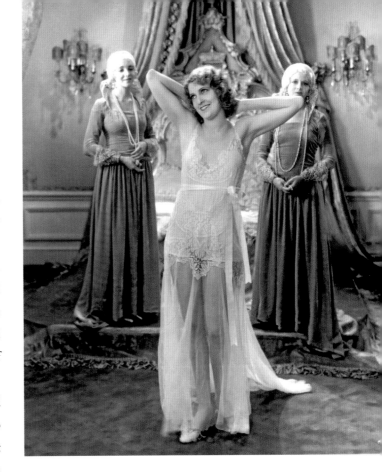

THIS PAGE: Jeanette MacDonald became the first pre-Code star in Ernst Lubitsch's *The Love Parade*.

PAGE 30: The cinema event of 1930 was the talking-picture debut of Greta Garbo in Clarence Brown's *Anna Christie*. In this scene, the world-weary prostitute is admitted to a waterfront bar by Lee Phelps.

On October 24, 1929, the stock market began to crash. Producers and technicians ran to soundstage telephones as the news spread. "The roar of voices which rose from the floor of the Stock Exchange had become a roar of panic," wrote Frederick Lewis Allen. "The gigantic edifice of prices was honeycombed with speculative credit and was now breaking under its own weight." After a few days of hesitation and hope, the disaster hit with full force. On October 29, sixteen million shares of stock were force-sold in a terror-filled free fall. On this "Black Tuesday," billions of dollars of wealth, real and imagined, melted into the void.

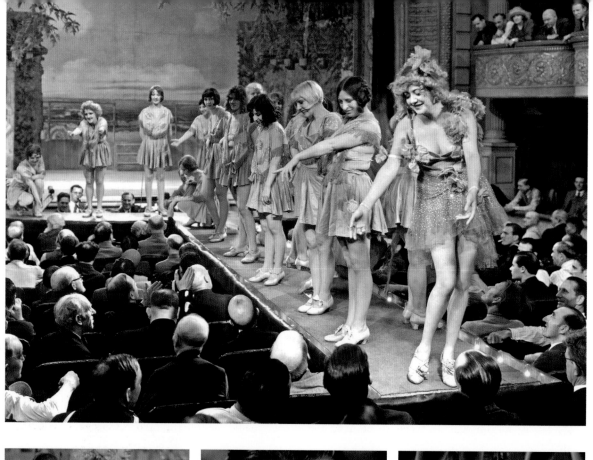

"Patronage Continues Despite Panic," was the November 12 headline in *Exhibitors Herald World*. "Wall Street is still struggling to clear the wreckage left by the greatest securities panic the world has ever known." Even though there were individual tales of loss, Hollywood shrugged off predictions of disaster. The major film companies were raking in profits, M-G-M with $12 million, Warner Bros. with $14 million, and Paramount with $25 million. Only Fox Film was troubled; William Fox had overextended his credit, first to build the largest studio complex in Hollywood, and then to buy up Loew's Inc., M-G-M's parent company. His purchase was blocked by an antitrust suit, a car crash, and the market crash, but Fox Film still managed to earn at $12 million profit.

There were eight major studios. The "major majors" were M-G-M, Paramount, Warner Bros., RKO Radio, and Fox Film. The "minor majors" were Universal, Columbia, and United Artists. Universal kept its sprawling acreage healthy with middlebrow fare, but Fox's product was making it look staid. "Uncle" Carl Laemmle was concerned. "The public knows that we stand for clean pictures," said Laemmle, "and that invariably they are too damn clean, and they stay away on account of it." Needing something more alluring, he asked Will Hays if "the Big U" could film John Colton's stage shocker, *The Shanghai Gesture*. This story of miscegenation, white slavery, opium addiction, and genocide had been proscribed by the Formula, so Hays said no to Laemmle and then said yes to a dozen

films of lesser pedigree and greater tawdriness, all the while placating the advocates of censorship.

Morris L. Ernst and Pare Lorentz had no respect for Hays. In their book *Censored*, they wrote:

> A man used to the ways of political subterfuge, with no especial literary or scientific background, Will Hays particularly epitomizes the class-conscious, fearful yet aggressive spirit that has made the American movie an industry, and little else. Search hard and find a man more fitted to handle petty politicians, middle-aged meddling prudes, and aggressive financiers. The controllers, the movie barons, are satisfied with his work. We can expect no fight for freedom, taste, or mature thought in this product so long as the Bishop of Hollywood chants his platitudes and swings his incense pot of purity.

Several of the "problem" films of early 1930 were both tasteful and mature. *The Love Parade* was Ernst Lubitsch's first sound film, the first to team Jeanette MacDonald and Maurice Chevalier, and the first talkie to integrate musical numbers into its plot. SRC staffer James B. M. Fisher screened the film and wrote, "There is a bathtub scene, very discreetly handled. There is also an early scene which shows Jeanette MacDonald in a very décolleté gown. There are a few lines with a rather explosively sophisticated meaning. None of these things should cause any adverse comment, however, because the picture is entirely free from vulgarity."

The New York State Censor Board passed *The Love Parade* without cuts, but it had its detractors. "I am not a mother, but I shudder for all mothers' children who see such vile pictures," a woman wrote to

OPPOSITE: Rouben Mamoulian's *Applause* used a montage of close-ups by George Folsey to convey the lusty ambience of a burlesque show headlined by Helen Morgan.

THE REAL PRE-CODE FILMS

Stanford University's *School Art* magazine. "There is so much real love in life, so much that is sweet and beautiful, why do writers feel they must resort to the sordid side of life to picture?" A male student wrote: "*The Love Parade* is a silly, indecent, and disreputable production. I could hardly blame the students for 'razzing' the show as they do." Yet it was a hit. It made stars of MacDonald and Chevalier and brought the "Lubitsch touch" into the sound era.

In reviewing the script of Rouben Mamoulian's *Applause*, Jason Joy advised Walter Wanger, its supervisor, not to clarify the relationship between an aging burlesque queen and her young common-law husband. Joy wrote: "The dialogue between Helen Morgan and Fuller Mellish Jr. in which she urges him to marry her because of the return of her daughter, might well be eliminated, allowing anyone to assume that they either have or have not been married, depending on the desire of the person who looks at the picture."

Joy believed that he could address the range of sophistication in the American audience only with a strategic vagueness. To his mind, children would not know (or care) whether the marriage was common law, but adults would read between the lines and understand the screenwriter's true intent. Joy carried this vagueness to the point of duplicity. "The assumption that they are married is clinched further on in the picture, when she speaks of him as her husband." This is how he adapted to the demands of spoken dialogue. When he could not approve a thorny plot point, he suggested a contradictory plotline, thus forcing the audience into two groups—duped or clued-in. This deliberate ambiguity would serve him well, becoming a keystone of code strategy.

Greta Garbo was the last star (other than Charles Chaplin) to make the transition to sound. For her first talkie, Irving Thalberg chose Eugene O'Neill's 1921 play *Anna Christie*. It was an unlikely vehicle for the star who had almost coined the words *exotic* and *mysterious*. In tough, slangy dialogue, it told the story of a Swedish-American girl driven to prostitution by her father's neglect. Could it be filmed? Jason Joy thought so, writing to Thalberg's assistant, Albert Lewin, "if Anna's past life is indicated and not actually picturized." There was also a confessional monologue that ended: "I was in a house. Yes, *that* kind of a house! The kind that you and Matt go to. And all men, God damn them!"

When New York audiences braved the February 1930 chill to hear Garbo speak from the screen for the first time, they didn't notice the "bup" on the sound track—the sound of a splice where three profane words had been replaced with "I hate them! I hate them!"

In Hollywood, *Anna Christie*'s supervisor had been doing some writing of his own. Working with a committee of supervisors, Irving Thalberg built on the documents written by Lord and Quigley, drafting the "General Principles to Govern the Preparation of a Revised Code of Ethics for Talking Pictures." Hollywood was giving birth to the Production Code.

OPPOSITE: While the 1930 Production Code was being ratified, Norma Shearer was making a film to test it, *The Divorcee*.

THE 1930 PRODUCTION CODE

The original code had no one author. Like a motion picture, it was made by a committee, to serve the needs of many. The moguls needed to soothe the censor boards. Will Hays needed to appease the Midwest Catholics and the increasingly unified Protestants. The bankers needed to protect their investments from threats like the Irish-American boycott that had pulled *The Callahans and the Murphys* from distribution in 1927. Clubwomen and churchmen needed films like *The Ten Commandments*, *Ben-Hur*, and *The Big Parade*. Catholics needed more than a ban on objectionable material; they needed to impose moral order. To this end, Father Daniel Lord drafted a document that would make the new code unassailable. He called it "The Reasons Supporting the Code."

Martin Quigley took it to Hays. "My eyes nearly popped out when I read it," recalled Hays. "This was the very thing I had been looking for!" While Hays pitched it to the MPPDA, Quigley pressed Cardinal George Mundelein to reel in Halsey, Stuart & Company. By January 1930, Lord and Quigley had rewritten "The General Principles" drafted by the Thalberg committee in November.

On February 10, 1930, Hays, Joy, Quigley, and Lord sat down for a decisive meeting with the MPPDA's West Coast Board of Directors: Thalberg (M-G-M); B. P. Schulberg and Jesse Lasky (Paramount); Jack Warner (Warner Bros.); and Sol Wurtzel (Fox Film). "After looking over your general code," Thalberg said to Lord, "it occurred to me that it was a little too far reaching." He and the other industry executives felt that Lord was seeking to arbitrate not only manners but also morals.

"I am talking only about the morality of entertainment," said Lord. "People go to the theatres; they sit there passively—*accept* and *receive*—with the result that they go out from that entertainment either very much improved or very much deteriorated; and that depends almost entirely upon the character of the entertainment."

In the November draft Thalberg had written: "We do not create types of entertainment. We merely present them. The motion picture does not present the audience with tastes and manners and views and morals; it reflects those they already have. People see in it a reflection of their own average thoughts and attitudes. If the reflection is much lower or higher than their own plane, they reject it. The motion picture

HARRISON'S REPORTS

Yearly Subscription Rates:

United States $15.00
U. S. Insular Possessions.. 16.00
Canada, Alaska.......... 16.00
Mexico, Spain, Cuba...... 16.00
Great Britain, New Zealand 16.00
Other Foreign Countries.. 17.50
 35c a Copy

1440 BROADWAY
New York, N. Y.

A Motion Picture Reviewing Service by a Former Exhibitor
Devoted Exclusively to the Interests of Exhibitors

Its Editorial Policy: No Problem Too Big for Its Editorial
Columns, if It is to Benefit the Exhibitor

Published Weekly by
P. S. HARRISON
Editor and Publisher

Established July 1, 1919

Tel.: Pennsylvania 7649

Cable Address:
Harroreot-
(Bentley Code)

A REVIEWING SERVICE FREE FROM THE INFLUENCE OF FILM ADVERTISING

Vol. XII SATURDAY, APRIL 5, 1930 No. 14

THE PRODUCERS' NEW CODE OF ETHICS

Marked "Confidential Until Morning of Release—Release Tuesday Morning, April 1, 1930," the following statement was issued by the Hays organization, which is quoted herewith verbatim:

"Sound, which revolutionized the art of the screen, has brought about the formulation of a new Code by the motion picture industry. The Code, which will apply to the making of talking, synchronized and silent motion pictures, was ratified by the Board of Directors of the Motion Picture Producers and Distributors of America, Inc., at their annual meeting here today, it was announced by Will H. Hays, president of that organization.

"'The motion picture, as developed for the primary purposes of the theatre, is a universal system of entertainment. Its appeal has broken through all barriers of class distinction. It is patronized by the poor man, the rich man, the old and the young. It is a messenger of democracy, and the motion picture industry is sensible of the great public responsibility. It is provided, therefore,

That every effort shall be made to reflect in drama and entertainment the better standards of life;
That law, natural or human, shall not be ridiculed;
That sympathy shall not be created for the violation of the law.

Trade papers dutifully reported the signing of the 1930 Production Code, but few expressed confidence in it.

is literally bound to the mental and moral level of its vast audience."

"We are really in the hands of men and women writing the current fiction, the literature of the day," added Lasky. "They are our reporters; and they are the ones that set the standards for the present type of entertainment."

Lord disagreed. "You set standards," he said. "You inculcate an idea of customs. You create fashions in dress, and you even go so far as to create fashions in automobiles. No art has done that before. You've got a larger audience! You've got an audience which pays 35¢, 50¢, as against a Broadway audience, which has to pay $4.00. And you've got closeness to that picture audience. You've got enlargement. You've got emphasis of light. You've got vividness." Lord believed that

the cinema had a persuasive, mesmerizing power. "You have built up enthusiasm for actors and actresses," he said. "You make them so real to people that you could get these people to like anything that your heroes and heroines do. You could make Clara Bow do almost anything, and people would still love what she did—up to a certain point, of course, depending on good taste. You have grave responsibilities, gentlemen!"

This was a sticking point. What constituted taste? "Five years ago if a man got on the stage and said 'damn' or 'God damn,' why, it created a sensation," said Thalberg. "That play was a success. As a consequence, other plays followed where those words were said. You can't offer that to people today. You could have a play with twenty swear words in it, but you wouldn't be able to drag five people to it."

Thalberg thought that the best approach would be an uplifting of tone. "If we could emphasize the better

picture, get behind it, and make it more the trend of the public, but never getting too far ahead of the public, you understand—just a little bit ahead of it—we would be doing our best to attract the public to that higher standard."

Lord was concerned that such a film could still contain immoral scenes that would stay with the viewer longer than a moral conclusion. "I will admit that at the end of your story you have illustrated where right is right and wrong is wrong," said Lord. "But what if, in the course of the story, that question has been left open, and there have been times when wrong has been right? When you are looking at Clara Bow get away with a lot of things, it has an evil effect, even though at the end you show retribution, because, you see, all of the time the audience has been in love with that woman."

"I think the idea of the code, in its inception, is splendid," said Lasky. "And it does occur to me that most of the pictures that we have made would be equally possible under this formula."

"Do you think," Lord asked the group, "that there would be any objection if the code insisted that writers and directors make changes so as to make the picture conform?"

"Oh, I think almost all of the pictures we have made could conform to it," said Schulberg.

"I do not think anybody objects to this in principle," said Thalberg. "Our hesitancy arises out of the fear that we might do something that would cause us, unintentionally, to be dishonest. Very often we make a picture which, in the minds of everybody, conforms to a particular code; yet we can be severely censured because of a local ordinance in only one city." Lord

jumped in, saying that a widespread acceptance to the Production Code would theoretically eliminate such pitfalls.

The draft of the General Principles had a loophole that allowed restricted material if "a special effort shall be made to include compensating moral values." When Thalberg and Lord reached an impasse over this issue, Will Hays called time-out, sending Quigley and Lord to rewrite the entire document in "three lively and sleepless sessions." The two authors returned on St. Valentine's Day, having married the Reasons to the Principles. Hays immediately annulled the marriage, hiding the Catholic Reasons from the MPPDA Board, who might not want the press to know that a Jewish-American industry was being influenced by an Irish-Catholic constituency.

On February 17, the Board unanimously adopted the "Code to Govern the Making of Silent, Synchronized and Talking Motion Pictures." Although Quigley saw the wisdom of not publishing the Reasons, he assumed his *Exhibitor's Herald World* would be the first to publish the actual Code. On February 19, *Variety* scooped him with an article, "Picture 'Don'ts' for '30." It glibly announced that "Will Hays put the halter around the necks of the members of the Association of Motion Picture Producers on Monday. Producer members agreed to abide by rules and regulations that will govern the industry in such a manner that censorship measures throughout the country will not be required and will possibly be abandoned." As if this wasn't bad enough, the newspaper printed the General Principles in toto.

Quigley guessed that Hays had leaked the text. Hays sent a frantic telegram to Lord: "As you know,

we were in no way to blame for it and were very anxious that nothing be published until resolutions were passed here." Lord tried to appease Quigley, but Quigley had a succinct response: "Hays is a worm."

Quigley also wanted sole credit for the Catholic editors' cooperation, so he dispatched Joseph Breen to secure it. He also wanted sole credit for the Code, which he was able to take when he caught Lord accepting a $500 stipend from Hays. In the midst of this intrigue, Father Dinneen cautioned Cardinal Mundelein against publicly endorsing the Code. When Quigley began to take credit for the Code, Mundelein, Lord, and Dinneen wondered who had done the double-crossing. It may not have been Hays who leaked the Code to *Variety*. Any of the executives could have done it, but the Midwest Catholics chose to blame Hays. They left Hollywood in March, slightly less unified and much less idealistic.

On March 31, Will Hays got the New York Board of the MPPDA—the center of power—to endorse the Code. He trumpeted his achievement in an April 1 press release: "Sound, which revolutionized the art of the screen, has brought about the formulation of a new Code by the motion picture industry." Most of the trades referred to the document as the "newest Hays code," perpetuating the myth that Hays was a dominating influence. He was happy to let the myth take root; it solidified his status. More importantly,

the industry did not want it known that the Chicago Catholics had been so involved in the process. In fact, Cardinal Mundelein felt that he—not Hays, Lord, or Quigley—was responsible for the Code. Resentful of an imagined slight, he refused to endorse the Code for six months.

The secular press was skeptical. "This code prohibits the use of all the ingredients that have proven sure-fire box office," opined *Variety*. "How can a movie which satisfies a child of twelve be made morally safe for a man of thirty-five?" asked the *Nation*. "Thus far the censors have spent all their time protecting children against adult movies; they might better protect adults against childlike movies." The *New York World* predicted, "That the code will actually be applied in any sincere and thorough way, we have not the slightest belief."

The Catholic press reflected Quigley and Lord's resentment. *Commonweal* thought Hays had made a "nominal alliance with the church to camouflage an actual alliance with the devil." Whatever the nature of his alliances, Hays had to make the Code work. He was being watched, by the MPPDA, the Midwest Catholics, the reformers, the secular press, and the trades. The real work was happening in Suite 408 of the Mayer Building, where Colonel Joy was reviewing his troops and reviewing scripts.

THE DIVORCEE

In May 1930, Fred W. Beetson, executive vice president of the AMPP, visited the SRC. "The entire office has developed into a beehive," he reported to Will Hays. Seventy-one scripts had already been reviewed by Jason Joy, Lamar Trotti, and James Fisher. Even as the country shuddered and hesitated, the studios were cranking out product. So far they appeared "Depression-proof." The October crash had been followed by smaller crashes, and, as the market slid, money tightened, spending slowed, and businesses panicked. "Each employee thrown out of work decreased the potential buying power of the country," wrote Frederick Lewis Allen. But film revenues were stable.

The studios were abiding by the Production Code, or at least willing to submit material. However, one of the noteworthy films released in May was not a product of the Code. *The Divorcee* had started shooting on February 1, while the Code was still being written. A wayward tale had traveled a wayward path to the screen.

Ex-Wife told the story of a young career woman who, nearly crushed by her husband's infidelity, impulsively divorces him and embarks on a freewheeling lifestyle. Ursula Parrott had not signed her novel because it was potentially scandalous, but when the book performed beyond expectations, she 'fessed up.

Irving Thalberg grabbed the property in September 1929, and when Will Hays tried to dissuade him, Thalberg went through the motions of putting it aside, meanwhile wondering who could portray the troubled young modern. The names of Greta Garbo and Joan Crawford were bandied about. "Irving laughed at me when I told him I thought I could do *Ex-Wife*," recalled Norma Shearer. Thalberg laughed because Hollywood thought she was not sexy enough. Shearer thought she was, and she even asked Ursula, her African-American maid. "Oh, Miss Shearer!" exclaimed Ursula. "You don't want to play a part like that. She's almost a bad woman!"

When Hays and Joy kept after Thalberg to drop *Ex-Wife*, Thalberg said, "The story presents divorce in the light of the growing evil it is looked upon to be, but looking at the subject with less suspicion than it was looked upon before. The result of divorce, viewed from the standpoint of the wife, is a very unhappy one, but if we show that the husband is desirous of going back to his former situation, we are positing a very worthwhile problem." To buttress his argument, Thalberg called

on a distinguished educator. "A picture based on this treatment will do a tremendous amount of good in the deterrence of divorces," said Father Joseph A. Sullivan, president of Loyola College.

Shearer was determined to snag the role of the ex-wife but had just seen a *Variety* article mentioning Claudette Colbert. "M-G-M was considering borrowing someone from another lot," she said. "I was there on the lot, under contract, and I felt in my heart I could do it." To help Thalberg visualize her as the woman of the world, Shearer tiptoed off the lot and had an unknown photographer named George Hurrell make seductive portraits of her. He had no great interest in the doings of the film companies. To him, Shearer was just "a tough little gal, fighting in her own way to get the part." When she showed the resulting images to Thalberg, he literally saw her in a different light. "Why, I believe you *can* play that part!" he smiled.

Casting was a moot point if Hays and Joy were unwilling to let Thalberg proceed, so he stalled them by announcing that *Ex-Wife* had been dropped from the production schedule and that Shearer's next film would be a Frederick Lonsdale property, *The High Road*. When the *Ex-Wife* script was ready, he offered Hays a concession. If the SRC would allow him to film it, he would use a different title and make sure that no mention of *Ex-Wife* appeared in the advertising. Hays said yes, perhaps aware that Thalberg was already shooting the film. *Variety* had just announced the start of production on *The Divorcee*, calling it a "whitewashed version of *Ex-Wife*." Thalberg was accustomed to having his way.

In *The Divorcee*, Norma Shearer portrays Jerry, a commercial artist, whose husband, Ted (Chester

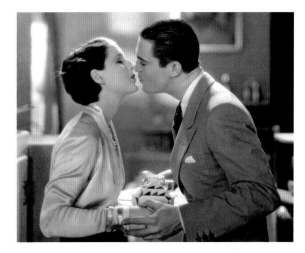

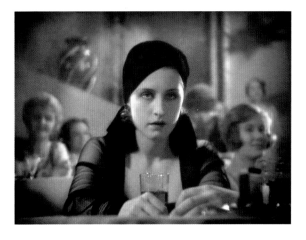

With *The Divorcee*, Irving Thalberg flouted the Code he had helped write, and Norma Shearer found a breakthrough role as a divorced woman on a spree.

THE DIVORCEE

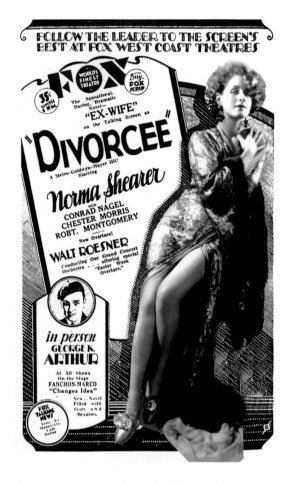

Theater owners were told by the M-G-M publicity department not to mention the controversial novel that was the basis of *The Divorcee*, but they did anyway.

Morris), justifies a casual affair with the phrase "It doesn't mean a thing." In a state of shock, Jerry finds herself testing the limits of 1930 convention: she sleeps with Ted's best friend, Don (Robert Montgomery). Then she tells Ted: "I've balanced our accounts." When Ted explodes with self-righteousness, Jerry delivers an electrifying fade-out line: "And from now on, *you're* the only man in the world my door is closed to!"

The SRC predicted negative reactions, but the preview was a relief. "It is a great picture," wrote reviewer W. F. Willis. As promised, M-G-M sent a directive to all branches and exchanges: "Warning: While *The Divorcee* is said to be based on the book *Ex-Wife*, you are NOT to refer to that fact in your paid advertising. Watch this closely to avoid legal difficulties." In the course of the film's release, Thalberg's rivals complained that ads were mentioning the novel, but there were only a few, and they had come from the exhibitors, not from the studio.

Shearer had rivals, too, and her primary rival was another M-G-M star. Joan Crawford had been vying for the lead in *The Divorcee*; she was resentful when Shearer got it. Crawford's first job upon arriving at Metro in December 1924 had been to double for Shearer in Monta Bell's *Lady of the Night*, a gem of a film that had nothing to do with streetwalkers. As Crawford did time in colorless leading-lady roles, she watched Shearer shoot to stardom. Only in 1928 had Crawford caught up with Shearer. After *Our Dancing Daughters* and *Our Modern Maidens*, Crawford was a major star, but she felt that Shearer had more influence with Thalberg.

"Certainly Norma had an advantage," recalled Crawford. "When an actress sleeps with the producer, she is bound to have an advantage. Sex is a very potent weapon." Shearer was married to this producer, and there was proof that she was sleeping with him. "As I was about to start the picture," wrote Shearer, "I discovered that I was going to have a baby."

HOWARD HUGHES
AND HELL'S ANGELS

W hen Norma Shearer went on maternity leave in the summer of 1930, Joan Crawford got Shearer's next project. *Paid* was the story of a falsely accused girl who pays back the rich folk who sent her to prison. Irving Thalberg believed that every film should have one great scene, but not at the expense of continuity. "Irving had a sixth sense about a manuscript," recalled producer Lawrence Weingarten, who had been a writer in 1930. "You could go out with a film to a preview, and if there was something that didn't quite come off, he could put his finger on it. Some of the great films that came out of Metro were remade at his suggestion." Sam Wood shot a five-minute fight scene in the women's shower, then had to shoot a ten-second replacement when the graphic scene was cut, not by the SRC, but by Thalberg, because the shower scene pulled the story off its track.

At Universal, Lewis Milestone directed *All Quiet on the Western Front*, an adaptation of the antiwar novel by Erich Maria Remarque. The film caused one censor to dictate: "Where men are bathing in river, cut out all scenes of them turning somersaults, or otherwise unduly exposing themselves." Another sequence in the

film has three German soldiers spending the night in a farmhouse with three French girls. It concludes with silhouettes on the bedroom wall and the voice of the hero, Paul (Lew Ayres), telling a French girl, Suzanne (Yola D'Avril): "I'll never see you again. I know that—and I wouldn't know you if I did, and yet I'll remember you—always. *Toujours.* Oh, if only you could know how

A candid photograph of Howard Hughes directing *Hell's Angels.*

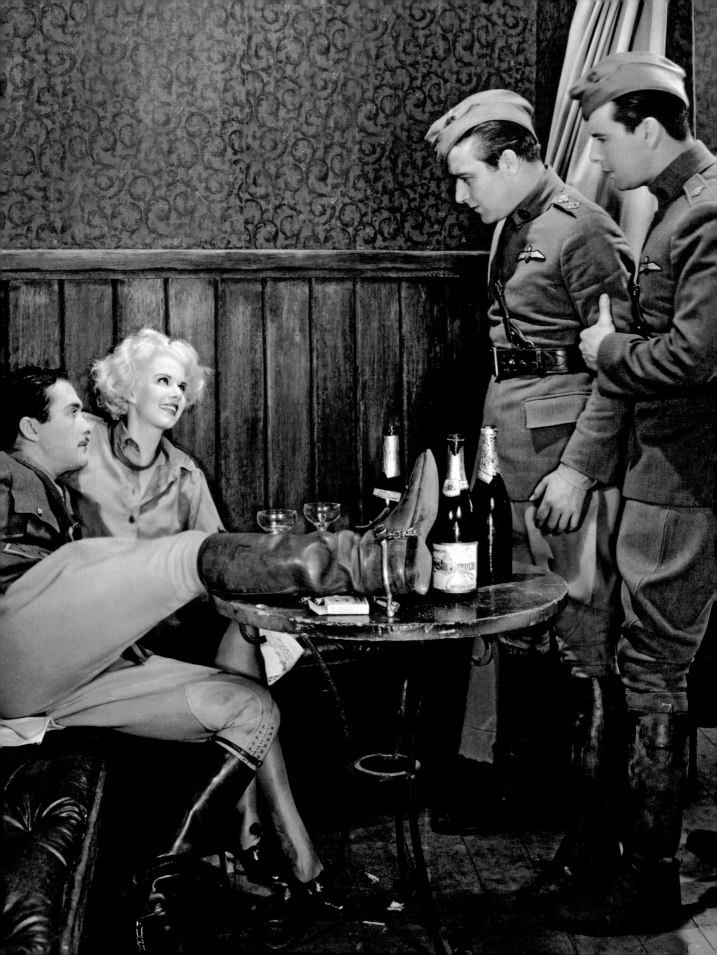

different this is from the women we soldiers meet." According to SRC reviewer James Fisher, "Audience reaction here was good, and there was no snickering or laughing as there would have been had they considered the scene at all off color." The Ohio Board thought otherwise, cutting the entire sequence.

Hell's Angels was another view of the Great War, an aviation epic as controversial as its producer. "There rose on the horizon of the land a sinister figure by the name of Howard Hughes," wrote Daniel Lord. "I was invited by Mr. Quigley to an early presentation of his picture *Hell's Angels*." The screening took place not at a major studio but at an independent outfit called Metropolitan Studios. This was Hughes. In a city of egotistical moguls, he was different. He was not Jewish, self-made, or sociable. He was twenty-four, had millions of dollars, and nobody was going to tell him how to spend it.

Lord was horrified by *Hell's Angels*. "Hughes had introduced about the most suggestive lines and situations that he could produce. The tough audience winced when Jean Harlow appeared in costumes that were not only immodest but also deliberately obscene, and when she set herself to seduce one of the aviators in the most candid and detailed fashion." The seduction commenced with a quotable line: "Would you be shocked if I put on something more comfortable?"

Thalberg usually negotiated with the SRC, but Hughes ignored it. Consequently *Hell's Angels* was shot down by the censor boards. Hays checked in with the SRC. "The difficulty, as you know," the SRC's Lamar

OPPOSITE: Douglas Gilmore, Jean Harlow, James Hall, and Ben Lyon in a scene from Howard Hughes's *Hell's Angels*.

Trotti explained, "lies in the fact that the story of *Hell's Angels* is stupid, rotten, sordid, and cheap." Trotti noted that scenes between British soldiers and French bar girls showed open-mouth kissing. "When the couples kiss each other, they invariably open their mouths and try to swallow each other. The men kiss the girls on the ears and the girls squeal." James E. West, chief scout executive of the Boy Scouts of America, wrote to Hays: "I didn't relish the idea of exposing my children to the unnecessary, disgusting evidence of passion and lust, the worst I have seen on the screen." *Hell's Angels* was well attended, but its $2.8 million budget precluded a profit. Still, it established Hughes as a studio head and made Harlow a celebrity.

As one mogul appeared, another disappeared. William Fox was ousted from the company he had founded fifteen years earlier, and by an avaricious triumvirate: the American Telephone & Telegraph Company; Halsey, Stuart & Company; and would-be company president Harley Clarke. Unlike M-G-M, the Fox Film Corporation had only a few stars: Will Rogers, Janet Gaynor, and Charles Farrell. To compensate for a lack of star power, production head Winfield Sheehan pushed projects that were fantastic, extravagant, and racy.

Just Imagine was a "science fiction musical." In it, 1980 Manhattan is an unpleasant place, its denizens known only by numbers and not allowed to procreate naturally. Three young men escape to Mars, where they encounter the Martian Queen, Looloo (Joyzelle Joyner), and her brutish bodyguard, Loko (Ivan Linow). Loko approaches earthling Single 0 (El Brendel) and caresses his face. Pointing first to Looloo, then to Loko, Single 0 exclaims to his comrades, "*She's*

not the queen! *He* is!" The SRC's John V. Wilson wrote, "Some of the censors may want to eliminate from Loko's actions that which seem to make it appear that he is 'queer.'"

In August, Trotti found M-G-M contentious. Cecil B. DeMille refused to rework his sex-and-Deco musical, *Madam Satan*, and Thalberg refused to cut Marie Prevost's lines in *War Nurse*: "What do you wear to clean the latrine? Your dark brown taffeta, dear."

"Not the usual Thalberg reaction," wrote Trotti. "The Metro attitude at the moment is, why should any small group of people decide what the rest of the world should see?" One of Joy's colleagues wrote him: "After reading the suggestions you made on *Madam Satan*, you have my entire sympathy. The marvel is that you are getting away with as much as you do." Censors were increasingly vigilant, and with good reason.

"We are struggling mightily with the cycle of sophistication which the success of *The Divorcee* induced," wrote Jason Joy. *Variety* knew Joy's terminology, judging from the title of a September article: "Cycle Wheels Right over Hays Code." The article reported: "Studios are more and more openly ignoring the Hays code of ethics." The *New York Telegraph* asked: "By the way, what ever became of that Hays code? It seems that all the producers got together when Hays issued his proclamation of picture cleanliness, and they all nodded their heads sagely and agreed to follow the code. Then along came Metro with *The Divorcee*, the picture version of *Ex-Wife*, and knocked the code for a row of big figures. Now every picture concern is trying for something sensational and startling."

There was reason to try. In ten months, weekly movie attendance had dropped precipitously, from ninety million to eighty million. On December 11, 1930, the secretary of Guaranty Savings and Loan in Hollywood announced that he had lost $7,630,000 in the stock market and closed his doors. A raft of businesses followed, and the industry finally believed the depression was real. Perhaps "something sensational and startling" would retrieve those ten million customers.

OPPOSITE: Lillian Roth, Roland Young, and Kay Johnson in a risqué scene from Cecil B. DeMille's *Madam Satan*. ◆ Yola D'Avril, Lew Ayres, William Bakewell, Renée Damonde, Scott Kolk, and Poupée Andriot in Lewis Milestone's *All Quiet on the Western Front*.

THIS PAGE, CLOCKWISE FROM TOP LEFT: "The woman all women want to see" was the tagline for Marlene Dietrich's arrival in Hollywood, but no one expected her to dress like a man in Josef von Sternberg's *Morocco*. Portrait by Eugene Robert Richee. ◆ In Harry Beaumont's *Our Blushing Brides*, Joan Crawford tries to comfort Anita Page, who has just been dumped by her rich boyfriend. ◆ The G Sisters were one of the many provocative acts in John Murray Anderson's *The King of Jazz*.

OPPOSITE: Kenneth Alexander made this portrait of an uncredited Goldwyn Girl for Thornton Freeland's *Whoopee!*

PART

———

1931

———

THREE

LITTLE CAESAR

The Volstead Act had been the law of the land since October 28, 1919. Herbert Hoover called it the "noble experiment." While it prohibited the sale of alcoholic beverages, it underestimated the thirst of a nation, and a criminal underclass emerged to meet this demand. There were no trade regulations for bootleggers, so territorial disputes were commonplace. In 1929, Chicago newspaperman W. R. Burnett visited the scene of the St. Valentine's Day Massacre. "It was a slaughterhouse," he recalled. "Blood all over the wall and guys lying around on the floor. I got one look at it and I said, 'Uh, uh.' I didn't want any of that." He thought about the type of person who would become a gangland boss. "I was reaching for a gutter Macbeth," said Burnett. "A figure that could rise to prominence under the most hazardous conditions, the picture of overriding ambition." The result was his best-selling novel, *Little Caesar*.

Darryl F. Zanuck was a Warners' production head at twenty-eight. Possessing an innate story sense, he had started as *Rin-Tin-Tin*'s writer and risen to hits like *Old San Francisco*. When a friend and mentor died in a bootleg dispute, Zanuck decided to produce *The Doorway to Hell*, the first film to look at gangland

life from the inside. The film had a successful release in October 1930, but Jason Joy was concerned about this new type of crime film. Zanuck disagreed. "*The Doorway to Hell* is not being cut by the censor boards," Zanuck wrote Joy. "They realize that the picture has a strong moral tone, and that is, the futility of crime as a business or as a profit."

Mervyn LeRoy felt unfulfilled directing comedies for Warners. "All I wanted to do was make a movie with some meat to it," he wrote, "with some substance, where before all I'd done had been froth." Then he read the galleys of *Little Caesar*. He rushed to the office of Jack, the Warner brother who made the films. (Albert and Harry Warner handled administration and distribution, respectively.) "The Boss, as we called him, wasn't alone," wrote LeRoy. "His two young right-hand men—Darryl Zanuck and Hal Wallis— were with him. I was so keyed up about my discovery that I didn't bother about protocol: 'This is what I've been looking for, Jack. This guy Burnett must have written this for me to do.'"

The eponymous "Little Caesar" was a megalomaniac named Cesare Enrico Bandello. The casting of such a role would be crucial. "I had intended to have

THIS PAGE: Anton Grot's art direction stylized Edward G. Robinson's cruelty in Mervyn LeRoy's *Little Caesar*.

PAGE 52: A portrait of Jean Harlow made by Elmer Fryer for William Wellman's *The Public Enemy*.

Edward G. Robinson play the small part of Otero," wrote Wallis. "But Eddie was determined to play Rico. He walked into my office one day wearing a homburg, heavy black overcoat, a white evening scarf, and a cigar clenched between his teeth. He was Rico."

George E. Stone was cast as Otero, the bodyguard who looks at his boss with more than fondness, while his boss looks at henchman Joe Massaro (Douglas Fairbanks Jr.) with repressed desire. Burnett had been hired as a writer and was visiting LeRoy's set. "Burnett didn't like our production," wrote Wallis. "He complained that in our version the relationship between Rico and Joe Massaro was homosexual! No such thing was in our minds." Perhaps not, but in the script by Robert N. Lee and Francis Edward Faragoh, Rico has no contact with women and flies into a jealous rage when Joe tells him he's leaving the gang. "I was disappointed in the film because they conventionalized it," said Burnett. "It was an Italian picture, and there was not an Italian in it. What made the movie was Robinson."

LITTLE CAESAR

Edward G. Robinson had some secret allure. Over three thousand people showed up for the New York opening in January. The pressure of their bodies broke the glass doors of the Strand Theatre at Broadway and 47th Street. "But ultimately, what made *Little Caesar* the smack in the face it was," said Burnett, "was the fact that it was the world seen completely through the eyes of a gangster." The gangster was based, of course, on Chicago's Al Capone, the person responsible for the St. Valentine's Day Massacre. New York congressman Fiorello La Guardia was angered by Robinson's portrayal of Rico as unmistakably Italian. "My guess is that La Guardia is sore because Little Caesar looks like him," wrote Maurice McKenzie, Will Hays's executive assistant, to Jason Joy.

In January 1931, Dr. James Wingate was the head of the Motion Picture Division of the State of New York Education Department. His censorship decisions affected not only his state, but also much of America.

The hero worship accorded *Little Caesar* angered him. "Children see a gangster riding around in a Rolls-Royce and living in luxury, and even though some other gangster gets him in the end, the child unconsciously forms the idea that *he* will be smarter and will get away with it."

Meanwhile, Joy was writing to McKenzie: "I saw *Little Caesar* with an audience last night, and how they ate it up. How La Guardia or the British Columbia censors can object to any part of it is beyond me." Then, atypically colloquial, he wrote: "Everything else seems to be O.K. except Wingate and the New York State Censor Board. They are riding hell out of us. One of us is awfully wrong, and my guess is it ain't me."

Wingate demanded extensive cuts. Joy argued against them. "The more ghastly and the more ruthless the criminal acts are," said Joy, "the stronger will be the audience reaction against men of this kind and organized crime in general." In an earnest letter, Joy tried to convince Wingate. "Always drama has been permitted to paint the unconventional, the unlawful, the immoral side of life in order to bring out in immediate contrast the happiness and benefits derived from wholesome, clean, and law-abiding conduct, and thus, without actually preaching a sermon, giving audiences the opportunity of inevitably forming the conclusion that the breaking of human or divine laws brings punishment." Wingate was unconvinced. He cut *Little Caesar* to shreds, and Pennsylvania followed suit.

THIS PAGE: H.B. Warner and Frances Starr are victims of a tabloid smear campaign in Mervyn LeRoy's *Five Star Final.*

OPPOSITE: The only character who loves Little Caesar is his henchman, Otero (George E. Stone).

THE PUBLIC ENEMY

I n 1931 Hollywood, the combined scents of gun-powder and cash were irresistible. Fox Film released *Quick Millions*, followed by M-G-M's *The Secret Six* and Paramount's *City Streets*, but the most charismatic gangster was at Warner Bros. He was created when Chicago producer Rufus LeMaire came to Darryl Zanuck, peddling an unpublished novel by two former druggists. LeMaire thought that *Beer and Blood* would be his ticket to a supervisor's job. Zanuck side-tracked him into the casting department, then hired John Bright and Kubec Glasmon to scenarize their manuscript. Acting out all the parts in story conferences with staff writer Harvey Thew, Zanuck had them build up one character, Tom Powers, and they created *The Public Enemy*.

"Our character was a swashbuckling, hard-fisted guy," said Bright, "a hoodlum who had come up from the Irish ghetto to the top. He had an income of ten thousand dollars a week or more. Notches on his gun. Been shot at many times." Zanuck submitted the script to Jason Joy with this pitch: "In *The Public Enemy*, we

also have a very strong moral theme, to-wit: If there is *pleasure* and *profit* in crime, or the violation of the Eighteenth Amendment, then *that* pleasure and *that* profit can only be momentary, and it ultimately ends in disaster to the participants."

When Joy approved the script, Zanuck took an active role in the production, casting, recasting, and then exhorting director William Wellman: "People are going to say the characters are immoral, but they're not because they don't have any morals. They steal, they kill, they lie, they hump each other because that's the way they're made, and if you allow a decent feeling or a pang of conscience to come into their makeup, you've lost 'em and changed the kind of movie we're making." *The Public Enemy* was shot in twenty-one days at a cost of $151,000, and Zanuck invited Irving Thalberg to its preview. Thalberg was stunned. "That's not a motion picture," he told Zanuck. "It's beyond a motion picture."

The Public Enemy opened on April 6, 1931, and Will Hays chose this inopportune moment to say: "The greatest of all censors—the American public—is beginning to vote thumbs down on the 'hard-boiled' realism in literature and on the stage which marked

the post-war period." Hays looked foolish when *The Public Enemy* outstripped *Little Caesar*'s box office. This time Wingate admitted that it was "a story that ought to be told," but lamented the weak role played by the police in the film.

The SRC's Lamar Trotti had reservations about a scene in which Powers buys a new suit. "The tailor is unmistakably a 'fairy,' with hands on hips, Nice-Nellie talk, etc.," wrote Trotti. Most state boards cut pistols, machine guns, and "pineapples" (hand grenades) from the film, but it was a grapefruit that separated *The Public Enemy* from the pack. The film showed James Cagney in pajamas, eating a grapefruit breakfast with Mae Clarke, while in the next room, Edward Woods chewed Joan Blondell's earlobe—in bed. Few movie-goers saw (or heard) what followed. "At the end of the scene between the two boys and two girls in the apartment, cut the sound track where action ceases and dialogue implies intimacy."

While *The Public Enemy* broke more attendance records, Will Hays received letters of complaint from the Daughters of the American Revolution, the Veterans of Foreign Wars, the United Presbyterian Church, the Catholic Knights of Columbus, and the National Federation of Men's Bible Classes. Hays also received a letter signed "Disgusted." It said: "Such pictures as *Little Caesar* are more destructive to the morality of our country than any other single force today. The public expects you to censor these movies."

"Gangster pictures are poisoning the minds of the younger generation?" asked H. Pal of Rochester in *Motion Picture* magazine. "Rot! Children have the desire to follow in the footsteps of the heroes—the cops and detectives—not the criminals. These pictures are more apt to teach right from wrong."

"Though I am but a timorous female who wouldn't so much as kill a fly," wrote Anita Mackland of Los Angeles, "I dote on gang pictures, but I don't approve of them. The offender is too often made so admirable, in spots, that we gulp a tear in his behalf. This is all wrong. Until the gangster screen character is entirely robbed of his glamour, he should be kept out of pictures and away from impressionable minds."

Even Al Capone had a comment: "These gang pictures—that's terrible kid stuff. They're doing nothing but harm to the younger element of the country. I don't blame the censors for trying to bar them."

At Warner Bros., Darryl Zanuck was so happy with John Bright's work that he invited him to a stag party. "It involved everything, including a lesbian show by two prostitutes," recalled Bright. "I remember commenting to myself that here were the leading creators of the nation's entertainment, including children's pictures, and they were behaving so obscenely, speculating whether the girls were on the level or not, were they having orgasms or not, while these wretched little creatures were involved in angleworm antics. I was shocked and revolted at the absurdity of it."

Meanwhile, at the corner of Hollywood and Western, the stalwart staff of the SRC, having survived a sophistication cycle and a gangster cycle, prepared for a horror cycle.

OPPOSITE: In *The Public Enemy*, gangster Eddie Woods gets more than breakfast in bed from Joan Blondell. The scene was cut from the negative in 1953, but only partially restored in 2005.

SMASHING ITS WAY TO NEW RECORDS EVERYWHERE!

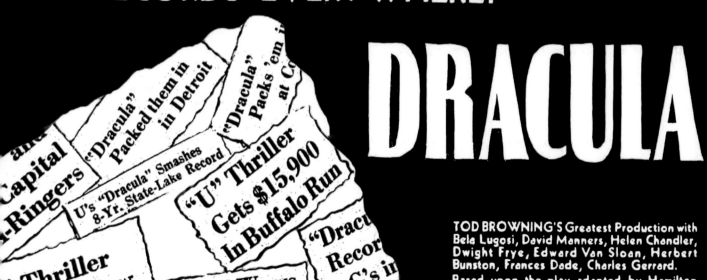

DRACULA

TOD BROWNING'S Greatest Production with Bela Lugosi, David Manners, Helen Chandler, Dwight Frye, Edward Van Sloan, Herbert Bunston, Frances Dade, Charles Gerrard.
Based upon the play adapted by Hamilton Deane and John L. Balderston from Bram Stoker's novel of the same name.

Presented by
CARL LAEMMLE

Produced by
CARL LAEMMLE, JR.

DRACULA

Charles Chaplin premiered his film *City Lights* on February 6, 1931, at the George M. Cohan Theatre in New York. As befit the only silent film released in more than a year, and the first Chaplin film in three, there was a mob. A bystander on Broadway saw the long line and asked, "Is that a breadline or a bank closing?" This was life in the second year of the Great Depression, when a thousand banks had failed and six million Americans were unemployed. Hollywood's response was to make films that avoided the issue.

Universal was a father-and-son concern. Carl Laemmle was the conservative father, and "Junior" Laemmle was trying to imitate Irving Thalberg. Junior had seen M-G-M's success with *The Big Parade* and *The Broadway Melody*. In 1930 he mounted *All Quiet on the Western Front* and *The King of Jazz*. The war epic did well. The innovative musical did not; audiences were tired of two-color songfests. Junior tried to bring back two Universal alumni, director Tod Browning and actor Lon Chaney. "As a producer, Junior may not

have been creative himself, but he knew how to put a package together," recalled Shirley Ulmer, who was then related to Junior by marriage. Before Junior could offer a project to the team, Chaney fell ill.

Browning and Chaney had become box-office champions at Metro-Goldwyn-Mayer with bizarre films in which Chaney used makeup and physical contortion to portray freakish, almost unearthly characters. What kind of package could Junior offer them? Bram Stoker's 1897 novel *Dracula* had become a million-dollar Broadway hit. A studio reader prepared a report. "Beautiful women with voluptuous mouths dripping blood—huge bats with flapping wings—wolves with hungry mouths—a man with sharp white teeth and eyes as red as fire—a vampire feeding on the blood of innocent girls and children in order to perpetuate himself and his kind."

Dracula was a departure from the Browning-Chaney vehicles. It made no attempt to explain its supernatural creature. Onstage, its vampirism was made credible by a Hungarian actor named Bela Lugosi. Even by Broadway's standards his performance was hypnotic. "I was under a veritable spell which I dared not break," Lugosi was quoted as saying. "If I stepped

Charles Farrell smokes opium in Raoul Walsh's *The Man Who Came Back.* ◆ Richard Barthelmess and Helen Chandler in William Dieterle's *The Last Flight.*

out of my character for even a moment, the seething menace of the terrible Count Dracula was gone from the characterization and my hold on the audience lost its force." The force of that hold was singular, as was its nature. "My audiences were women," said Lugosi. "They came—and knew an ecstasy dragged from the depths of unspeakable things. Came—and then wrote me letters of a horrible hunger, asking me if I cared only for maidens' blood."

Another studio was contemplating a film based on *Dracula.* "I felt out all our supervisors on *Dracula,*" wrote Paramount supervisor E. J. Montagne to production head B. P. Schulberg. "I did not receive one favorable reaction. The very things which made people gasp and talk about the play, such as the blood-sucking scenes, would be prohibited by the Code and cut by censors because of the effect of these scenes on children." Junior's father was also opposed, even as Universal's box office continued to lag. Then Lon Chaney, only forty-seven, died of throat cancer. Junior made his move. In a complicated deal, involving Bram Stoker's widow and a half-dozen theatrical entities, he acquired the rights to *Dracula* and assigned it to novelist Louis Bromfield and screenwriter Dudley Murphy, who submitted a first-draft script on September 8, 1930.

When Junior read that Count Dracula was attacking a hapless male real estate agent, he wrote in the script margin, "Dracula should go only for women and not men." He also wanted to drop Dracula's lines: "To die, to be really dead. That must be glorious. There are far worse things awaiting man than death." Junior's suggestions were ignored when Tod Browning and writer Garrett Fort polished the script.

Bela Lugosi assumed that he would be part of the Universal package, but his classical training and stage acclaim meant little in Hollywood, where he had been playing second-string villains. He was desperate for the part of Dracula. Unfortunately everyone at Universal knew this. Playing on his need, they offered him a paltry $3,500. "Bela knew there were five hungry actors waiting to get the part," recalled his publicity agent, Evan Hoskins. "What could he do but accept the terms?"

In 1930 Universal had lost $2.2 million. Junior was allowing no film but *Dracula* a budget higher than $225,000. Even so, he had Fort cut a number of Bromfield's scenes and monitored the production budget. "The studio was hell-bent on saving money," recalled Lugosi. "They even cut rubber erasers in half. Everything that Tod Browning wanted to do was queried. Couldn't it be done cheaper? Wouldn't it be just as effective if—? That sort of thing. It was most dispiriting." According to the film's romantic lead, David Manners, Lugosi insulated himself from studio politics by "parading up and down the stage, posing in front of a full-length mirror, throwing his cape over his shoulder, and shouting, 'I am Dracula!'" (Perhaps Lugosi knew that Manners was being paid $14,000.)

The Transylvanian count who "prolongs his unnatural life by draining the blood of the living" did not frighten Jason Joy. He viewed *Dracula* a week after its final retakes and pronounced it "quite satisfactory from the standpoint of the Code." There was still the "foreign angle." Would the Romanian government take umbrage at this loathsome characterization? James B. M. Fisher thought not: "Dracula is not really a human being so he cannot conceivably cause any trouble."

Dracula premiered at the huge Roxy Theatre in New York on February 12, 1931. In two days it sold fifty thousand tickets, building a momentum that would bring the film a $700,000 profit, the largest of Universal's 1931 releases. A Canadian filmgoer wrote to *Photoplay*: "Give us more pictures like *Dracula*. Bela Lugosi was magnificent. He almost hypnotized the audience."

"With *Dracula* making money at the box office for Universal," wrote *Variety*, "other studios are looking for horror roles." Not to be left behind, Junior Laemmle asked his father to buy the rights to Peggy Webling's play *Frankenstein*, which was based on Mary Shelley's 1818 novel. "I don't believe in horror pictures," answered Carl Laemmle Sr. "It's morbid. People don't want that sort of thing."

"Yes, they do, Pop," Junior pleaded. "They *do* want that sort of thing. Just give me a chance and I'll show you." Before long, Junior announced: "As a result of the reception given *Dracula*, we're pushing plans for *Frankenstein* and *Murders in the Rue Morgue*. The stories are well under way." Joy heard about this—and about movie patrons fainting at *Dracula* showings. "Is this the beginning of a cycle which ought to be retarded or killed?" he wrote Will Hays.

Hays was still a partner in the firm of Hays & Hays in Sullivan, Indiana, and, while visiting his client Peabody Coal, he encountered Peabody's publicist Joseph Breen, who was doing the occasional article for the MPPDA. At some point Hays sat in on an arbitration meeting. He saw Breen, sometimes diplomatic, sometimes pugnacious, bring order to chaos. If Breen could contain coal miners, what might he do with producers? After an earnest interview, Breen was given the word to leave his wife and children in Chicago and try a full-time job as Hays's assistant at the Hollywood office of the MPPDA. Once again, Hays set in motion a significant chain of events.

FRANKENSTEIN

The first-draft screenplay of *Frankenstein*, written by playwright John L. Balderston, was the parable of a reckless scientist who creates a human from the parts of various corpses, only to have it become a murderous machine. The script was then adapted by story editor Richard Schayer, director Robert Florey, and writers Garrett Fort and Francis Edwards Faragoh. Junior Laemmle did not think Florey was up to the job, and Tod Browning had decamped to M-G-M, so Junior offered it to the sleek and sardonic James Whale, the British director of *Waterloo Bridge*. "I chose *Frankenstein* out of about thirty available stories," said Whale. "It was the strongest meat and gave me a chance to dabble in the macabre."

One day Whale spied a British character actor eating lunch in the Universal commissary. Boris Karloff was Anglo-Indian, gaunt, and soulful. "Your face has startling possibilities," said Whale. Collaborating with makeup artist Jack Pierce, Whale used diverse literary and visual elements to transform Karloff into a cinematic monster. "This was a pathetic creature," said Karloff. "Like all of us, it had neither wish nor say in its creation and certainly did not wish upon itself the hideous image which automatically terrified humans whom it tried to befriend."

On a hot September morning, a caravan of trucks took cast and crew to sylvan Malibou Lake for the scene in which the Monster meets the one human who does not shun him. Eight-year-old Marilyn Harris was playing that character. "Here is Mr. Karloff in a funny costume who's just being friendly," said Whale to the child. "You just look up at him and say, 'I am Maria.'" Marilyn liked working with Karloff. "He had such warmth and gentleness about him," she recalled. As Karloff understood the scene, the Monster would think the little girl was just like the pretty daisies they were tossing into the water and that she, too, would float. He would gently set her in the water—and then be distraught when she sank. "Well," said Karloff, "Jimmy made me pick her up and do *that* [motioning violently] over my head, which became a brutal and deliberate act."

When Karloff protested, Whale said, "The death has to take place." Karloff continued to argue, and

OPPOSITE: With *Dracula* and *Frankenstein*, Universal created another cycle to vex Jason Joy and the SRC.

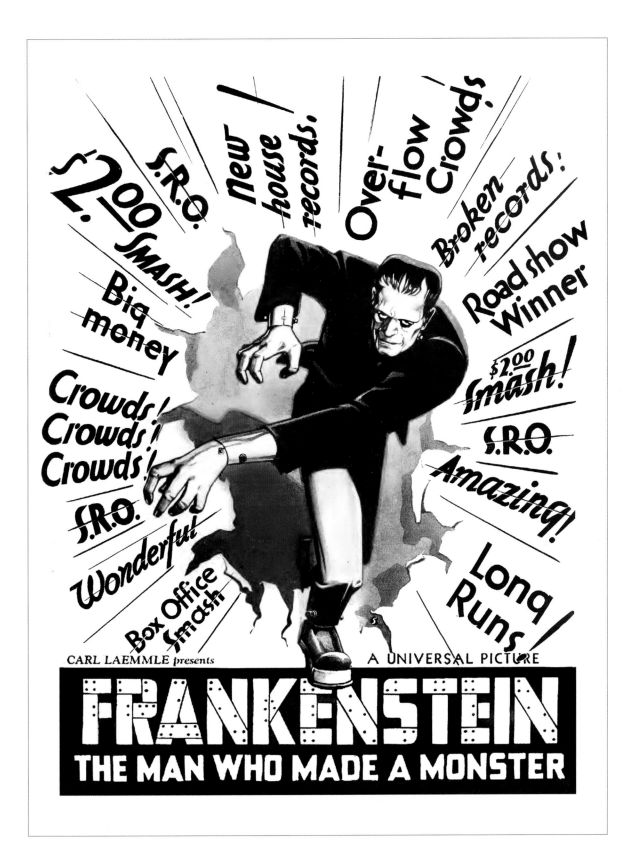

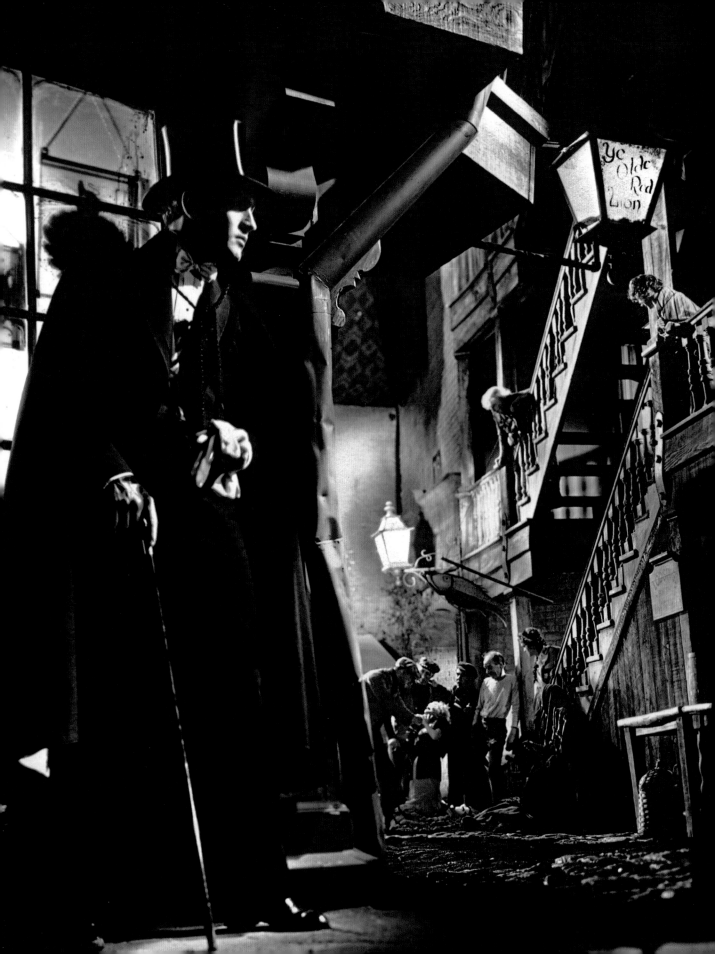

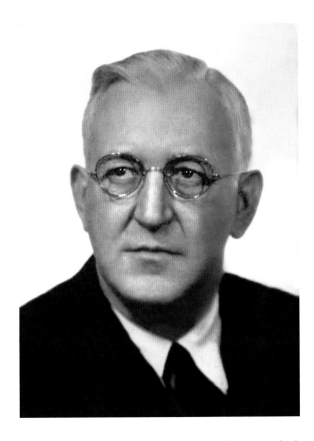

Jason Joy was the voice of reason in an industry panicked by the Great Depression.

Whale "fumbled for his words as he tried to convey 'why' to us, because in a strange way, we were all very hostile about it. He couldn't just bully us into acceptance. Then he said, 'You see, it's all part of the *ritual.*'"

The shooting of the scene was as unnerving as its content. In the first take, Karloff's tight jacket constrained his throw, and Marilyn landed too close to shore. "Throw her in again!" her mother yelled. "Farther!" Whale ordered two technicians to take Karloff's place off camera. They were too vigorous; the girl landed in vegetation and had trouble surfacing. Whale rewarded her courage with two dozen boiled eggs; her mother was depriving her of food to make her obey.

The first preview of *Frankenstein* took place on October 29, 1931, at the Granada Theatre in Santa Barbara, California. Whale was accompanied by Paramount producer David Lewis, who was also his live-in lover. "As the preview progressed," said Lewis, "people got up, walked out, came back in, walked out again." Junior Laemmle was panicky. "Jesus, God, we've got to do something!" he whispered. "This thing's a disaster!"

The next preview was at Universal, and a fan magazine gleefully described it. "A hard-boiled newspaper-woman turned green at the scene where the doctor moves a tray of glittering operating knives close to the body of the Monster to dissect him. She rushed out of the studio, violently ill."

The next preview of *Frankenstein* took place at the Hollywood Theatre. Leo Meehan was there on behalf of Martin Quigley's newly incorporated trade paper, the *Motion Picture Herald*. "Women came out trembling, men exhausted," wrote Meehan. "I don't know what it might do to children, but I wouldn't want my kids to see it. And I won't forgive Junior Laemmle or James Whale for permitting the Monster to drown a little girl before my very eyes. That job should come out before the picture is released. It is too dreadfully brutal, no matter what the story calls for."

Junior told Whale and Lewis that he was thinking of shelving the film. Lewis's boss, Eddie Montagne, phoned Junior from Paramount. "You're insane!" Montagne told him. "If we had a picture like that, we'd

OPPOSITE: Rouben Mamoulian's *Dr. Jekyll and Mr. Hyde* was Paramount's entry in the horror cycle. In this scene, the repressed doctor (Fredric March) saves a street girl (Miriam Hopkins) from a beating.

FRANKENSTEIN

clean up!" The Laemmles opened *Frankenstein* at New York's Mayfair Theatre on December 4. It grossed a startling $53,000 in one week.

Ignoring Joy's admonitions, the censor boards attacked *Frankenstein*. Massachusetts, Pennsylvania, and New York cut the drowning scene and Henry Frankenstein's speech: "In the name of God! Now I know what it feels like to *be* God!" In Detroit, children were barred, and no adult was allowed to enter the theater during the film's last ten minutes.

When the Kansas State Censor Board made thirty-one cuts, a Universal executive wrote Joy: "These eliminations destroy the dramatic power of the picture. Junior urgently requests you to do anything you can to have these cuts reconsidered." After a long telephone chat with the Kansas censor, Joy sent Joseph Breen there. On December 17 he managed a compromise. In the rest of the country, the film was seen intact. "Boris Karloff is superb," wrote *Motion Picture*. "His makeup is awe-inspiring, and he arouses morbid sympathy as well as loathing. A remarkable picture, but one of its kind is enough." It may have been enough for that reviewer, but the studios wanted more.

Before long, Paramount got its own horror film, *Dr. Jekyll and Mr. Hyde*, and Rouben Mamoulian made his version of Robert Louis Stevenson's 1886 novel as much a study of sexual release as a horror film. "I didn't want Hyde to be a monster," said Mamoulian. "Hyde is not evil. He is the primitive, the animal in us, whereas Jekyll is a cultured man, representing the intellect." Cinematographer Karl Struss used colored lights, filters, and Wally Westmore's makeup to transform Fredric March's face from good to evil without resorting to lap dissolves. Struss was uncomfortable with atavism. "The change from Jekyll should have been largely a psychological one, with subtle changes only in the makeup," said Struss. "But they foolishly changed the hair and put false teeth in and made him look like a monkey." Indeed, Hyde's love scenes with Ivy (Miriam Hopkins) smacked of bestiality. *Dr. Jekyll and Mr. Hyde* was raw, brutal, and relentlessly sexual.

"There is a definite note of anticipation in Jekyll's manner as Ivy takes off one garment after another," Joy wrote Schulberg. "No one should be permitted to think this is dragged in simply to titillate the audience." Mamoulian later conceded that he had been testing the Code. "The scene in Miriam's bedroom was quite erotic for the time," he told a Los Angeles audience in 1977. "There were several different versions of her undressing on the bed that were shipped to different territories, depending on our prior experience with those censor boards." *Dr. Jekyll and Mr. Hyde* received critical plaudits and made a respectable profit. Even Louella Parsons liked it. "Those who lament the lack of good pictures should see *Dr. Jekyll and Mr. Hyde*," she wrote. "It's by long odds the best picture Paramount has made since *Skippy*."

OPPOSITE: Photographer Gordon Head caught the emotion passing from Miriam Hopkins to Fredric March in *Dr. Jekyll and Mr. Hyde*. Photograph courtesy of Ronald V. Borst.

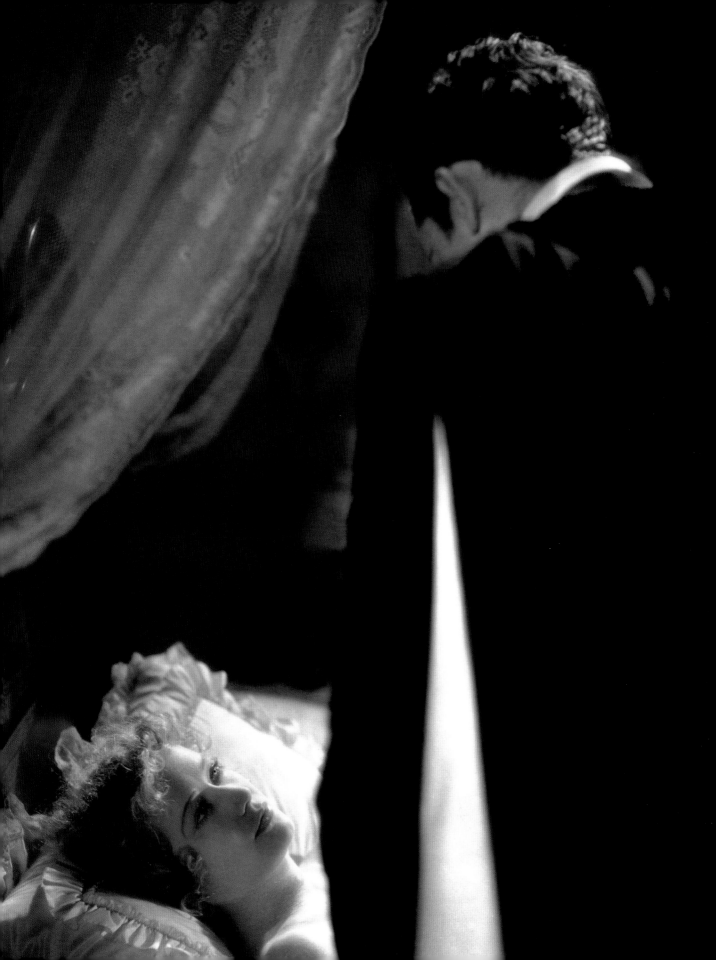

When a much-read columnist could write of an adult-themed film and a children's film in the same review, Joy knew that his office was losing control. "Talking to the companies won't do much good with the cycle as successful as it is," he wrote Hays. "*Frankenstein* is taking in big money at theatres which were on the rocks a month ago. Public resentment is being built up. How could it be otherwise if children go to these pictures and have the jitters, followed by nightmares? I, for one, would hate to have my children see *Frankenstein* or *Jekyll*. Not only is there a future economic consideration, but maybe there is a real moral responsibility to which we as individuals ought to lend our support." Will Hays had no comment. There was another cycle on the horizon.

THIS PAGE: Miriam Hopkins tempts the repressed doctor.
OPPOSITE: A potion turns the doctor into a demon.
Photograph courtesy of Greenbriar Picture Shows.

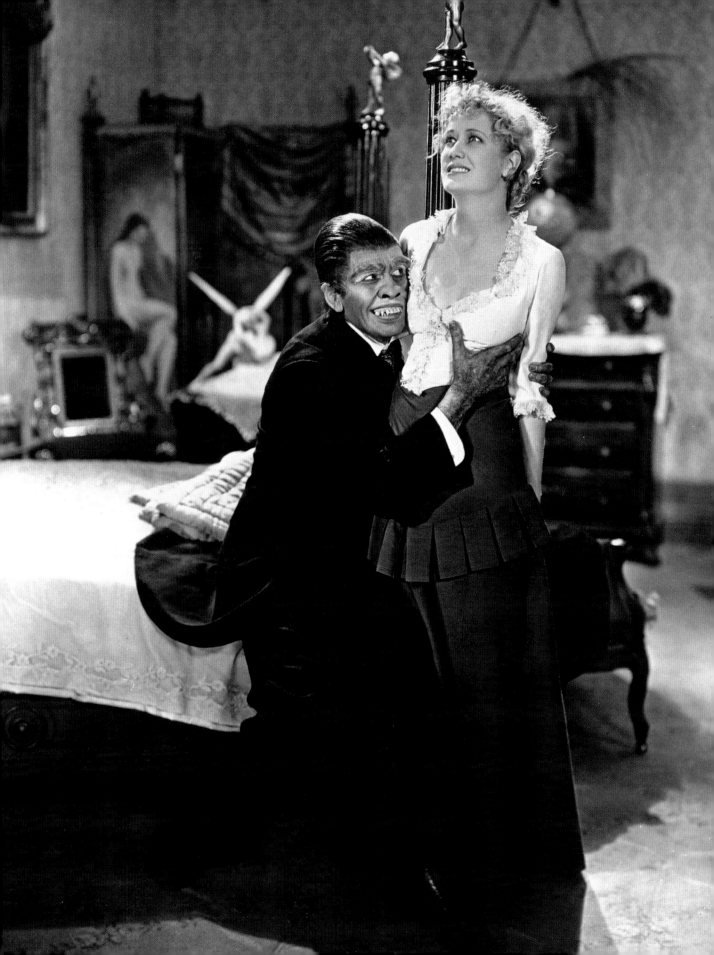

A FREE SOUL

"Studios are accused of imitation because they so often move in cycles," said Irving Thalberg to the *Los Angeles Times* in 1931. "Yet imitation is not their purpose. It is simply that a new field has been opened to them, and they are eager to develop that field." Imitation was not Thalberg's purpose, nor was it a necessity. Metro-Goldwyn-Mayer roared into 1931 with a profit of $15 million, so Thalberg could exper-

iment with untried ideas such as *Trader Horn* and *The Guardsman*. Less prosperous studios eyed the "fallen woman" cycle. One of the first fallen women appeared in the RKO epic *Cimarron*. Estelle Taylor played a sinuous prostitute caught up in the Oklahoma Land Rush. Then Mae Clarke played a desperate gal in *The Front Page*. "Mae Clarke as Molly, a prostie, looks like a Dumb Dora," wrote "Sime" in *Variety*. "But she gets right into the action and stays that way until she jumps out of a window."

Paramount, envious of M-G-M's success with Garbo, imported Marlene Dietrich, whom Josef von Sternberg had directed to stardom in Germany's first sound film, *The Blue Angel*. For her American debut, he transformed a California desert into *Morocco*. Dietrich was playing a lady with a past, but her only censorship news occurred at the Colorado Theatre in Pasadena, where an audience expecting *The Blue Angel* got a chopped-up version; the response was "a terrific razzing."

In Lewis Milestone's *The Front Page*, Mae Clarke is a streetwalker seeking help for convict George E. Stone from reporter Pat O'Brien.

The third Sternberg-Dietrich film was *Dishonored*, a stylized look at a World War I prostitute who leaves the sidewalks of Vienna to spy on Germany. Jason Joy mandated seven cuts before *Dishonored* could start filming, but much of its adult content was in Sternberg's direction. Having made Dietrich a star in *The Blue Angel* and *Morocco*, he continued to design her every gesture. In one talked-about scene, Dietrich slouches in a chair and dangles her leg over its armrest. Within weeks, teenage girls were scandalizing their mothers by sitting like Dietrich, and a fan-mag controversy was brewing. Who was the greater actress, Garbo or Dietrich? Neither star would comment, but there were catty items in the trades. "They say Greta is playing Marlene's phonograph records on the set. Well, Marlene can play one of Greta's records: *Inspiration* stayed three weeks at the Capitol Theatre. Try that on your old Orthophonic, baby!"

Next came Norma Shearer in *Strangers May Kiss*, seeking to outdo her *Divorcee*. Lisbeth, a career girl, believes that a woman, like a man, "can love, and ride on." She tests her philosophy when a callous journalist abandons her in Mexico. Instead of returning to Philadelphia in tears, she goes to the Continent and "changes her men with her lingerie."

TOP: The white goddess in W. S. Van Dyke's *Trader Horn* is more savage than the natives she rules. From left: an unidentified player, Edwina Booth, Harry Carey, and Duncan Renaldo.

MIDDLE: Sidney Franklin's *The Guardsman* introduced the celebrated stage couple Alfred Lunt and Lynn Fontanne to moviegoers.

BOTTOM: Wesley Ruggles's *Cimarron* acknowledged the newest cycle by putting a prostitute in the Oklahoma Land Rush. From left: Estelle Taylor, Richard Dix, and an unidentified actor.

A FREE SOUL

Complete
Movie Novel
Magazine

June 1931

25¢
In Canada
30¢

The Complete Stories of
DISHONORED
Featuring Marlene Dietrich
and
The EASIEST WAY
Featuring Constance Bennett

"All right, Marlene Dietrich, come in and dry the dishes!"

In Josef von Sternberg's *Dishonored*, Marlene Dietrich dangled her leg over the arm of a chair, which no lady had done on the screen before. Then a cartoon in *Photoplay* confirmed moralists' fears that movies were influencing children.

The journalist decides that he wants Lisbeth back, but when he learns of her notoriety, he castigates her for being "promiscuous."

"Mr. Irving Thalberg invited me to come to his house," wrote Jason Joy, "for the purpose of discussing with him, the director, and several writers, the story *Strangers May Kiss* by Ursula Parrott." Joy spent a Sunday in Santa Monica trying to contain the script. He did manage to cut one speech. "This world wasn't made for moralists," says Lisbeth. "You take what you want—if you can get it. You take it from people who have scruples—and no brains."

After seeing the finished film, Joy counseled Thalberg to "vigorously oppose any major cuts, not only for the protection of this particular picture, but for the subsequent effect which such an attitude will have." The first warning came from a New York correspondent for the *Los Angeles Times*. "*Strangers May Kiss*," wrote Norbert Lusk, "is meeting the same success at the Capitol that has greeted it elsewhere. Basically the picture is just trash, but this need not necessarily be gone into, for its box-office appeal invalidates criticism. It is curious, though, how the moral standard of the screen is changing even as censorship is relaxing."

The second warning came from within the SRC. "It would be difficult for me," wrote Alice Ames Winter of the General Federation of Women's Clubs, "to exaggerate my revulsion at this picture and my sense of horror that our present setup is permitting a product of this type to go through. This is a reflection of the initiatory stages of the degeneration of a people." Sure enough, *Strangers May Kiss* was heavily cut by censor boards and banned outright in Canadian territories for showing "promiscuous prostitution."

In the late spring, sexy movies were unreeling every week, and if they weren't literally about prostitutes, as was *Waterloo Bridge*, they had a meretricious tone. In *Night Nurse*, there were revealing views of Barbara Stanwyck and Joan Blondell. "We undressed in our nursing assistants' bedroom and walked around in our lingerie, which was considered scandalous," recalled Blondell. Other films included *Illicit*, *Ten Cents a Dance*, *Men Call It Love*, *Party Husband*, and *Goldie*, the first talkie in which a woman is called a "tramp." A Fox Film programmer like *Goldie* was not likely to cause much comment. A Thalberg-Shearer production was. No two individuals were better placed to challenge the Code.

A Free Soul has a lawyer's daughter begin a torrid affair with her father's client, a gangster. "Our film established the gangster as a glamour boy, not just a villain," wrote Shearer. "The effect of this on the morals of our world leaves some room for doubt, but it did start a rush of fascinating films." In the course of wardrobe fittings with studio designer Gilbert Adrian, Shearer was heard to say: "Cut it down here. Don't forget the sex appeal."

Jason Joy told M-G-M to end a scene between Jan Ashe (Norma Shearer) and Ace Wilfong (Clark Gable) "at the moment she extends her arms to him and lies back on the divan and Ace comes down beside her." The scene was not edited, nor was her suggestive line: "C'mon. Put 'em around me." Just before the New York premiere, James Wingate told M-G-M supervisor Bernard Hyman that he was planning numerous cuts. Hyman pleaded for leniency. "If you can help us in this situation," he wrote, "you will have the heartfelt gratitude of the Lion and me."

A Free Soul was more controversial than *The Divorcee* had been a year earlier. "Talking pictures are by no means elevated by this presentation," wrote Mordaunt Hall in the *New York Times*. "Miss Shearer is called upon to act a part which is unsuited to her intelligent type of beauty." *Motion Picture Daily* reported audience reactions: "That shimmering and closely fitting white evening gown of Norma Shearer's caused some eyes to open at the Astor t'other night." *Photoplay* said: "Her clothes are breathtaking in their daring. But you couldn't get away with them in your drawing room." Because of its notoriety, *A Free Soul* was heavily cut by local censors and banned entirely in Ireland, but it grossed nearly three times its cost.

"Dirt Craze Due to Women" was the *Variety* headline the day before *A Free Soul* opened. "Women love dirt. Nothing shocks 'em. They want to know about bad women. The badder the better. Women who make up the bulk of the picture audience are also the majority readers of the tabloids, scandal sheets, flashy magazines and erotic books. It is to cater to them that all the hot stuff of the present day is turned out." An industry estimate set female attendance at 65 percent, so more hot stuff was on the way.

In Fox Film's *The Brat*, an urchin played by Sally O'Neil declines a ride to a Long Island estate, saying, "That's where they have them orgies an' seduction scenes!" In M-G-M's *Dance, Fools, Dance*, Joan Crawford has just such a party, and on a yacht, no less. "All right, everybody! Off with your clothes!" says her fiancé, and their guests happily strip to their underwear for a moonlight dip. In Warners' *Five Star Final*, a tabloid editor (Edward G. Robinson) is ordered by his publisher (Oscar Apfel) to run salacious

pieces with phony endorsements to "raise sex to a dignified attitude," and a secretary critiques an article: "The part about the illegitimate child isn't made quite clear enough."

Garbo's next film had her playing a Swedish farm girl who tells her first suitor (Clark Gable) about her late mother: "She didn't have a wedding ring." Garbo is likewise unencumbered as she runs the gamut from barn to penthouse. When M-G-M hosted a preview of *Susan Lenox*, *Motion Picture Daily* published a wry column. "Having sent Miss Shearer on a well-earned—or much needed—vacation following her appearance as a gorgeous lady of dubious morals," wrote Leo Meehan, "M-G-M has continued its 'sin and succeed' series with Greta Garbo. *Susan Lenox* is proof sufficient that the Hays Code is nothing for producers to worry about—or that it is all in fun." Jason Joy promptly made M-G-M reshoot numerous scenes. Garbo blamed the studio for incoherent script drafts, and the studio blamed the Code.

The film was released as *Susan Lenox: Her Fall and Rise*, which prompted the *Herald's* Charles E. Lewis to quip: "This picture is 'box office' everywhere but those places where the long-nosed, straitlaced keepers of public morals will be preaching sermons against such pictures." As if on cue, the British censors refused to release *Susan Lenox* unless major cuts were made and its title was changed. "We are living in an era of dirt," proclaimed a London magistrate. "I do not hesitate to say that Hollywood is earning a distinction second only to Gomorrah." Great Britain and British territories saw the shortened film as *The Rise of Helga*.

OPPOSITE: A portrait of Barbara Stanwyck by Elmer Fryer for Archie Mayo's *Illicit*.

By August 1931, the studios had grudgingly agreed not to produce any more gangster films. "There is an undercurrent of dissatisfaction," wrote *Variety*. "The producers' viewpoint is that gang pictures have been more productive commercially than any other so-called cycle in years." They were hardly running out of cycles; there were animal pictures, Mark Twain adaptations, and, of course, shady ladies.

In late October, M-G-M released a fallen woman film that had nearly been shelved. Helen Hayes left a stellar Broadway career to try Hollywood with her husband, Charles MacArthur. He wrote her first film, *Lullaby*, but when a preview audience saw Hayes sell herself to put her unknowing son through medical school, they were displeased. "They hissed at the end," recalled Hayes. Louis B. Mayer wanted to shelve the film. "Suppose it had gone out as it was," said Ina Claire, another Broadway star working in Hollywood. "Helen Hayes would have been a failure. But she and her husband fought for a mass of retakes. They had their way." And Thalberg had MacArthur write a scene that would motivate a woman to sacrifice her life for a child she had not wanted. Ben Hecht helped find the missing element—eye contact between the mother and her newborn. "In the bed scene following the childbirth," wrote *Variety*, "Miss Hayes takes up her first option on the audience's tear ducts." Retitled *The Sin of Madelon Claudet*, the film became a hit, and Hayes became a star.

An ill-fated courtesan inspired *Mata Hari*, Garbo's most glamorous, exotic—and erotic—film of the sound era to date. Cinematographer William Daniels shot its love scenes with a dreamlike diffusion, fogging the implausibility of the action and making Garbo glow like a goddess in a jungle temple. She makes her entrance in a bejeweled Javanese costume, dances seductively before a statue of the Lord Shiva, and finishes the dance by offering herself naked to the idol.

The film had two talked-about bedroom scenes. In the first, Garbo seduces Ramon Novarro by coming from behind satin curtains, dressed in a diaphanous peignoir. In the second, she makes him extinguish a votive candle as proof of his devotion before letting him carry her into his bedroom. Fade out. Fade in on a tableau of a rainswept bedroom window. Garbo and Novarro are silhouetted in front of it, sharing a postcoital cigarette. "I wanted to illuminate the whole scene with just the glow from this cigarette," recalled Daniels. "I had a dummy cigarette made with one of those medical bulbs in it, and I stuck the ashes on with glue. All you'd see was just one gleam."

Mata Hari became M-G-M's second biggest hit of the year, grossing $2.2 million. (*Trader Horn* grossed $4.2 million.) It also ran afoul of the censors. James Wingate cut the walk to the bedroom, the cigarette scene, the morning view of the Eiffel Tower, and Garbo relighting the votive candle. This was insufficient, according to the Atlanta Better Film Committee. "I wish this picture could be destroyed," wrote a reviewer.

OPPOSITE, CLOCKWISE FROM TOP LEFT: Harry Beaumont's *Laughing Sinners* was begun as *Complete Surrender*, and when it was released, so much of it had been reshot that this scene was not included. ◆ Jean Harlow and Warren Hymer in Benjamin Stoloff's *Goldie*, the first talkie in which a woman was called a "tramp." ◆ Jean Harlow and Blanche Williams, her real-life maid, in a scene from Tod Browning's *Iron Man*. ◆ James Cagney and Joan Blondell in Roy Del Ruth's *Blonde Crazy*.

A FREE SOUL

Jean Harlow in Frank Capra's *Platinum Blonde*.

"It is not fit to be shown anywhere." *Mata Hari* was cut but not banned; another film was not so lucky.

Five Star Final glowed with off-color dialogue, but its greatest sin was offending a powerful figure. Its fictional tabloid, the *Evening Gazette*, was a composite of several newspapers, two of which—the *New York Journal* and the *New York Daily Mirror*—were published by William Randolph Hearst. "The patience of newspaper people has been very much taxed by films which portray reporters as drunkards and editors as unscrupulous rascals," said Hearst in a letter to Jack Warner. "Producers are continually appealing

to newspaper editors to prevent censor boards from banning their productions, yet all the newspaper folk get in return is a succession of slaps in the face." The *Mirror*'s editor Walter Howey had been caricatured in *The Front Page*, so it was he who paid a call on Boston mayor James M. Curley. "The mayor has banned *Five Star Final*," Joseph Breen notified Jason Joy.

"I am sorry that the picture has gotten into such a jam," responded Joy. "I anticipated trouble from the tabloids but did not believe the regular papers would find it offensive."

Will Hays also received a letter from Hearst.

Thelma Todd in Roy Del Ruth's *The Maltese Falcon*.
Photo by Mac Julian.

"Your advice and authority are made effective only because of the fear that producers have of getting into government difficulties," said Hearst. "Remove that fear of disaster and your department would not last as long as a drink of whiskey in Kentucky."

Hays was increasingly on the defensive. A nondenominational religious journal called the *Christian Century* charged that "the three prominent Protestants—Will Hays, Carl E. Milliken, and Colonel Jason S. Joy—employed by the producers to man their office of public relations have no authority whatever to clean up a single film." James Wingate confirmed that the New York board needed to make a thousand more cuts in 1931 than in 1930.

Joseph Breen was still working at the SRC as director of public relations. He was not tactful, like Joy; he was truculent. When a Philadelphia priest questioned the integrity of the IFCA, Breen wrote him with the salutation "My dear Bozo" and the conclusion "I respectfully suggest that both yourself and Dr. Pace are fat-heads. I don't even hope that you are well. But I do hope that you get fired out of that soft job at the Seminary and have to go to work. I say, again, that you are a fat-head."

In August Breen appealed to Hays. "The responsible heads of the studios are a cowardly lot," claimed Breen. "They are, too, an ignorant lot—in the sense that they don't know just what to do to clean the situation up." Breen pitched Hays the idea of finding a crusading administrator to make them toe the line. "We ought to try to get the best man in America to seriously take off his coat and go to work," said Breen. "Who that man is, I do not know." Hays hesitated. Breen was too zealous to be let loose in the studio system. And he had ties to Daniel Lord, Cardinal Mundelein, and Father Dinneen. What Hays did not know was that Breen was already reporting to the Midwest Catholics. And M-G-M was continuing its "sin and succeed" series.

THIS PAGE: Milton Brown made this portrait of Greta Garbo on the set of George Fitzmaurice's *Mata Hari*.

OPPOSITE: Jean Harlow was still under contract to Howard Hughes when Clarence Bull called her back to M-G-M to make more photos for George Hill's *The Secret Six*, which she had completed five months earlier.

PAGE 86: An on-the-set portrait of Jean Harlow from *The Iron Man*.

PAGE 87: On seeing Clarence Brown's *A Free Soul*, British critic Creighton Peet wrote: "Some people may think they have had their money's worth when they have seen Norma Shearer silhouetted in a doorway, wrapped in a skin-tight gold lamé negligee, her knee archly kinked, her hair coyly fluffed, and her chin in her palm—but I don't."

PAGE 88–89: *Susan Lenox: Her Fall and Rise* prompted the *Herald's* Charles E. Lewis to quip: "From what I saw, Greta Garbo was doing more falling than rising." This scene with Hale Hamilton and Clark Gable was reshot to make the film acceptable to the Studio Relations Committee.

POSSESSED

T he "kept woman" cycle of 1931 owed something to *Common Clay*, a 1930 Fox film in which Constance Bennett plays a maid seduced by a rich young man. Unwilling to accept ruination, she goes to court to denounce the hypocrites of the story. Thalberg prolonged the cycle by borrowing Bennett from Pathé Studios for a project that was not supposed to be produced. Will Hays had put the 1909 play, *The Easiest Way*, on the proscribed list. Even so, three of the five "major majors" (Warner Bros., Paramount, Fox) wanted to buy it; so did the three "minor majors" (Universal, Columbia, and United Artists). Thalberg ignored the Formula and began shooting.

Constance Bennett played Laura Murdock, a slum girl whose modeling job exposes her (literally) to Brockton (Adolphe Menjou), an ad agency owner. Since Laura prefers a penthouse to a tenement, she becomes a kept woman. Joy prevailed upon supervisor Hunt Stromberg to show Laura punished for her immorality, so he added scenes showing Laura shunned by her reproachful brother-in-law (Clark Gable). After previewing the film, Joy wrote Thalberg: "We were rather disappointed in our expectation that your picture would more thoroughly bring out

contrasting moral values to balance the evident attractions and benefits of the life of a 'kept woman.'" Joy was receiving angry letters.

"*The Easiest Way* makes immorality alluring to young people before it reaches its final lesson," wrote Daniel Lord. "Its moral values are swamped by the attractive life portrayed in it," wrote Alice Ames Winter. James Wingate wrote Joy that it showed "the alluring evils of life," and was "too explicit in details." Harry Cohn wanted to know why M-G-M got the film that Columbia Pictures had been denied. Welford Beaton threw down the gauntlet in the *Hollywood Spectator*: "I was watching *The Easiest Way*, when there came the exact moment when I had had enough sex. The makers of screen entertainment may continue to earn dividends by selling the immorality of women, but no longer can they sell it to me. Every sex picture I

OPPOSITE, CLOCKWISE FROM TOP LEFT: "A pretty girl like you is just prey for men," says Marjorie Rambeau to Constance Bennett in Jack Conway's *The Easiest Way*. "They like to look on us as some animal that they're proud to own." ◆ Constance Bennett is caught unawares by her keeper, Adolphe Menjou. ◆ In William Wellman's *Safe in Hell*, Dorothy Mackaill gets a call from a helpful older lady about a "date" with a nice man.

review from now on is going to be estimated for what it is—a filthy thing manufactured by businessmen." Many censor boards felt the same way.

"*The Easiest Way* has been brutally mutilated by the Pennsylvania censors," said *Harrison's Reports*. "Because so much was cut, subtitles were inserted to tell the plot. The practice is so obvious and the titles so poor that the audience laughed out loud." One exhibitor was unable to run the print he received. "*The Easiest Way* had been cut so badly before it reached us that we had to stop in the middle because we thought we were looking at the wrong reels." Lamar Trotti summed it up in a letter to Joy: "We have a hell of a time, don't we?"

If the cycle had detractors, it had fans, too, and Constance Bennett did well by it. Within a year, she was "the queen of the confession films." With *Born to Love*, *The Common Law*, and *Bought*, Bennett hopped from studio to studio, each of which borrowed elements of her formula for upcoming productions. M-G-M's *This Modern Age* has Joan Crawford learn that her mother (Pauline Frederick) is a kept woman. RKO's *Kept Husbands* has a bored rich girl (Dorothy Mackaill) marry a lanky laborer (Joel McCrea) and stop him from working. If Bennett was 1931's queen of confession films, there was no doubt who was the queen of films.

The stampede to hear Greta Garbo speak in her first two talkies had created a phenomenon called "Garbomania." Her fans did not care that she played a prostitute in *Anna Christie* and a rich man's mistress in

Romance. "The public loves Garbo with all her faults, and there can be no substitute," a Mississippi fan wrote to *Photoplay*. Counting on these fans, M-G-M entered Garbo's next film in the kept woman cycle. In *Inspiration*, Garbo played Yvonne Valbret, a languid artist's model who has carried on with every painter, sculptor, and poet on the Left Bank. She lives in a velvet-lined bandbox that belongs to an older man (Oscar Apfel), and she pays no rent.

Without seeing *Inspiration*, James Wingate jumped on Jason Joy, who responded with a telegram: "While the kept woman idea is evident, it is by inference and not treated explicitly."

SINFUL GIRLS LEAD IN 1931

When Columbia Pictures borrowed Jean Harlow from Howard Hughes, William Fraker's photos made the most of her attributes.

"Have you people changed your standards?" Wingate responded. The New York censor was unaware that Joy had worked with M-G-M to minimize the sexual content in *Inspiration*. Its first script, by Jacques Deval, had Garbo hungrily picking up a man at a swank party. "I like your eyes," she says to Andre, a consular student (Robert Montgomery). "Do you mind? Who are you?"

"From the orchestra—savage music," writes Deval. "The scene between them becomes more and more charged with sex."

Honoring the formula that Thalberg had devised for Garbo four years earlier, *Inspiration* forces Yvonne to choose between the earnest young man and the rich protector, but Garbo's fans got to see her living the high life before she loses everything. "The movies had a double attitude," said Ben Hecht. "Virtue always had to triumph, but the only way to sell that triumph was to show as much suggestive detail as possible before virtue triumphed. You had all kinds of innuendos, and the lewdest part of a movie was what happened at the fade out." *Inspiration* had several such fade-outs and grossed $1.2 million, even though the Pennsylvania censor cut it from seventy-four minutes to sixty.

When director Edgar Selwyn sold his proscribed play *Mirage* to M-G-M, the studio changed its title to *Possessed*, and ignored Jason Joy, who had not seen two-thirds of the scenarios filmed that year. On October 8, 1931, Will Hays got the MPPDA to pass a resolution that made script submission compulsory. Lamar Trotti sent a telegram to Jason Joy: "My fear is we have another *Common Law* or *Strangers May Kiss* on our hands." Joy was incredulous. How had a kept woman story gotten by them?

"We didn't get a script on it," replied Trotti. "Mr. Thalberg was very understanding of our worry, but he holds that they have a perfect right to use the theme provided they do it with care." In deference, Thalberg cut these lines: "Will sell her virtue to the highest bidder." "And a yielding body." "I haven't anything to sell for pennies."

Possessed was the story of Marian (Joan Crawford), a beautiful girl who works in a paper box factory. When a train full of socialites stops near her side of the tracks, Marian glimpses luxuries she will never attain. A fey playboy (Skeets Gallagher) pours her a glass of champagne from the observation deck, gives her his card, and feigns shock when she shows up at his Manhattan apartment. Once she decides he is of no use to her, she accosts his friend, a wealthy politician named Mark Whitney (Clark Gable). Mark sets Marian up in a penthouse, educates her, and all goes well until Marian wants to get married and Mark wants to get elected governor. With nary a nod to "compensating moral values," Lenore Coffee's script saves Marian's honor and Mark's ballots. If Marian had been played by Constance Bennett, Loretta Young, or any of a dozen other players, the film would have

gotten by the bluenoses, but Crawford's profits had begun to surpass Shearer's, and Crawford was paired with Clark Gable, with whom she promptly fell in love. Their extramarital chemistry amplified the power of *Possessed*.

"You will be interested to hear the comment of two young girls sitting next to me when I previewed the picture," wrote Mrs. Alonzo Richardson, a member of the Atlanta Board of Review. "One said to the other, 'I would live with him too, under any conditions.'" A preview card from the same theater read: "What are the moral standards of writers and producers when they produce a picture of this tipe [sic]? The story is awful disgusting."

Creighton Peet singled out Joan Crawford and Norma Shearer, laying at their feet the responsibility for "all modern thought in matters of morals and marriage" and saying that "school girls and serving maids will pay Metro hundreds of thousands of dollars to watch this film, and dream about it for days afterward." Daniel Lord charged that "Norma Shearer and Joan Crawford introduce our little girls to the 'romance' of kept women." Another critic wrote: "Norma Shearer's success was only mediocre until she came along as the reckless girl in *The Divorcee*. In every film since then, she has been ravishing and revealing, almost a torchbearer for the single standard. And the fans have flocked into her camp."

Perhaps in response to her critics, Norma Shearer gave Gladys Hall of *Motion Picture* magazine a widely quoted interview. "Economic independence has put woman on exactly the same footing as man," said Shearer. "A woman today is good, or she is bad, according to the way she does a thing—and not

because of the thing itself. An adventure may be worn as a muddy spot or it may be worn as a proud insignia. It is the woman wearing it who makes it the one thing or the other.

"There are women who could have only one lover and yet be cheap and futile," Shearer continued. "There are women who could have a half dozen lovers in their lives and somehow remain worthwhile. The girl in *A Free Soul* would make a splendid and capable wife. She had seen both sides of life, both kinds of love. At all times, she believed in what she was doing. When she found out she was wrong, she was willing to pay the fiddler. She was able to weigh values."

Did anyone believe this? A fan in Charlotte, North Carolina, was skeptical. "Norma is getting a little bit too gay," wrote Mrs. Joe Miller to *Motion Picture*. "And we are getting a bit fed up on a steady diet of her indiscretions. We want to see her in a quiet countryside, in the middle walks of life, instead of having her 'go to Paris' in every picture."

Father Daniel Lord warned the MPPDA that the SRC was wasting time on details and missing the larger picture. "These authors are injecting into basic stories an underlying philosophy of life," he wrote. "These stories discuss morals, divorce, free love, unborn children, relationships outside of marriage, single and double standards, the relationship of sex to religion, marriage and its effects upon the freedom of women. These subjects are fundamentally dangerous."

All Jason Joy could do was cite the obvious. "With crime practically denied them, with box-office figures down, with high pressure being employed back home to spur the studios on to get a little more cash, it was almost inevitable that sex, the nearest thing at hand and pretty generally sure-fire, should be seized on. It was." Yet he disagreed with Lord on a central issue. "I am not optimistic enough to think we will ever get to the place where there will be no sex pictures. Nor do I know that would be a good thing. Sex has a legitimate use in drama as one of the most interesting factors in life. It is only by overdoing it that we get in trouble."

"Sinful Girls Lead in 1931" was *Variety*'s appraisal of the fallen woman and kept woman cycles. "'The Easiest Way' was the surest way to box-office success in 1931," wrote Ruth Biery. "The Great God Public, formerly considered a Puritan censor, endorsed heroines of easy virtue. Wistful Helen Hayes shot to screen success as a be-sodden wretch of the Parisian byways. The Misses Chatterton, Dietrich, Garbo, Bennett, Crawford, and Shearer switched to glamorous, shameful ladies. In 1931 playing an unpunished fallen heroine became a ticket to box-office supremacy."

Where exactly was this box office? Weekly attendance had dropped to seventy million. Paramount's year-end profit was $6 million, a steep slide from the $18 million of 1930. Fox Film reported a mere $3 million. RKO Radio Pictures was $5 million in the red. Warner Bros., which had struck it rich with sound, was $8 million in the red. It was obvious that M-G-M, with a profit of $12 million, was hogging the trough. For seven other companies, there was no choice but to "sin and succeed."

OPPOSITE: Joan Crawford played a kept woman in *Possessed*, and Clark Gable played the politician who keeps her. Coming at the end of 1931, the film confirmed that both M-G-M players had become major stars, and that the 1930 Production Code was only a minor annoyance to producers like Irving Thalberg.

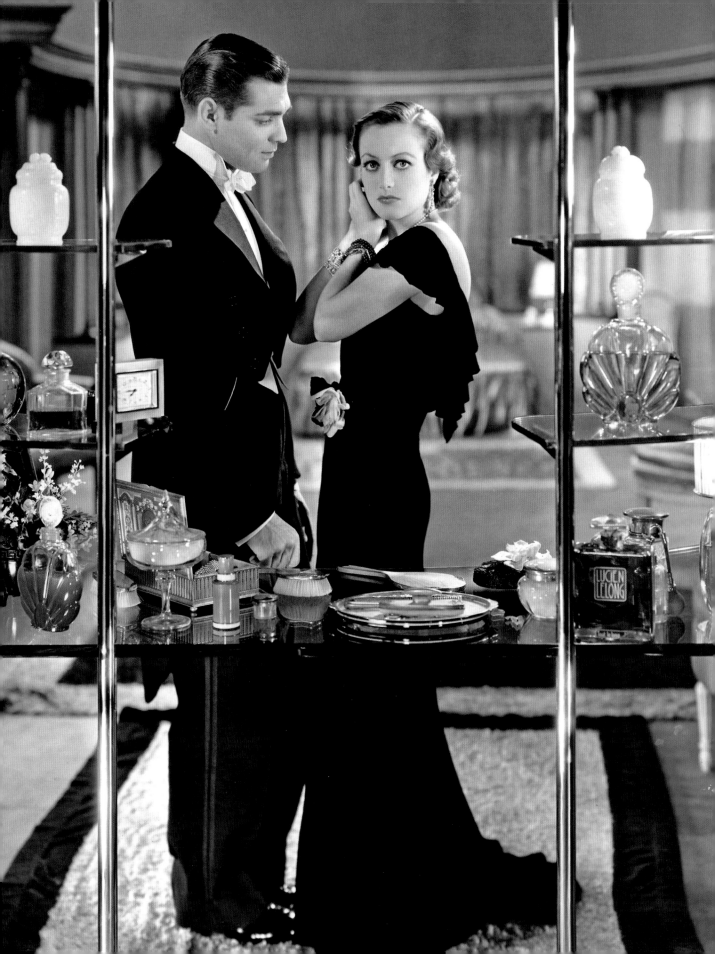

1932

SCARFACE

n 1932 the Studio Relations Committee was no longer a beehive. It was a command post. Producers needed hits, and Colonel Joy was fighting them, one sin at a time. The Depression had caused chaos, and box office was still declining. A popular song asked: "Brother, can you spare a dime?" Few could spare it for a movie. Unemployment was at twelve million, and 28 percent of America was in need. People had no time for movies. Or did they?

"Unemployed, dejected and dog-tired, I wandered into a theater," wrote J. L. Thompson from Lynchburg, Virginia. "I hardly knew what was showing and cared less, suspecting I'd sleep through most of it. Imagine sleeping through a picture like *The Conquerors*. What a tonic it turned out to be! And what a buoyant-spirited fellow emerged from that theater two hours later, with faith restored in my country, my fellow citizens, and myself!" *The Conquerors* was an epic that began with the Depression of 1873 and ended with the Depression of 1932. It showed a typical American overcoming tragedy and misfortune. Beyond that, it showed that a film could both transport and inspire. It was this power that concerned the critics of Hollywood.

President Herbert Hoover urged Louis B. Mayer to produce a film that would show the effectiveness of police, not their failures, so *Beast of the City* was made at M-G-M by William Randolph Hearst's Cosmopolitan Pictures. At some point it got away from Hearst, judging from his letter to Mayer. "The wholesale slaughter at the end of the film is ludicrous," wrote Hearst. "The dying handclasp of the honest cop and his renegade brother is a cheap study in strained sentiment. The director even had to shoot poor Jean Harlow in the little belly she had used so effectively in her dancing number earlier in the picture. The only person who wasn't shot was the supervisor, and he should have been. Moreover, why wait till sunrise?"

The supervisor in question was Hunt Stromberg, perhaps the most able of Irving Thalberg's associates. Stromberg may have been concentrating on Harlow's seduction scenes, the sexiness of which occasioned comment. "One episode between Miss Harlow and Wallace Ford is managed with especial frankness," wrote Philip K. Scheuer. "And this is the first time the platinum lady has appeared as other than a fearfully bad actress."

Harlow was being loaned to various companies

because Howard Hughes had no interest in grooming her for stardom. He was, however, grooming the silent-film star Billie Dove. Even by Hollywood's lofty standards, Dove was a raving beauty, and by Hughes's exacting standards, well endowed. *Cock of the Air* was one of several films he made in order to utilize airplane footage left over from *Hell's Angels*, but before long, the film turned into an earthbound sex comedy bedizened with Dove's attributes. Jason Joy was not amused. "Miss Dove's breasts are overexposed in almost all of her costumes," he wrote. Moreover, most of the comedy was devoted to Craig the aviator (Chester Morris) seducing as many women as possible. "The title, in connection with the picture in its present form, conveys an immoral suggestion," wrote Joy. "Craig attains no supremacy in the air. He is portrayed as a seducer of women, giving the title an immoral significance."

Hughes was not interested in letters from the SRC. He had already shipped fifty prints of the film to fifty censor boards, an unprecedented act. Joy notified Will Hays that "Steps should be taken to keep Hughes from breaking down the machinery." No one had sidestepped SRC protocol before, and Hughes had to be stopped before other producers got ideas. United Artists was distributing the film, so Hays applied pressure to Joseph Schenck, the head of United Artists, to make Hughes bring back the prints and edit the film, which was "obscene and immoral in title, theme and portrayal." Instead of cooperating, Hughes submitted his film to the AMPP jury. This bought neither time nor goodwill. The AMPP quickly reviewed *Cock of the Air*: "The jurors felt that the principal character is a seducer and that the title of the picture might be given a lewd interpretation in light of the story."

THIS PAGE: Billie Dove starred in Howard Hughes's controversial film *Cock of the Air*.

PAGE 98: A Don English portrait of Marlene Dietrich for Josef von Sternberg's *Blonde Venus*.

"Howard Hughes is reported to have paid $100,000 for a censor spanking," wrote *Variety* two weeks later. "Now everybody's happy." At least the SRC was happy. "The changes required have been faithfully carried out," said a memo. "The entire prolonged episode showing the girl in the suit of armor and the boy with the can opener, et cetera, has been eliminated." Audiences were less happy. "If many more pictures like *Cock of the Air* get by the censors," wrote Mary Hulbert from New Jersey, "I'm turning elsewhere for my entertainment. One can scarcely believe that there *are* censors after seeing some of the new pictures. It has gone far enough! The public prefers clean, wholesome pictures. Why can't we have them?" This letter referred to the censored version of *Cock of the Air*, which was twelve minutes shorter than the version Hughes tried to slip by the SRC. One can only speculate how Mary Hulbert would have reacted to the uncensored version—or to the next Howard Hughes film.

In Howard Hawks's *Scarface*, gangster Tony Camonte
(Paul Muni) wastes no time on flattery. ◆ Howard Hughes
had Ben Hecht write an incestuous undertone into
Camonte's affection for his sister (Ann Dvorak).

When a novel called *Scarface* was published in March 1930, Hughes paid $25,000 for it. Maurice Coons had written a barely fictional biography of Al Capone under the pen name of Armitage Trail. He was afraid that the gangsters he had befriended for research purposes would track him down and kill him. He saved them the trouble. He spent so much of his Hughes money on food and drink that he died of a heart attack at the downtown Paramount Theatre in October of the same year. He was twenty-eight.

Hughes hired a series of writers to adapt the novel, including W. R. Burnett. "I had twelve scripts piled on my desk," said Burnett. "Hughes had the writers use the book as a sort of skeleton. It was an awful piece of crap. But it had an incest theme. I don't know what it was with Hughes and incest. So I wrote a whole script. But Howard Hawks didn't like my script. So they brought in Ben Hecht ten days before shooting was to start."

Hecht had written the first gangster film, *Underworld*, in 1927 and had just signed a contract with Sam Goldwyn at the United Artists studio when he ran into Howard Hawks. "We went to see Mr. Hughes," said Hecht. "He looked kind of goofy. He had a weak face and was lanky and seemed to be a mess all around. I couldn't imagine he had any money, so I made him pay me a thousand dollars in cash every day at six p.m."

Hecht's treatment turned the Capone family into the Borgias of Chicago, incest and all. "There have been several gangster pictures," Hecht told Hughes. "*The Secret Six* just killed off about eight people. I will kill off twenty, and we'll have the audience right in our hand." Hecht toiled for eleven days, and the completed treatment had more than forty fatalities. Burnett and a few others returned to write dialogue, often acting out scenes with Hawks.

"A great many of the gangsters that I met were pretty childish," recalled Hawks. "They were just like kids. So I asked Ben Hecht, 'Can't you write a machine gun scene with Muni like a kid finding a new toy?' And Ben wrote a marvelous line: 'Get out of my way! I'm gonna spit!'"

Hecht recommended the stage actor Paul Muni to Hawks for the part of Tony "Scarface" Camonte. Muni declined the role, saying that he was too sedentary to play such a physical, aggressive character, so Hecht worked with him, showing him how to throw punches. Hawks cast Karen Morley as a gun moll, even though M-G-M was casting her as an ingénue. "I will not continually be cast as a Misunderstood Young Thing," said Morley. "This girl is a tart. I'll play her hard-boiled and tough in a blonde wig." Morley brought her M-G-M pal Ann Dvorak to a party to meet Hawks, and, when he saw her do a sexy dance in front of actor George Raft, Hawks visualized it as a scene in which Dvorak's flirtation inflames Camonte, her brother.

After reviewing the *Scarface* script, Jason Joy told Will Hays that *Scarface* would be "the most harsh and frank gangster picture we ever had." Hays told him to make Hughes revise it. Hughes ignored his letters. The colonel got tough.

"Under no circumstances is this film to be made," Joy wrote Hughes. "The American public and all conscientious State Boards of Censorship find mobsters and hoodlums repugnant. Gangsterism must not be mentioned in the cinema. If you should be foolhardy

enough to make *Scarface*, this office will make certain it is never released."

Hughes sent a memo to Hawks: "Screw the Hays Office. Start the picture and make it as realistic, as exciting, as grisly as possible."

Two months later, Hughes showed Joy a rough cut of *Scarface*. Joy made numerous suggestions. Hughes accepted them. "Naturally all of us would like to be able to make and release our pictures just as we wish," he conceded. "However, I don't own my own releasing company and when United Artists tells me they won't release the picture unless it's passed by Hays, there is only one thing I can do, and that is to get the picture passed by Hays." Accordingly, Hughes reshot the ending of the film to show Camonte turning coward when deprived of his gun. Encouraged, Hays guessed that this second version would be passed by the state boards. Just to make sure, he sent Joy to show this version to the Ohio, Pennsylvania, and New York boards. Their districts represented 40 percent of the country's filmgoers, so it was essential to convince them.

As was his wont, the eccentric Hughes grew tired of conferences and hid out on his yacht. His publicity director, Lincoln Quarberg, took over. Meanwhile, Joy had shown the new version to everyone but James Wingate and the New York board. This strategy, probably Hays's, had Joy return to Quarberg, pretending that Wingate would not pass the film. Joy then made Quarberg cut all "inferences of incest" and hire uncredited technicians to shoot new material: a didactic scene of editors and politicians condemning gangsters, and an anticlimactic sequence in which Camonte is sentenced and goes to the gallows.

After four months of knuckling under, Hughes

got an unpleasant payoff: James Wingate rejected the film in total. "As you undoubtedly realize by now," Quarberg wrote Hughes, "the men who are actually running the picture business, including Will Hays and the Big-Shot Jews, particularly the M-G-M moguls, are secretly hoping you have made your last picture. They are jealous of your successful pictures, and have resented your independence, and your entrance into the industry from the start." The head of UA was Joseph Schenck, whose brother Nicholas was the head of Loew's Inc., the parent company of M-G-M. As if to confirm Quarberg's suspicions, UA took Hughes's negative and prepared a third version of the film.

On March 2, 1932, Quarberg bypassed UA and screened the first version of *Scarface* for the press. "It brought considerable discussion immediately following its showing by newspaper, magazine, and trade press reviewers," wrote Philip Scheuer in the *Los Angeles Times*. "It seemed to be pretty generally conceded among the members of this experienced audience that *Scarface* is one of the best, if not *the* best, of all the gang pictures, splendidly done, magnificent in its sweep." The *Hollywood Reporter* called it "a masterpiece." On March 31, Hughes opened *Scarface* in New Orleans, which had a lax censor board. A month later the film formally opened in Los Angeles. "In a superbly shaded portrayal, Paul Muni frequently suggests the Frankenstein's monster of recent unhallowed memory, and he should enchant those millions to whom the grisly and the macabre recommend themselves as assets. Tony Camonte is not only the worst gunman of

OPPOSITE: For a time, it appeared that Paul Muni's stunning performance in *Scarface* would be seen by no one.

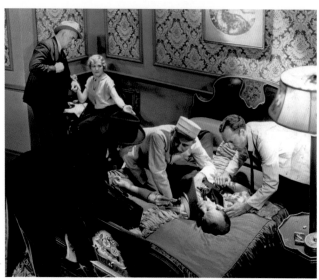

them all, but also an A No. 1 monstrosity. How can he miss? He can't. Neither can Howard Hughes."

After good press and attendance, Hughes retrieved all prints of the third version, and tried to release the second version. The Ohio Board passed the film, but others, including Pennsylvania and Chicago, did not. Lincoln Quarberg began issuing press releases condemning "censorship," as if the SRC—and indeed the MPPDA—were agencies of a fascist government. Hughes and Quarberg consistently failed to admit that the industry was paying for Hays and Joy to regulate it, in order to protect films from the kind of mutilation that *Frankenstein* and *The Easiest Way* had suffered. But no. Hughes and Quarberg preferred the stance of the bullied new kid in the playground, forgetting that this particular kid had been playing the arrogant arriviste for five years. The millionaire aviator from Texas was, after all, only twenty-six years old.

Schenck submitted the third version to Wingate—without Hughes's approval. Wingate approved this version, but it was a moot point when the first version was playing in New Jersey. *Photoplay* printed a sampling of letters on *Scarface*. "The government owes Howard Hughes a vote of thanks instead of criticism," wrote Mrs. W. S. Bargetz of Los Angeles. "*Scarface* gives the public a realistic portrayal of organized crime." Nancy Vercellini of Torrington, Connecticut wrote: "*Scarface* is not only a picture, it's modern history. Almost every incident is something I have read about, discussed with others and pondered over." George Champion of Oakland asked: "Why does the censor board wish to ban a great picture that every American should see?"

In February 1933, the Mason Theatre in Mason, Michigan, played *Scarface* without reproach or incident.

"A perfect picture in every respect," wrote Roy Adams, parenthetically adding that it was "pretty strong stuff for the kiddies." The controversy had blown over, but Howard Hughes no longer cared. He was opening Hughes Aircraft in Glendale and turning his back on Hollywood. Years later he had grown resentful. "The Hays Office demanded that I reshoot a lot of *Scarface*," he said in 1946. "I was willing to bow to their desires, but only a few weeks after the release of my picture, M-G-M released *Red-Headed Woman*, which made *Scarface* look like a religious picture."

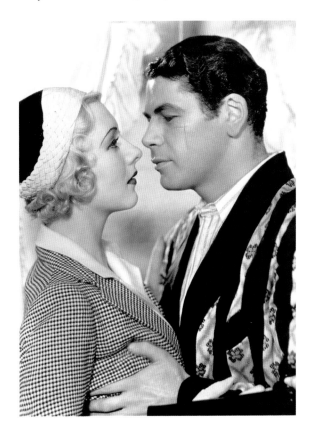

THIS PAGE: Camonte steals his boss's girlfriend (Karen Morley) with his usual directness.

OPPOSITE: The violence in *Scarface* was vivid, relentless, and unprecedented. Not even Boris Karloff, George Raft, or Ann Dvorak were spared.

RED-HEADED WOMAN

Howard Hughes had made Jean Harlow a celebrity, but he had no idea how to make her a star. That was M-G-M's specialty. "More Stars Than There Are in Heaven" was the reason for its eminence. It had Marie Dressler, Wallace Beery, Buster Keaton, Joan Crawford, Norma Shearer, Greta Garbo, and a couple of Barrymores thrown in for good measure. Irving Thalberg felt that the box office, not the Hays Office, should decide what was suitable for the public. *It's a Wise Child* was a comedy of sexy errors.

In 1932, prosperity was often spoken of but rarely encountered—unless you worked at M-G-M.

Marion Davies refused to act in it, so Thalberg argued with her. "Mr. Hearst doesn't want you to do anything the slightest bit off-color," he said. "I have no intention of doing that. I just want you to do something that isn't entirely gutless."

In 1932 Thalberg created the most diverse catalogue of entertainment in M-G-M's eight-year history. A self-taught genius, his taste ran to explorations of human nature, abnormal psychology, and sex. His first hit of 1932 was also the first "all-star" film. *Grand Hotel* featured John and Lionel Barrymore, Joan Crawford, Greta Garbo, and Wallace Beery. The film's theme is that money destroys relationships. Baron von Gaigern (John Barrymore) tries to steal Grusinskaya's (Garbo) pearls, then relents when she is about to commit suicide. He comforts her, then sleeps with her. Meanwhile, he has spurned "stenographress" Flaemmchen (Joan Crawford), who decides to sell herself to the vulgar industrialist Preysing (Wallace Beery). Before she can sleep with him, a burglar distracts him. It is the Baron, trying to raise money so he can start a new life with Grusinskaya. Preysing kills the Baron with a telephone. Flaemmchen finds the body and runs into the hotel corridor.

In Jack Conway's *Red-Headed Woman*, Una Merkel tries to restrain her friend Jean Harlow, but drunkenness, adultery, and violence occur nonetheless. The eponymous bad girl suffers no punishment for these sins, which appalled women's groups and churchmen alike.

Edmund Goulding, the film's director, described the scene in a story conference: "Flaemmchen looks this way and that. After all, it is Flaemmchen, not Lillian Gish running across the ice in *Way Down East*. It is Flaemmchen, the Berlin girl. She pauses to try to clear her brain. 'What the hell is this? What is it?' The impulse naturally is to scream in alarm. She doesn't. Flaemmchens don't." Goulding was a brilliant eccentric, too careless to cover his indiscreet drinking, drug-taking, and orgies.

Grand Hotel was convincing because its adult themes were presented without winks or leers. During a story conference, Thalberg told Goulding how to rewrite the scene of the Baron watching Grusinskaya undressing: "When he's on a sex thing, he's perfectly within his rights. When he has seen a naked woman, he can suddenly, very honestly, have a sex desire come over him. Why does a man want one woman and another man want another? That's the kick of it, God damn it!"

Thalberg hoped *Grand Hotel* would be "full of life, a painted carpet upon which the figures walk." Even Jason Joy was enthusiastic. "The picture is so big and so fine," said Joy, "but some censor boards may see

RED-HEADED WOMAN

something to cut—for example, Preysing's line to Flaemmchen in the bedroom while she is winding the alarm clock: 'Are you going to be nice to me? Very nice?'"

Joy was right. Everyone wanted to see the film, but not everyone saw all of it. "I was looking forward to the bedroom scene," wrote H. D. Van Tassell of Newark, New Jersey. "The most exciting thing that the scintillating Joan got to do in said bedroom scene was wind the clock! Why? The answer is state censorship!!!" The film was badly cut in Pennsylvania, too. "*Grand Hotel* was ruined by having so much conversation eliminated," wrote Mrs. W. J. Thompson. "When pictures are cut, the younger generation imagines things worse than they are. What a shame to live in such a nice city as Philadelphia and know you can't see a picture without feeling gypped." Another fan wrote: "I saw *Grand Hotel* in Wilmington and hardly recognized it as the same picture. There was so much more than I'd seen in Philadelphia."

Samuel Marx, Thalberg's story editor, was visiting the Philadelphia offices of the *Saturday Evening Post* to bid on short stories by F. Scott Fitzgerald. While looking through other material, Marx came across *Red-Headed Woman*, an incomplete serial by novelist Katharine Brush. In short order, Thalberg bought the property, hired Fitzgerald to adapt it, and bought Harlow's contract from Hughes. Harlow's claim to fame was her platinum-blonde hair, but Thalberg believed in "oblique casting," so he cast her as the *Red-Headed Woman*. "Do you think you can make an audience laugh?" Thalberg asked Harlow.

"*With* me or *at* me?"

"*At* you."

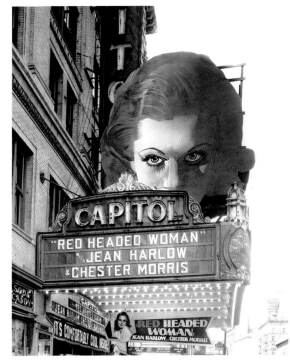

THIS PAGE: Charles Brabin's *The Beast of the City* was produced by William Randolph Hearst to show the effectiveness of honest cops, but those scenes were upstaged by the sex scenes between Wallace Ford and Jean Harlow. In 1932 even voyeurism got past the Code. ◆ Canny exhibitors exploited the notoriety of Jack Conway's *Red-Headed Woman* with ads that were more scary than sexy. "Look Out! The Red-Headed Woman Is Coming!"

OPPOSITE: Jean Harlow and Wallace Ford in *The Beast of the City*.

"Why not? People have been laughing at me all my life."

Fitzgerald tried to turn the racy story into a prose poem, so Thalberg took it away from him and gave it to screenwriter Anita Loos. "I want you to make fun of its sex element," he told her, "just as you did in *Gentlemen Prefer Blondes*." In her script, Lil, an amoral girl from the wrong side of the tracks, pursues her married boss, wrecks his home, then takes up with his boss—and his chauffeur. When her boss objects, she shoots him. How does she pay for her sins? She winds up in Paris, kept by a rich man, with the amorous chauffeur nearby.

"This is in my mind the most awful script I have ever read," wrote Lamar Trotti on April 27, 1932. "Not since I have been here have we had so many problems involving sex situations. The time has come to crack down as hard as we can." Trotti summoned Thalberg to the SRC offices. "He and I went into a session which lasted literally far into the night," Trotti wrote Joy. "While my wife and his wife sat outside in the anteroom and starved! Thalberg, of course, is a man of persuasive powers, and he used the usual high pressure salesmanship methods on me." Trotti wasn't buying. "Thalberg's contention is that they are playing it as a broad burlesque and that the audience will laugh at the situations as broad comedy. Maybe so; but that isn't in the script." *Red-Headed Woman* was previewed in Glendale, and the comedy was not on the screen, either. The audience was perplexed.

Thalberg added a prologue establishing Lil as a sexy cutup. When he previewed the new version in Pasadena, it worked. "Laughs began at once and never ceased," wrote Loos. When Joy returned from his *Scarface* campaign, he screened the film, first at Metro and then at a theater. "My feeling is that this picture is either very good or very bad," said Joy, "dependent on the point of view of the spectator who sees it as either farce or as heavy sex." One scene has the boss's wife (Leila Hyams) rebuke Lil. "You caught him with sex," she snarls. "But sex isn't the only thing in life. And it doesn't last forever. And when it's gone, you'll lose him. Because then he'll want love. And love is one thing you don't know anything about—and never will!"

"When we saw the picture with an audience," Joy reported, "we got a definite impression that the audience was laughing *at* the girl, and when the wife turned on the girl, the audience applauded."

While Joy was persuading Hays to pass the film, Mrs. Alonzo Richardson of the Atlanta Board of Review was doing the opposite. "We have been working for years for clean decent pictures," she wrote him. "And here, in 1932, we have *this* . . . Sex! Sex! Sex! The picture just reeks with it until one is positively nauseated."

"In the cold projection room it seemed entirely contrary to the Code," Joy explained to Carl Milliken, MPPDA secretary. "However, when seeing it with an audience, it took on a different flavor. So farcical did it seem that I was convinced that it was not contrary to the Code." The SRC passed *Red-Headed Woman* on

OPPOSITE: At a time when movie companies were having a hard time getting audiences to see one star, Irving Thalberg boldly put five into *Grand Hotel*. Here are Joan Crawford, John Barrymore, Lionel Barrymore, and the ubiquitous supporting player, Lewis Stone. ◆ The highlight of Edmund Goulding's *Grand Hotel* was the sexy meeting of Greta Garbo and John Barrymore. ◆ Hurrell's portraits of Crawford and Beery made fans want to see their scenes, but Philadelphia censors cut them.

July 1, 1932—a week after Metro had released it in Los Angeles.

"The erstwhile Platinum Blonde sets a new mark for bold, bad babies," wrote Philip Scheuer in the *Los Angeles Times*. "Departing from the norm of movie morals, she neither sins to 'forget' the 'one man' nor emerges chastened from her experiences. The film might have lain itself open to the disapproval of the rank and file of theater patrons. That it has not redounds to the credit of those concerned with its making." There were no reports of rocks being thrown at screens; in fact, the film's New York engagement was cheerfully noisy, with reports of "guffaws" at the cavernous Capitol Theatre.

Massachusetts and Pennsylvania cut scenes of Lil's romance with her chauffeur (Charles Boyer). Ohio cut the unrepentant ending. England banned the film altogether, but a print found its way into the private collection of King George V.

"Somehow M-G-M, more than any other producing company, has a way of getting around the critical prejudices of Will Hays," wrote the *Hollywood Citizen-News*. "The other companies are watching the big box-office grosses of this picture with shocked chagrin," wrote the *Los Angeles Times*. When Darryl Zanuck heard that Joy had used audience reaction

as an argument, he wrote the SRC: "I insist that you give Warner Bros. the same privileges you gave Metro-Goldwyn-Mayer."

"I am in for it," Joy admitted to Carl Milliken. "Probably half of the other companies are trying to figure out ways of topping this particular picture, and when the results of their planning get to me, it will require all of our strength to dissuade them." Sure enough, Fox Film was planning *Call Her Savage*, Warners was planning *Baby Face*, and M-G-M was shooting *Red Dust*.

There were no cries of outrage from regional theaters. The State in Minneapolis capitalized on the notoriety with a citywide campaign: "Wives! Husbands! Look Out! The Red-Headed Woman Is Coming." When she arrived, she was duly welcomed. "Business above average," said a typical report. "A little too torrid for the kids and family trade, but it pulled for us. Some patrons thought it silly and others thought it good entertainment." Letters to the fan magazines were divided. "What a blues chaser the picture is," wrote Jean Florio of East Haven, Connecticut. "It has just enough sex to be amusing." Helen Price of Pennington, New Jersey, was upset. "Usually I avoid sex-problem plays, but *Photoplay* gave this one such a boost. 'Risqué,' it said. No, it was just plain common." Whatever it was, *Red-Headed Woman* was profitable, more than paying for Harlow's contract.

Thalberg next cast Harlow as a Saigon prostitute in a jungle melodrama called *Red Dust*. On July 2, twenty-one-year-old Harlow married forty-two-year-old Paul Bern. On July 22, filming commenced, and easy-going Clark Gable found the first scenes vulgar. On September 5, Paul Bern was found dead of a bullet

wound. The production shut down. When Harlow recovered sufficiently, the first scenes were reshot with more modesty and less roughhousing.

Jason Joy reviewed the film on October 10. He mentioned "the extremely harassing circumstances which attended its delivery" but was satisfied that "the sex element has been handled well." There was apprehension at Metro. Although public opinion was solidly behind Harlow, viewing her as an innocent victim, there was the issue of a sexy film being released two months after a tragedy. And publicity had already gone out. "I played a trollop, to be sure," said Harlow later, "and sex was suggested by situations, but there was nothing actual. I think Clark kissed me twice in the entire film. The advertising prepared the public for a sexy picture, and consequently they read sex into it."

Red Dust opened October 22, and *Time* said: "Given *Red Dust*'s brazen moral values, Gable and Harlow have full play for their curiously similar sort of good-natured toughness." A score of exhibitors reported good box office with phrases like "a clean picture" and "nothing offensive." "A little hot, but my audience ate it up," said Missouri. "Young set liked it; older folks frowned on it," said Arkansas. "One mighty fine picture," wrote Joe Hewitt of the Lincoln Theatre in Robinson, Illinois. "Pleased them all. Paul Bern's

death might have hurt the draw of Harlow on this, but there should be no doubt about her future after they see her in this."

Red Dust confirmed Harlow and Gable as stars and grossed $1.2 million, but it could not please everyone. "This is the same old story from the perverted master minds of production," wrote Gerald Stettmund of the H. & S. Theatre in Chandler, Oklahoma. "This is the type of picture you will not play after the Brookhart bill is passed." The anti-Hollywood bill did not pass, but resentment persisted. "The whole Code scheme has practically become a wash-out during the past few months," wrote Martin Quigley to Hays. "I am astounded at the things that have been getting by."

By this time, Colonel Joy had endured five years of arguments, and he was growing weary. "Jason saw the Code was not working," recalled Geoffrey Shurlock, a future censor who was still at Paramount. "It had no teeth, and he was not about to spend his life fighting a losing battle." Joy told Will Hays privately that he wanted to resign but would wait until there was someone to replace him. Hays approached Carl Milliken, the former governor of Maine, who politely but firmly declined. Hays started sniffing around the state boards. As 1932 wore on, the Depression worsened, box office dropped, and writers were told to spice up scripts.

THE M-G-M GLOSS

"I suppose I'm on the wrong side of the fence," wrote a Kansas mother in 1932, "but I contend that we are not helping our children fight evil by tying a black cloth over their eyes and telling them that evil is not there. Censor the cigaret-smoking woman on the screen, and they will see one in our own little city. The real problem is that mothers say, 'Here's a dime. You may go to the movies. (And stay out of my way.)' How much better to say, 'Let's go to the movies.'"

This letter was quoted in Rita McGoldrick's *Motion Picture Herald* column. From all available evidence, this mother was right. There was less "evil" than the bluenoses said. First, the censor boards were continuing to cut films. Second, both urban and rural exhibitors routinely notified their patrons as to which films were not suitable for children. Third, regional exhibitors showed adult films on Monday or Tuesday, but never on Sundays. Fourth, the latest cycles were aimed at young viewers, who loved animal stories. There were the "wild animal cycle" and the "jungle cycle." Surely these would not be sexy movies.

In *Trader Horn*, an African expedition finds a half-naked "White Goddess." Living with wild beasts, whipping natives, and torturing explorers, Edwina

Booth captured America's imagination and brought M-G-M a massive profit. In a few months, studios were turning backlots into jungles.

THIS PAGE: Greta Garbo was at the apex of her worldwide popularity when she appeared in George Fitzmaurice's *As You Desire Me*. Garbo insisted that M-G-M hire Erich von Stroheim.

OPPOSITE: Norma Shearer was the First Lady of M-G-M when George Hurrell made this portrait.

The Tarzan books by Edgar Rice Burroughs posited that a hero raised by apes was morally superior to civilized profiteers. There had been numerous silent films based on the books, but Irving Thalberg thought he could do better. M-G-M was known for its Art Deco gloss. And for sex. In a story conference, director W. S. Van Dyke asked his colleagues just how sexy the film should be. "It would be very nice to establish the sophistication of the English girl, even with all her sweetness," he said. "I don't know, though. This is a kids' picture." In *Tarzan the Ape Man*, Johnny Weissmuller fights wild beasts, kills natives, and romances an explorer, Jane Parker (Maureen O'Sullivan). The film charmed viewers all over the globe, achieving the almost unprecedented feat of staying in circulation for five years (officially) and for decades (unofficially). As it became the most profitable film M-G-M had yet made, it prompted a rash of tropical films: *Thunder Below*, *Panama Flo*, *The Painted Woman*, *A Passport to Hell*, and *The Most Dangerous Game*.

RKO sent King Vidor to Catalina Island to direct an exotic project, *Bird of Paradise*. Jason Joy suggested that native dances, a breast-feeding scene, and Dolores Del Rio's nude swimming scene be shortened. The Pennsylvania board cut a scene of Johnny (Joel McCrea) and a "small boy with Johnny's shirt on, standing with back to camera, when you see a shadow of his sex on the shirt." A Minnesota audience reacted to another scene. "Dolores Del Rio sucks an orange and then transfers the juice to Joel McCrea's mouth to give him a drink," wrote G. N. Turner of Pine City.

OPPOSITE: Tallulah Bankhead has lost her fortune in *Faithless*, but Hugh Herbert is ready to stake her.

Billie Dove and Marion Davies in *Blondie of the Follies*.

"Everyone remarked that it was disgusting and spoiled the picture."

Following the trend, Joan Crawford's next film, *Letty Lynton*, was set in the tropics. Letty is an aimless, cynical socialite. While visiting Montevideo, she becomes a sex slave to a sloe-eyed *homme fatal*, Emile Renaul (Nils Asther). She escapes on an ocean liner, where she meets wholesome Jerry Darrow (Robert Montgomery). Emile threatens to tell Jerry about Letty's sinful past, so she puts poison in her own glass of champagne. Before she can drink it, Emile grabs it and downs it. At his inquest, Letty is accused of murder. Jerry saves her by saying that she had no motive—he knew of her past. Her mother also perjures herself. "The wicked prosecuting attorney is foiled by a parcel of lies," wrote Florence Fisher Parry in the *Pittsburgh Press*. "And the M-G-M lion yawns a benign blessing

upon the impending nuptials. This talkie is typical of Hollywood's concept of morals."

Jason Joy had warned M-G-M that the film could be censured because the Lynton character "has affairs because of the sex urge, not out of love." *Letty Lynton* was banned in three states and three countries because it "justified homicide without penalty." In many ways *Letty Lynton* was more immoral than *Red-Headed Woman*. "In real life, no man, no matter how dissipated, would take to his heart and into his home the kind of woman that Letty Lynton confesses she is," wrote Winifred Payne of Lynchburg, Virginia. "Our favorite actors run the gamut of sins," wrote Jesse E. Word of Houston, "with illicit love, murder, lying—and oh, what lying—how it is enjoyed by all! Then they come out gloriously triumphant in the final happy fadeout. How may we train our young things toward right thinking when our finest pictures teach lessons like these?"

The phrase "right-thinking" invariably recalled Will Hays. "There is no difference of opinion among decent people as to what is right and what is wrong in motion pictures or in anything else," said Hays in the '20s. "All the world over, men's minds are much alike." Inflexible righteousness was not an issue for *Letty Lynton*. The film did well both in the cities and in the towns. "It pleased our crowd of Monday and Tuesday fans," wrote a small-town Arkansas exhibitor. "They expect a sophistication [sic] sex picture." *Letty Lynton* pleased enough crowds to reap a profit of $600,000— quarter by quarter, dime by dime, in a dismal season of a dismal year.

The cycles were changing not only the kinds of films being made but also the images of the stars. "Joan Crawford acts with great feeling and understanding," wrote a San Francisco fan. "But her eye and mouth makeup on the screen are bad." A fan in Glendale, California wrote: "It's a shame that this beautiful girl should paint her mouth so grotesquely to assure the public that she is 'different.'" A Kansas fan wrote: "Let's have a little less sham from Joan Crawford. I think the majority of people do not like their dream world so fantastic."

Blondie of the Follies was the story of a cheerful New York girl who joins the Ziegfeld Follies and meets an oil magnate. Playing Blondie was Marion Davies, the cheerful New York girl who had joined the Follies and met a newspaper magnate—William Randolph Hearst, the film's producer.

OPPOSITE: W. S. Van Dyke's *Tarzan the Ape Man* featured Maureen O'Sullivan and made a star of Johnny Weissmuller.

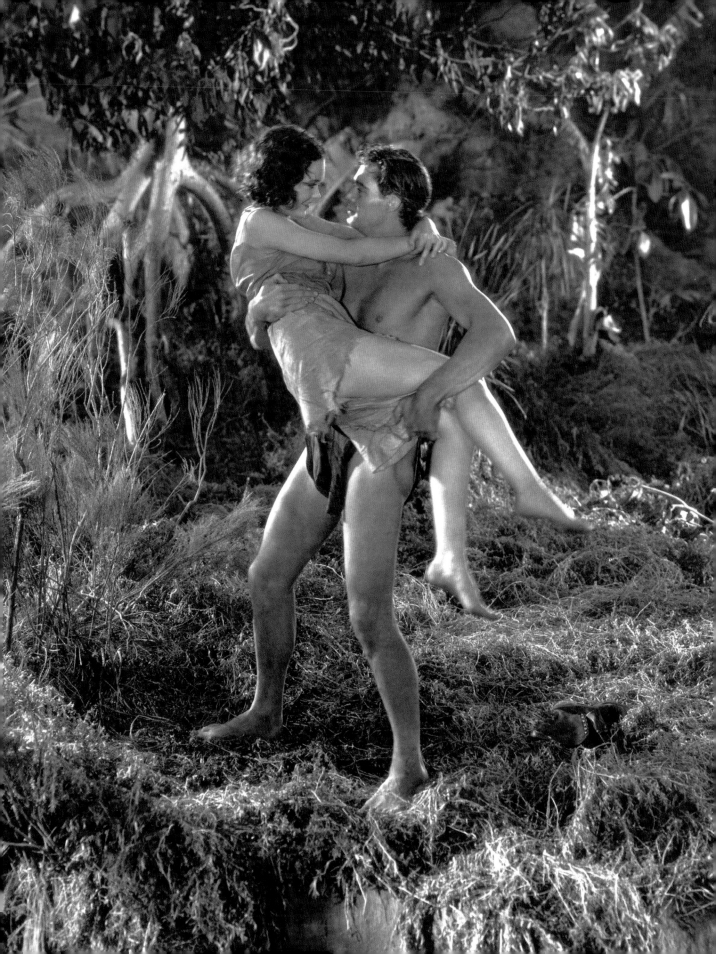

CLOCKWISE FROM TOP LEFT: Virginia Bruce, Lupe Velez, and Conrad Nagel in a scene from William Cowen's *Kongo*. ◆ In Richard Boleslavsky's *Rasputin and the Empress*, Lionel Barrymore stole numerous scenes from his brother John and his sister Ethel. "Lionel gives Rasp a little of the old Svengali-Frankenstein treatment," wrote Abel Green in *Variety*. "There's no doubt that Raspie was the 'black monk' incarnate. Lionel is a debaucher of women, a scarer of children, and a cabalistic ghoul who gives out the Frankie-Dracula stuff when ogling an adolescent princess." ◆ Boris Karloff in a scene from Charles Brabin's *The Mask of Fu Manchu*.

"I want to soft-pedal it if we can," said director Edmund Goulding at a story conference. "But you do know Blondie is kept. Murchison, [the oil magnate, played by Douglas Dumbrille] is after Blondie. He's a climber. He's a Joe Kennedy. She's a chicken, and he's definitely after her." Goulding also wanted cross-dressers in the film. He was a habitué of the popular Ship Café at the Venice Pier. One of its attractions was an act starring the Rocky Twins, identical Norwegian brothers who had achieved fame in Europe. Goulding wanted to put them in a Follies sequence. "We have a very funny routine worked out with Blondie and the Rocky Twins," said Goulding to Thalberg. "The boys are dressed up in skirts and so forth to look like girls. Marion is the gendarme and comes on the scene to stop an argument."

The bilateral gender-bending was no doubt conceived to honor a Hearst requirement: every Marion Davies film had to include a sequence in which she donned men's clothes. The Rocky Twins idea never materialized. They performed conventional chorus boy routines, but Davies had to satisfy Hearst. She and her best friend, Lurline (Billie Dove), fall off a yacht, and Blondie replaces her wet clothes with a captain's uniform. Lamar Trotti wrote to Will Hays that "most of the M-G-M pictures have escaped drastic censorship action in this country because of the very fine manner in which the alleged dubious themes are handled."

Kongo was the grim tale of "Deadlegs" Flint (Walter Huston), the crippled ruler of a planting empire deep in the African jungle. Flint is a demented, sadistic man plotting revenge against another planter. Twenty years earlier, Gregg (C. Henry Gordon) stole Flint's wife and broke his spine. To punish Gregg, Flint pulls Gregg's daughter Ann (Virginia Bruce) out of a convent and shoves her into a brothel. "There was a 'house,'" says Ann. "From a convent . . . to a house in Zanzibar . . . I 'graduated.'" Flint's vengeance degrades Ann into an alcoholic, fever-ridden prisoner until a drug-addicted doctor (Conrad Nagel) stumbles onto the plantation, recovers, and takes her away. "Swell fare for a small town theatre!" wrote Columbia City, Indiana. "This is not fit for either adults or children to see. M-G-M should be 'proud' of this one and the *Freaks* that they put out the first of the season. And they dare to compare it to *Trader Horn* and *Tarzan*!" Despite its grimness, *Kongo* was a success.

Thalberg wanted to make a film that would jointly star John, Ethel, and Lionel Barrymore, the "Royal Family of Broadway." This would be pure showmanship, "like a circus with three white whales," as John Barrymore put it. For a vehicle, Thalberg had Charles MacArthur write the story of the Russian court in the decadent days before the revolution.

The SRC rejected six drafts of *Rasputin* because they made the Romanovs look stupid and unsympathetic. When Thalberg told MacArthur to turn them into "Mr. and Mrs. Hoover," the writer was incredulous. "The Romanovs kicked your people around for three hundred years," said MacArthur. "Now you're trying to make a hero out of that stupid Nicholas."

"The tsarina was the granddaughter of Queen Victoria," said Thalberg. "Fifty percent of our foreign receipts come from England. I am not going to risk harming our foreign market because I'm a Jew. It wouldn't be fair to the stockholders."

MacArthur dutifully made the Romanovs nice and then gleefully made Rasputin the most licentious

character ever written for an M-G-M film, a crude, lip-smacking lecher. When Joy saw the film, he immediately urged cuts. Because the film's cost would be further bloated by censorship problems, Thalberg agreed. Gone was John's line to Lionel: "I'm not interested in your anatomy." Also cut was a sequence that takes place in Rasputin's lair, where demented, scantily clad female disciples are shown to be living with him. Curiously, the most flagrant violation of the Code was retained: a scene in which Rasputin tries to seduce one of the underage princesses. Finally titled *Rasputin and the Empress*, the film justified its ballyhoo; there was a riot when it opened in New York.

Regional audiences had little interest in the royal families of either St. Petersburg or Broadway, but the preview trailer promised orgies and a rape, so they came to take a look. "*Rasputin* did well for us," wrote Herman J. Brown of Nampa, Idaho. "Some raved, some said 'no like.' The degenerate Czar was really a liberal democrat? Nope. That's Hollywood fodder for the morons."

The Mask of Fu Manchu presented Boris Karloff as a Chinese megalomaniac on a crusade to "kill the white man and take his women!" If this was not bad enough, the film also had Myrna Loy as his "ugly and insignificant daughter." Her character was a problem for both the SRC and Loy. "I've done a lot of terrible things in films," said Loy, "but this girl's a sadistic nymphomaniac!" In one scene she has the handsome hero (Charles Starrett) stripped to the waist and whipped, as she cries out: "Faster, faster, faster!" The scene was censored so that the whip never wrapped around his torso.

Perhaps not satisfied that *Kongo*, *Rasputin*, or *Fu Manchu* were scary enough, Thalberg told Willis Goldbeck to write a vehicle for Tod Browning, who had returned to M-G-M after the success of *Dracula*. "I want you to write me something even more horrible than *Dracula* or *Frankenstein*," said Thalberg. Goldbeck adapted a novel with the unappetizing title of *Spurs*. When Thalberg finished reading the script, retitled *Freaks*, he was oddly silent. "Irving looked at me sadly," said Goldbeck. "Then he shook his head, rested it in his hands, and sighed, 'Well, I asked for something horrible.'"

In *Freaks*, Thalberg and Browning populated a circus sideshow with a bearded lady, a human skeleton, a hermaphrodite, Siamese twins, simpering pinheads, and an armless, legless man. The hero is a little person named Hans (Harry Earles). The villain is a narcissistic strongman, Hercules (Henry Victor), who plots with the vain acrobat Cleopatra (Olga Baclanova) to murder the frugal Hans—after she marries him.

According to Muriel Babcock of the *Los Angeles Times*, when the film was previewed in an outlying district of Los Angeles, Thalberg knew they were in trouble: "Some horrified spectators got up from their seats and ran—did not walk—to the nearest exit." Thalberg cut twenty-five minutes from the film, discarded the ending in which the freaks castrate the strong man and mutilate the acrobat, and replaced it with an improbable reunion between Hans and his wife (played by Earle's sister, Daisy). These measures failed to save *Freaks*.

The usually wry Philip Scheuer minced no words in the *Los Angeles Times*: "No guile here. *Freaks* it is and freaks they are, and upon your own reaction to the immemorial side show will depend your reaction

to this and these. For the affair is not so much frightening as it is revolting."

Freaks got a trial run in San Diego, where it broke house records. In Los Angeles, word of mouth killed it after two weeks. It did well in Boston, Cincinnati, and Omaha, but the Atlanta board banned it, as did the boards in San Francisco and Great Britain. Browning received outraged letters: "You must have the mental equipment of a freak yourself to devise such a picture!" For the first time since *The Callahans and the Murphys* in 1927, M-G-M pulled a film from circulation. Unable to play out its contracts, *Freaks* lost $158,607.

Thalberg often said that he had his "finger on the pulse of America." Two of the forty films that he shepherded in 1932 starred his wife, Norma Shearer. *Strange Interlude* wowed audiences with Eugene O'Neill's controversial theme of a woman who has a child by a man other than her husband in order to keep hereditary insanity out of the child's blood. "Not good for children," said an Oklahoma exhibitor. "It's as full of sex as a dog is of fleas." This was Shearer's fifth daring film. A backlash was brewing. "Mothers wrote letters begging Miss Shearer to return to good clean pictures that their children could see," said *Photoplay*. "The public had enough shady dames without little Mrs. Thalberg." Even an M-G-M film editor went on record. "I like to see Miss Shearer in the kind of things she did when she began," Danny Gray told *Photoplay*. "In the lovely kind of things. I've always felt that's where she belongs."

For Shearer's next outing Thalberg chose *Smilin' Through*, a beloved play about transcendent love. Shearer dared to doubt her husband. "I felt, having played so many sophisticated roles, that this would

be old-fashioned and overly sentimental." She need not have worried; the film had a scene that defied the Code. As Shearer's sweetheart (Fredric March) departs for the Front, she sits on a running board with him, imploring him to sleep with her first.

The sentiment of *Smilin' Through* was just what 1932 needed. Reports from exhibitors described packed houses and weeping patrons. There was weeping at the other studios, too, because *Smilin' Through*, *Tarzan*, *Grand Hotel*, and *Red Dust* sucked up what little box office was left in the country, and M-G-M ended the worst year of the Depression with an improbable profit of $8 million.

Louis B. Mayer told a Christmas Eve gathering of his employees: "I say the country has emerged from the Depression, and so we have!" After he went home, M-G-M celebrated with apposite abandon. "Bacchanalia reigned," recalled story editor Samuel Marx. Bootleg liquor flowed like film developer, and offices were turned into trysting places, confirming Joseph Breen's idea of Hollywood as a hedonist ghetto. Irving Thalberg, whose heart had been damaged in childhood by rheumatic fever, allowed himself the risky luxury of a few cocktails. Then he faltered. His work pace, Paul Bern's death, and salary battles with Mayer had taken a toll. Thalberg suffered a heart attack. Doctors ordered him to rest for six months, and Norma Shearer put aside her career to care for him. While Thalberg sailed to Europe to see a specialist, the Depression grew worse, and the Code grew weaker.

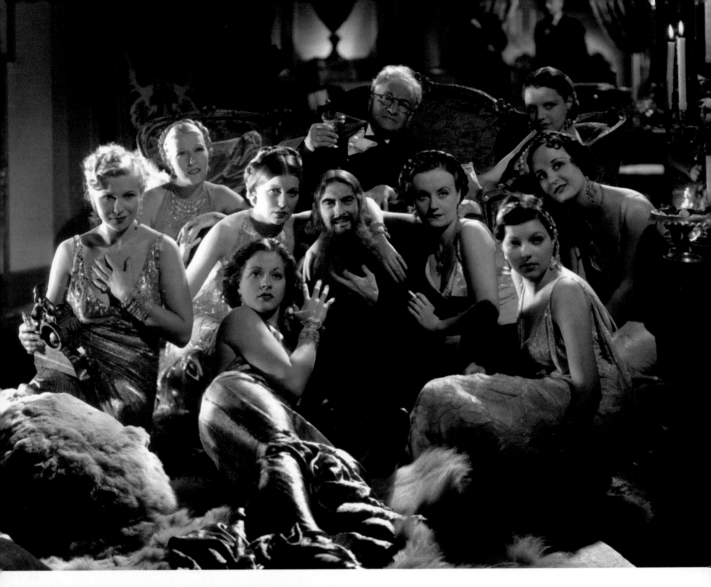

THIS PAGE: Lionel Barrymore had the role of a lifetime in *Rasputin and the Empress*. In this Milton Brown photograph, the identifiable players are Barbara Barondess (far left); Claudelle Kaye (resting on sofa back); and Martha Sleeper (hand on Lionel's knee). ◆ John Barrymore and Karen Morley had a bedroom scene in Jack Conway's *Arsène Lupin*.

OPPOSITE: While working on Tod Browning's *Freaks*, Olga Baclanova became friendly with thirty-year-old Harry Earles, who was well aware of the script's implications. "And I make him jump on my lap," said Baclanova. "And I treat him like a baby. But always he say to me, 'You be surprised!'"

"THE NEW SHADY DAMES OF THE SCREEN"

"Hollywood has created a new woman, a different type of heroine, a unique feminine personality." So wrote Ruth Biery in a 1932 *Photoplay* article, titled "The New Shady Dames of the Screen." This category included Garbo, Dietrich, Tallulah Bankhead, and Joan Crawford, who were taking "glamorous" and "mysterious" to new heights. "Yesterday's screen sirens led a man to destruction and laughed—heh! heh!—at the poor, bewildered thing. But these women were heartless creatures, villainesses, vampires. In the final reel, the fallen hero returned to the golden-haired girl who was waiting in a halo of sunlight. Nowadays it's the heroine who falls. The bad woman—the shady dame—is today's heroine. She has a man's viewpoint, and a man's ability to deal with brutal situations; hence, the new sex."

Hollywood was not responsible for the new breed. The brutal situations these characters encountered onscreen reflected the depression, which was making men desperate and women resourceful. Theater owners were desperate, too. Exhibitors blamed poor films and radio and weather, but whatever the reason, movie patrons were simply not showing up. By 1932, the number of theaters had slid from 18,000 to 12,000.

America was in crisis. In New York alone, 1.5 million people were destitute. Who was going to movies?

"In these days of unemployment," wrote B. D. Claire of St. Petersburg, "people do not appreciate a picture show until they cannot afford to go, until they turn pockets inside out and find, that by doing without some food, they can go to a picture. During the weary time that my husband has been out of work we have squeezed the occasional quarters from our slender store, and we *live* that show—in anticipation, in actuality, and in retrospect."

Patrons in better circumstances were choosy about their fare, and the studios worked to entice them. Even a film purified by Jason Joy could be made alluring through advertising. "She gave her love to a man who only wanted to borrow it," said an ad for *The Strange Love of Molly Louvain*. "All men go too far, but most girls are poor judges of distance," read the sign above a theater playing *Red-Headed Woman*. "This boss was a whirlwind for big business by day—and big mergers by night," promised *Beauty and the Boss*. Criticized for

OPPOSITE: David Landau and Thelma Todd are observed by Chico, Groucho, and Harpo Marx in Norman Z. McLeod's *Horse Feathers*.

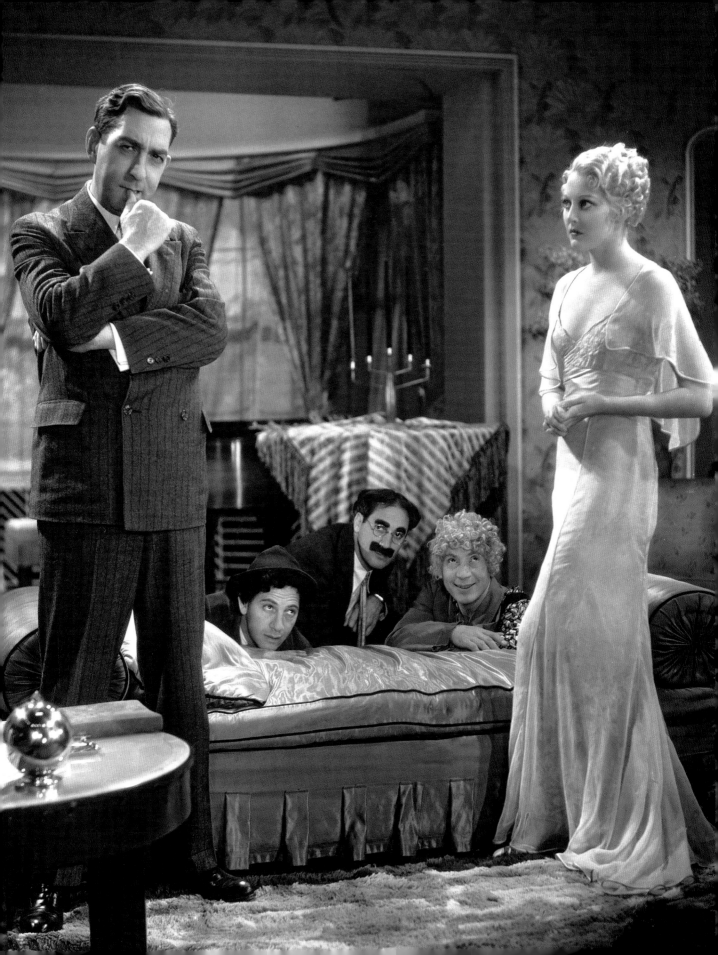

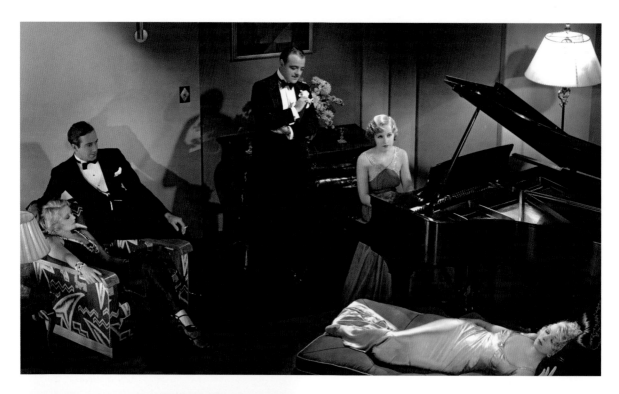

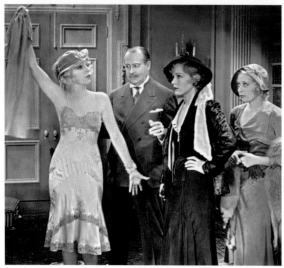

Lowell Sherman (center) directed *The Greeks Had a Word for Them*, which also featured Joan Blondell, David Manners, Madge Evans, and Ina Claire. ◆ Ina Claire got raves for this scene with Phillips Smalley, Madge Evans, and Joan Blondell. "If the censors take too many liberties with this tangy and diverting comedy it will be too bad," wrote the *Motion Picture Herald*. "Unfortunately there are pursy people who fear the downfall of a nation's morals when a girl partially disrobes in front of the camera." Numerous censor boards cut the scene.

tainting the neighborhood, banner ads worked with studio-supplied posters and still photographs to tempt anyone passing a theater. Sometimes the film failed to live up to the ballyhoo; sometimes it surpassed it. In a mad dash to pull business away from M-G-M, United Artists and Warner Bros. were making racy movies.

Possessed, *Grand Hotel*, and *Letty Lynton* had put Joan Crawford at the top of the heap. Because she wanted to do a prestige picture, United Artists was able to borrow her, but Joseph Schenck needed permission from Will Hays to buy a legendary play. *Rain* was adapted by John Colton in 1922 from Somerset Maugham's short story *Miss Thompson*, and it created a star. "The role of Sadie Thompson should have died with Jeanne Eagels," wrote Mollie Merrick in the *Los Angeles Times*. "She could say more with those twitching calves than a whole world of actresses can do with makeup and costuming." Hays approved the project only after Schenck agreed to change the

cleric "Reverend Davidson" to the secular reformer "Mr. Davidson." Walter Huston was cast as the man obsessed with a prostitute in a steamy Samoan hotel.

To transform the ultra-chic Crawford into a Honolulu hooker, designer Milo Anderson bought a gingham dress off the rack in downtown Los Angeles. Crawford's makeup was more fanciful. "I let Joan go the limit," said director Lewis Milestone. "I had a reason. In the first part of the picture it was necessary for her to look the part. But after her reformation, after she bit the dust, so to speak, when Davidson had converted her, I had her do away with makeup entirely, for contrast."

Milestone was determined to erase the memory of the Eagels production of *Rain*. He sequestered his cast on Catalina Island, rehearsed them to numbness, and added a scene. In the play, the conversion of Sadie from sinner to penitent is not shown. Milestone thought it should be. He had Maxwell Anderson write a scene in which the reformer bullies the hooker into praying. Then Milestone more or less ruined it with self-conscious camera movement and heavy-handed direction.

At a Hollywood preview the mood was solemn. "*Rain* left a professional audience gasping for breath at the frankness of its adherence to Colton's ironical concept," wrote Mollie Merrick. "Members of the Hays office looked a bit somber and thoughtful as they filed out of the theater." Philip K. Scheuer of the *Los Angeles Times* was aghast at the Sadie Thompson makeup. "Joan Crawford's mouth is a chaotic smear, like a sock in the teeth."

The scene that could have sparked a religious backlash was snuffed by its own pretensions. "I remember an audience greeting with a belly laugh the scene in which Huston pursues Crawford down a staircase while reciting the Lord's Prayer," said Milestone. "Mr. Huston is at his worst," Mordaunt Hall wrote in *The New York Times*. "His lines so weaken several sequences that many in the crowded theatre giggled and laughed when they should have been held in silence."

When *Rain* reached the hinterlands, exhibitors were hostile. Nampa, Idaho wrote: "A flop. Stupid beyond words. Terrible direction. Crawford has not the slightest idea of how to dress or play her role." Rochester, Indiana: "Companies should not be allowed to release pictures of this kind." Monroe, Georgia: "If this is a small town picture, then I'm a bricklayer."

"It's hard to realize that a star of Crawford's caliber means so little at the box office," wrote Erie, Pennsylvania. "Audience reaction was very bad, so I had to pull the picture before the end of its run. This picture will hurt this star." The exhibitor was right. Crawford's fans wanted a dancing daughter or an ascendant shop girl, not a shady dame. This was the first time that a star's standing was affected by this kind of film. It would take Crawford two more films to regain her footing.

United Artists did better with releases of Samuel Goldwyn's films. The most independent of independent producers had snapped up *The Greeks Had a Word for It*, the Zöe Akins play about three gold diggers, Jean, Schatze, and Polaire. Goldwyn pitched the project to Broadway star Ina Claire in—where else—an elevator. "You will wear Chanel gowns," said Goldwyn. "Think of that!"

"I did not have the heart to tell him that I had worn dozens of them on the stage," Claire recalled.

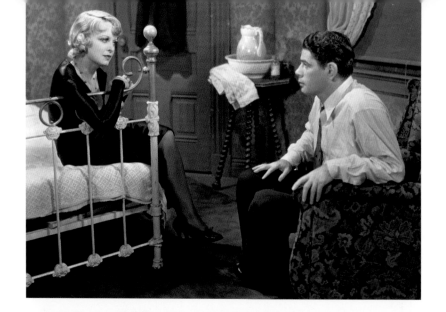

"And any chorus girl could have played my role." In truth, only an actress of her accomplishment could do justice to Jean, an amoral character who steals men from her roommates by wearing a chinchilla coat with nothing underneath—and flashing them. "This story ought not to be told if it is to be of three whores," said John V. Wilson of the SRC. "This will require the omission of the many objectionable incidents in which Jean removes her clothing when she gets 'hot.'"

Before screenwriter Sidney Howard could make changes in the text, the SRC made him change the title to *Greeks Had a Word for Them*. "Nobody ever explained that change of title to me," recalled Joan Blondell, who played Schatze. "It's still dirty."

Having forsaken two-color Technicolor musicals in 1931, Warner Bros. began to replace the costume dramas of John Barrymore and George Arliss with the urban melodramas of James Cagney and Edward G. Robinson. There were also the crime-and-sex stories of William Powell, Ruth Chatterton, and Kay Francis—stars whose contracts Warners had snatched from Paramount in the notorious star raid of 1931. The new Warners policy was to make fifty films a year, as quickly and as cheaply as possible: a feature had to be shot in eighteen days. In 1932 Warners established itself as the fastest-moving studio, prompting a rumor that directors Mervyn LeRoy and Michael Curtiz were cutting one frame from every shot in every film to hasten its pace.

OPPOSITE: Noel Francis solicits Paul Muni in Mervyn LeRoy's *I Am a Fugitive from a Chain Gang*. ◆ Irene Dunne waits decades for John Boles to divorce his wife in John Stahl's *Back Street*. ◆ Drug-addicted Ann Dvorak tries to save her son, Buster Phelps, from kidnappers in Mervyn LeRoy's *Three on a Match*.

Every week Jack Warner and Darryl Zanuck traversed the studio's 135 acres, looking for standing sets to use as the basis for a new film. Plots were reused or stolen from newspapers. "A story must have the punch and smash that would entitle it to be a headline on the front page of any successful metropolitan daily," said Zanuck. "Our one rule is: Don't bore the audience," said writer Robert Lord. "Anything goes, as long as it's entertaining and interesting."

Lee Tracy had become a Broadway star in *The Front Page*, but he lost the starring role to Pat O'Brien in the film version and was languishing in dull parts when Warners cast him as the rat-a-tat columnist of *Blessed Event*. His recounting of a grisly execution was a showstopper. "Tracy makes history with this one," wrote a South Dakota exhibitor. "It will shock some, but the humor will make most overlook the low moral tone, or should we say, the lack of moral tone."

Scarlet Dawn was the story of a titled libertine (Douglas Fairbanks Jr.) caught in the Russian Revolution. The film opens with Baron Nikita's off-duty revelry, which includes an incipient orgy and a visit to his mistress, Vera Zimina (Lilyan Tashman). "Lilyan Tashman and I had a torrid love scene to do," Fairbanks recalled. "The director William Dieterle would not let us go to lunch until the scene was finally concluded—about two hours later. His theory was that one could not and should not make love on a full stomach."

The SRC cut the ending of the scene, in which Nikita finds Vera's older lover hiding in her bedroom. Zanuck thought this was unfair. "I want to go officially on record now," he wrote Joy. "We have less eliminations and less cuts made by the censorship boards than

JOAN CRAWFORD'S MOUTH
SMEARED UP TO THE LIMIT

*Lewis Milestone, Director of "Rain," Finds Made-Up
Lips Sadie Thompson's Biggest Asset*

any other company in the business. We have never violated the Code at any time in any picture, and we have never produced a condemned or barred novel or play, either in the open or by subterfuge, or by alteration of title." This was technically true, because Warners did not buy hit plays or novels; its original stories were racy enough.

Three on a Match was the quintessential Warners film of 1932, cramming headlines, history, sociology, sex, alcohol, drugs, adultery, kidnapping, blackmail, and suicide into sixty-three frantic minutes. Its cast was equally rich: Joan Blondell, Ann Dvorak, Bette Davis, Humphrey Bogart, Glenda Farrell, Allen Jenkins, Lyle Talbot—and Warren William, who came out of nowhere and quickly became the house seducer, exerting his oleaginous charms in *Beauty and the Boss*, *The Dark Horse*, and *The Match King*. The stepped-up pace and austerity measures did little good. By the end of 1932, Warners had lost $14 million.

THIS PAGE: In 1932 Joan Crawford's highly stylized look began to worry her fans. Portrait by George Hurrell for Clarence Brown's *Letty Lynton*.

OPPOSITE: John Miehle made this portrait of Joan Crawford in character as Sadie Thompson.

CALL HER SAVAGE

The Fox Film Corporation was struggling to support two immense facilities. "Movietone City" was ninety-six acres of Art Deco soundstages and virgin backlots in the "Westwood Hills" (which were flat). "Fox Hills" (also flat) was its older lot at Sunset and Western in Hollywood. Since Charles Farrell's career had lost its zip, Fox's stars were Janet Gaynor, Will Rogers, and Warner Baxter. Directing them were genuine talents like John Ford and Frank Borzage. These highly individual directors liked Fox because its executives rarely interfered with them.

Fox Film was an odd studio. Since the ouster of William Fox, it had no clear-cut image. Its president was Sidney R. Kent, an ex–boiler stoker whom Darryl Zanuck characterized as "an absolutely honest man." Kent had come to Fox from an executive sales position at Paramount in early 1932 because he saw a shakeup coming. Fox's head of production was also its cofounder, Winfield Sheehan. Zanuck considered

him "a good discoverer of talent," and it was true that under his watch Charles Farrell and Janet Gaynor had become stars in Borzage's exquisite *Seventh Heaven*. Sheehan had also produced F. W. Murnau's *Sunrise*. But Sheehan had not adapted to life without William Fox and could not work as a team with Kent.

THIS PAGE: On the set of *Call Her Savage*: Gilbert Roland, director John Francis Dillon, Clara Bow, writer Edwin Burke, and Monroe Owsley.

OPPOSITE: This scene still of Clara Bow was made by Max Munn Autrey for Fox Film.

MOVIETONE CITY

Located at
Beverly Hills, California

FOX FILM CORPORATION

FOX HILLS

At left is an airplane view of the Hollywood studios and laboratories on both sides of North-Western Avenue on Sunset Blvd.

After Fox Film ousted William Fox and before it merged with Darryl Zanuck's Twentieth Century Pictures, it made quirky, overproduced films from first-draft scripts. It also made some of the most vulgar movies of the pre-Code era.

"Fox Film lacked positive studio leadership and a clearly defined policy," wrote film historian William K. Everson. "Offbeat, basically uncommercial properties slipped through because there was, in essence, no one to stop them." Darryl Zanuck was blunt: "Fox had the best distribution organization in the business—and the worst films." Even so, five of them had grossed a million dollars in 1931. In 1932, however, Fox needed a star.

Clara Bow had been off the screen for more than a year following the morals scandal and a nervous breakdown that ended her winning streak at Paramount.

The "It Girl" was still in demand, so Fox offered her a competitive $75,000 for one film, with approval of script, director, and cast, and she accepted. To assure Bow of privacy, Sheehan reopened the Fox Hills plant, which had been closed for two years

For Clara Bow's comeback vehicle, Fox Film submitted the Tiffany Thayer novel *Call Her Savage*, a book that any other studio would have dropped with singed fingers. "The book is about as far wrong as it is possible to be," Joy wrote to Hays. Besides having such elements as incest, masturbation, transvestism, and venereal disease, the book was patently racist, blaming its heroine's personality problems on her Native American blood. Thayer claimed that "the background and local color, and some of the incidents, were all based on the life of my wife, who was a resident of Texas and is one-half Osage Indian." Independent producer Sam Rork bought the book for Bow, and sold it to Fox Film. "The writer took most of the real flavor of the story out of the first treatment," said Joy, "with the result that only another stupid picture was in prospect. Somewhere in between there lies a good film." Rork and supervisor Al Rockett worked with screenwriter Edwin Burke to find it.

In Burke's version of *Call Her Savage*, Nasa Springer (Clara Bow) is the tempestuous daughter of a rich Texas rancher (Willard Robertson). She does not know that her real father was an "Injun" (Weldon Heyburn), who killed himself after her mother (Estelle Taylor) gave him up. Nasa's temper propels her through a series of imbroglios that end only at her mother's deathbed, when she learns the truth about herself. She resigns herself to a quiet life with Moonglow (Gilbert Roland), a "half-breed" who works for her father.

Lamentable though it was, the plot gave Bow what most actors crave, a role with multiple identities. In one film Bow plays a wild teenager, an impulsive debutante, a jilted newlywed, a thrill-seeking party girl, a young mother, a prostitute, an aloof society gal, a slumming brawler, a sexy drunk, and a repentant daughter.

"Because it is a new Clara Bow that the screen is presenting," Jason Joy wrote to the state boards, "we are all very hopeful that the picture will be judged as a whole for the character study that it is, all parts of which inter-link importantly." Bow's return should have been a sufficient pull for the film, but Fox wanted a hit on the scale of *Tarzan* or *Smilin' Through*, so no expense was spared—and no sensation. *Call Her Savage* had more production value than M-G-M, more topicality than Warners, and more titillating scenes than Paramount. At one point it appeared that the studio was trying a little too hard.

"Actress Rita La Roy has claimed that she was compelled to go beyond the bounds of modesty," wrote *Variety*. "Director John Francis Dillon was 'ungentlemanly' in endeavoring to have Miss La Roy open more of her dress than she considered necessary in an attack scene." Fox replaced La Roy with Margaret Livingstone, who was willing to expose her chest and let a man roll on top of her in the back of a covered wagon.

The studio mounted a vigorous ad campaign for *Call Her Savage*, and then previewed it in Long Beach. "It was a smart move," wrote *Variety*, "to spot her preview in the longhaired church center which has always frowned upon Clara Bow's frivolous screen activities. Her first appearance on the screen was the signal for a burst of applause which continued for several minutes,

Sunny DuLane (Thelma Todd) is no longer welcome in the home of lounge lizard Larry Crosby (Monroe Owsley).

drowning out the dialog in spite of the operator fading up the sound."

The critics praised Bow's new look, new figure, and new acting technique, but they tiptoed around the tone of the proceedings; perhaps, like Joy, they felt that any effort was pointless. Only a college newspaper took aim and fired. Cecil Ball wrote in the *Daily Texan*:

For the initial picture of what she optimistically calls her second career, Clara Bow has *Call Her Savage*, the story of a tempestuous rapscallion destined for no particularly good end. Let it be generally conceded that her acting has improved, having become more restrained, but she succeeds mostly in giving a picture of what a tough specimen a flapper will grow up to be. *Call Her Savage* has been condemned by the more discriminating as a flashy, trashy, tasteless, and unpleasant exhibit, but not even the most captious can deny its superficial appeal to the larger public.

CALL HER SAVAGE

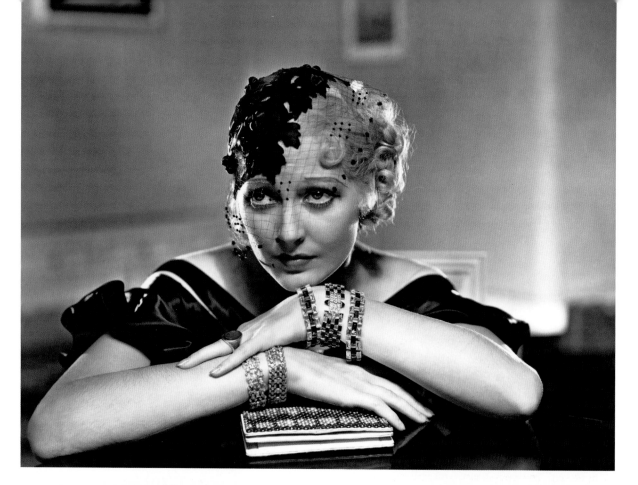

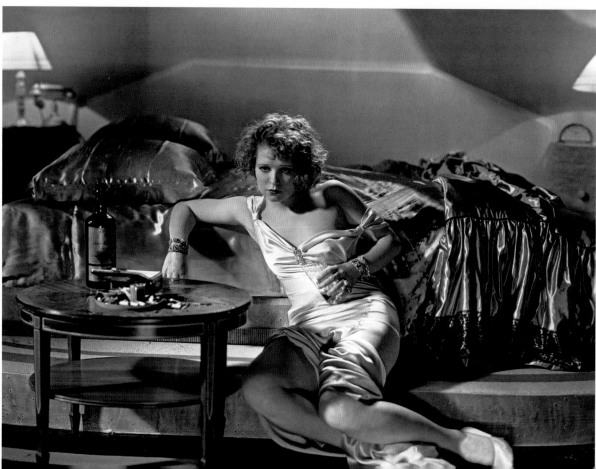

The fans were not long in responding. "Clara has come back to her loving public," wrote a Pennsylvania woman. "Her figure is once more slender and graceful." Another fan agreed: "How she does wear underwear!"

The exhibitors were eager to comment, too. "The first real business I have done in six months," wrote Montpelier, Idaho. "They came to see the return of Bow, and, let me tell you, they were not disappointed. She looks more beautiful than ever, and boy what a shape she's got!" But what about the vehicle? "Patrons remarked it was better than they expected," wrote Chandler, Oklahoma. "They know *Call Her Savage* is by Tiffany Thayer, and this smutty stuff of his 'has done had its day.' The public have gone clean-minded now and will like this picture because it is Clara, and not on account of the sordid story." Graham, Texas wrote: "A little more comedy and a little less smut would have been much better for Clara. But this gal can act." North Dakota was less sanguine: "This picture is a big disappointment, entirely unsuited for the star. Those who remember her in silent pictures will not like this. Another one like this one and Clara is through."

In the winter of 1932, 20 percent of theaters were closed. Moviegoers who could afford only one film chose *Smilin' Through*. Consequently, *Call Her Savage* made a profit of only $17,407, and the Fox Film Corporation ended the year with a loss of $16,964,499.

OPPOSITE: Unit still photographer Max Munn Autrey made this on-the-set portrait of Thelma Todd, who nearly stole *Call Her Savage* from Clara Bow. ◆ A pre-Code heroine at the turning point.

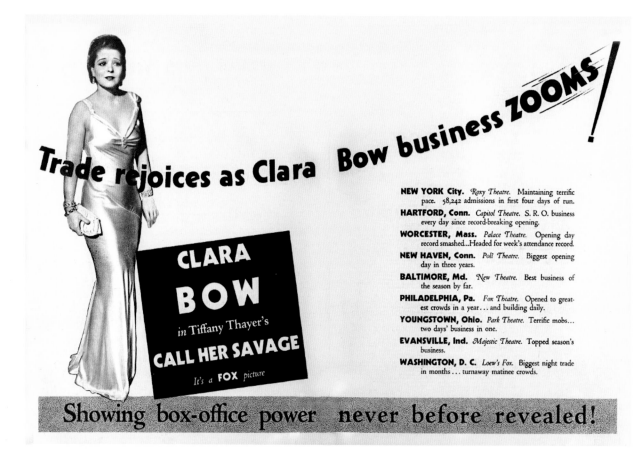

Trade rejoices as Clara Bow business ZOOMS!

CLARA BOW in Tiffany Thayer's **CALL HER SAVAGE**

It's a **FOX** picture

NEW YORK CITY. *Roxy Theatre.* Maintaining terrific pace. 58,242 admissions in first four days of run.
HARTFORD, Conn. *Capitol Theatre.* S. R. O. business every day since record-breaking opening.
WORCESTER, Mass. *Palace Theatre.* Opening day record smashed...Headed for week's attendance record.
NEW HAVEN, Conn. *Poli Theatre.* Biggest opening day in three years.
BALTIMORE, Md. *New Theatre.* Best business of the season by far.
PHILADELPHIA, Pa. *Fox Theatre.* Opened to greatest crowds in a year... and building daily.
YOUNGSTOWN, Ohio. *Park Theatre.* Terrific mobs... two days' business in one.
EVANSVILLE, Ind. *Majestic Theatre.* Topped season's business.
WASHINGTON, D. C. *Loew's Fox.* Biggest night trade in months... turnaway matinee crowds.

Showing box-office power never before revealed!

THIS PAGE: The company's box-office reports were perhaps overly optimistic, given competition from M-G-M.

OPPOSITE: Then, as now, audiences were not sure what to make of *Call Her Savage*, but Clara Bow was a genuinely beloved star. Portrait by Hal Phyfe.

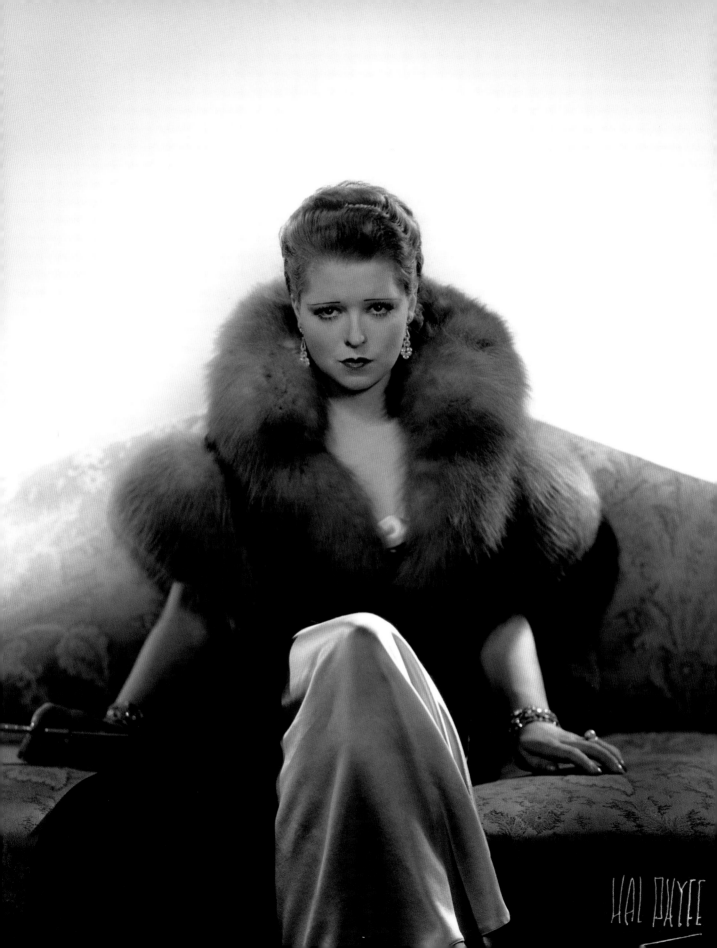

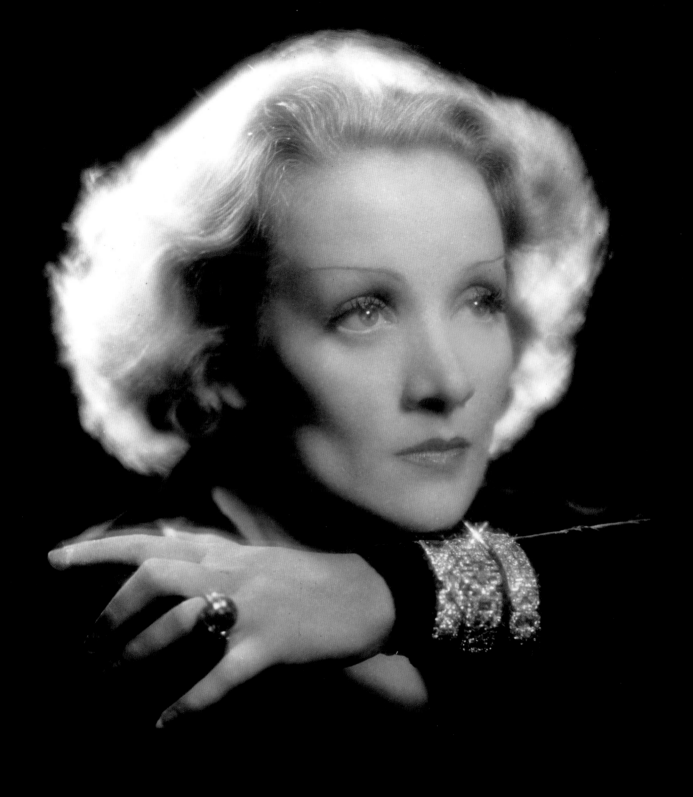

THE PARAMOUNT GLOW

"The public is a lonely, lonely mob," said Ben Hecht. "It has nothing much to do, and no capacity for enjoying itself. If these people can't go to church or be led off to war or be given a new hysteria, they're kind of lost. After they finish washing the dishes, they can't think of anything to do. Hollywood comes into their lives and gives them visions of castles and knights and wild playboys and rich nymphomaniacs. It's pleasant."

This was true for most of the 1920s, and then, at the decade's end, came radio, entering homes with an intimacy that movie theaters could not match. By 1932, sixteen million radios were competing with the box office. "The average family of five," wrote a station owner, "can sit home Sunday nights and listen to the biggest stars. If they went downtown to the picture house, they would pay a minimum of $1.75 plus cost of transportation. In these times, $1.75 plus transportation provides the average family with bread, butter, and milk for a week."

Choosing to work with radio, rather than against it, Paramount produced *The Big Broadcast*, a film about a radio star that featured an actual radio star, Bing Crosby. In the film, he leads a dozen radio acts,

including Cab Calloway, who does a musical number, "Kickin' the Gong Around." The song refers to opium smoking, heroin, and cocaine, and the loose-limbed Calloway mimics the inhaling of cocaine. *The Big Broadcast* did "swell business," in regional theaters, said *Variety*. "Hicks are natural huggers of radio."

Paramount was not quirky, like Fox Film, or aggressive, like Warners. It was elegant, sophisticated, and "continental." More of its directors and writers came from Europe than those of any other studio. Its films had a distinctive look. Director Josef von Sternberg, cinematographer Lee Garmes, and portrait photographer Eugene Robert Richee used marquisette fabric instead of glass in their soft-focus filters to put star patterns on highlights and create a diffused golden glow.

In 1932, Paramount's glow was on the screen and not in its coffers; the studio was in trouble. By April, it had already lost $2,450,211. There were rumblings, audible to Lamar Trotti when he visited the studio. "There seems to me to be a very real and distressing

OPPOSITE: Soft-focus portraits of Marlene Dietrich made by Eugene Robert Richee and supervised by Josef von Sternberg gave Paramount publicity a unique glow.

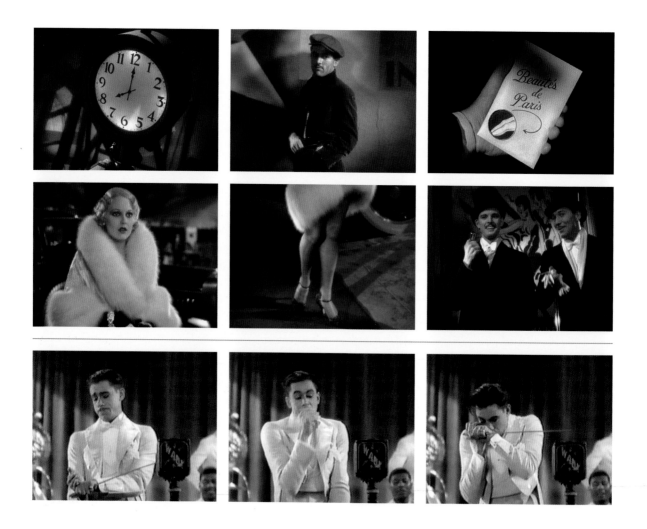

TOP: Jean Negulesco designed "Madame Has Lost Her Dress," the montage that opens *This Is the Night*. The dress belongs to Thelma Todd.

BOTTOM: Cab Calloway mimics cocaine use in his performance of "Kickin' the Gong Around" in Frank Tuttle's *The Big Broadcast*.

tendency at Paramount to go for the sex stuff on a heavy scale," he wrote Will Hays. "One gets that feeling not only in the scripts but also in the conversations in the studio where talk about pictures having to have 'guts' and about 'having to do this or do that to make a little money to pay our salaries' is too frequently heard." If the studio was thinking of sex, so were its executives.

Two men were responsible for the tone of Paramount's films. Vice president Jesse L. Lasky co-founded Paramount with Cecil B. DeMille, Samuel Goldwyn, and Adolph Zukor in 1916. Production head B. P. Schulberg came to Paramount in 1925, after six years as an independent. According to Lasky's daughter Betty, both married executives spent an inordinate amount of time with the available young women who abounded in Hollywood. As Paramount slid toward insolvency, Lasky and Schulberg planned fifty-seven features. Eight of them would be later acclaimed as works of cinematic art, and all of them were sexy.

Merrily We Go to Hell was the story of New York sophisticates Fredric March and Sylvia Sidney in "the holy state of matrimony—single lives, double beds, and triple bromides in the morning." The *Los Angeles Times* refused to print the title of the film.

Schulberg persisted in trying to make over Tallulah Bankhead in the image of Garbo. In *My Sin, Thunder Below,* and *Devil and the Deep,* Bankhead played a languid vamp stuck in a turgid zone, and her flair for comedy went unused. But she was entertaining in interviews. "When I first started to make pictures," Bankhead told Gladys Hall of *Motion Picture* magazine, "I was said to be trying to 'do a Garbo.' A fatal thing to say about anyone. If there's anything the matter with me now, it's certainly not Hollywood's state of mind about me. The matter with me is I haven't had an *affaire* for six months. Six months is a long, long while. I want a man!" After making *Faithless* a hit for M-G-M, Bankhead left Hollywood.

Paramount did well with sexy comedies. The best of them had flights of fancy created by Jean Negulesco, a portrait painter turned production designer. He evolved a visual vocabulary: slow motion, musical transitions, and cartoon-like choruses. He first used these in *This Is the Night,* a comedy set in Paris. "All my memories of Paris crowded the screen," wrote Negulesco. "The dirty-postcard vendor, the midinette with her hatbox, waiters in outdoor cafes counting plates in rhythm with the music, lovely legs and delicious smiles—these were images all moving, all dancing in time to the music."

One running gag has an evening gown torn off Claire (Thelma Todd) by a limousine door. Jason Joy wrote: "When Claire's coat flies open and Gerald [Roland Young] looks down on a 'vista' afforded by the open coat, he gasps—with a great intake of breath. The assumption is that he has seen a great deal." Schulberg made the requested cuts without ruining the rhythm of Negulesco's sequence. In a letter to *Photoplay,* a teenage boy defended the film to his date: "Even if a couple risqué scenes did embarrass you girls, you're old enough to bear up under it. Guess your moral characters are formed, or whatever it is that worries the censors." *This Is the Night* became a template for Paramount's sophisticated comedies, but it lost money.

One Hour with You reunited *The Love Parade*'s Ernst Lubitsch, Jeanette MacDonald, and Maurice Chevalier. "This script makes pretty light of adultery," wrote Lamar Trotti. "It has a continental flavor that I fear will be dangerous." That flavor was the best thing the studio had going for it. As Lubitsch said, "There

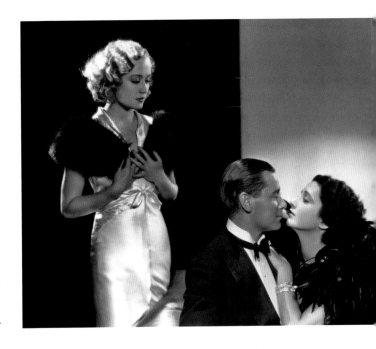

Eugene Richee shot this poster art of Miriam Hopkins, Herbert Marshall, and Kay Francis for *Trouble in Paradise.*

THE PARAMOUNT GLOW

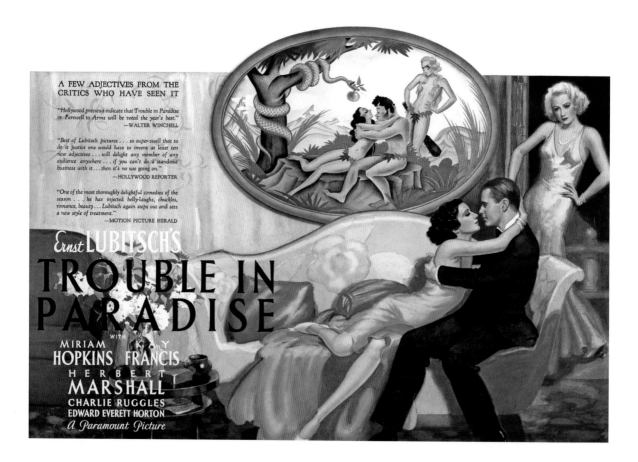

is Paramount Paris and Metro Paris, and, of course, the real Paris. Paramount's is the most Parisian of all." When Jason Joy viewed the completed *One Hour with You,* he praised the "delicate and charming manner in which the subject matter has been treated."

"The Lubitsch touch, which has become more than a legend, is omnipresent here," wrote Edwin Schallert in the *Los Angeles Times.* "Deviltry, innuendo, and slick new tricks disclose the influence of this stellar producer and director." Jeanette MacDonald remembered: "The first pictures I made were very 'naughty.' I was flaunting around in sleazy negligees and slinky gowns. Oh, yes! The famous 'Lubitsch touch.' It had an amusing kind of naughtiness. Not 'dirty.' Not really 'sexy,' but it really had great *whimsy.*"

A costly production, *One Hour with You* lost money. And MacDonald began to feel a chill. "I have

gone far enough in lingerie," she told *Motion Picture.* "I'm sure they must say about me, on the screen, 'Good gracious, is Jeanette MacDonald going to take off her clothes—*again*?'

Trouble in Paradise, Lubitsch's next film, was created in three months of daily script sessions with Samson Raphaelson. Even Geoffrey Shurlock, a new SRC reviewer, was wowed by its precision. "This is the most sparkling and entertaining of Lubitsch's comedies since the advent of talkies." Then he added: "For adults." After all, it was the story of two jewel thieves (living together, of course) who fleece a rich, glamorous widow. As in all Lubitsch films, the meanness of the plot belied the sympathy of its director.

"Not very uplifting, from a moral viewpoint," wrote a Detroit exhibitor, "but done in a foreign locale in such a humorous vein that few will take exception to

the nature of the story." A Neligh, Nebraska exhibitor wrote: "One of the finest directed and timed pictures we have ever run, but darned hard to make the farmers and plain folks think that way."

Lubitsch could not (or would not) direct the next MacDonald-Chevalier vehicle, so Paramount anxiously approached another director. "They had no book and no theme," recalled Rouben Mamoulian. "I'd have to find one in a hurry because they had the two stars on five thousand a week, there was no picture, and the money was mounting up." The resulting screenplay, *Love Me Tonight*, included lyrics by Richard Rodgers and Lorenz Hart. Trotti made a few suggestions to Schulberg about some risqué verses, then concluded: "May I add that this is one of the most delightful scripts that I have ever read." The finished film was even more delightful, with tunes like "Isn't It Romantic" and Mamoulian's masterly effects, but the risqué material did occasion comment. "Many readers begged Maurice Chevalier to stick to the double entendre if he must, but to be less frankly naughty," wrote *Photoplay*. A theater in Sodus, New York, wrote: "Those who did attend were pleased with the exception of—now and then—a person who objected because they considered it a bit risqué." *Love Me Tonight* was Paramount at its best, but incredibly, it lost money, too. What did make money for Paramount in 1932?

THIS PAGE: "The best looking clock that was ever in pictures is in *Trouble in Paradise*," wrote a Nebraska exhibitor. "Look for it. It's a pip. And Kay Francis is a honey." He did not specify which clock he meant, but he was right about Kay Francis, seen here with Herbert Marshall.

OPPOSITE: Only the Great Depression kept a masterpiece from becoming a hit.

THE PARAMOUNT GLOW

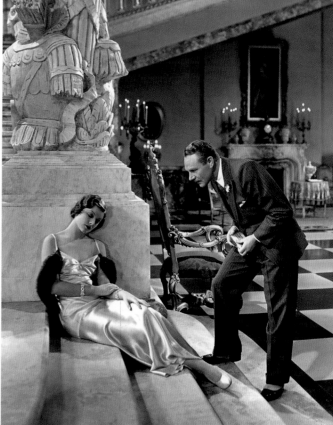

CLOCKWISE FROM TOP LEFT: "What's a Maurice Chevalier picture without a scene showing the gorgeous Jeanette MacDonald in bed?" asked a *Photoplay* caption. Rouben Mamoulian is riding the crane, and cinematographer Victor Milner is below. ◆ This scene still from *Love Me Tonight* was shot by Bert Longworth. ◆ Myrna Loy and Charles Ruggles were two members of the cast assembled for Rouben Mamoulian's *Love Me Tonight*.

OPPOSITE: In *Love Me Tonight*, Myrna Loy sings a stanza from "Mimi." The SRC commented on her negligée, but allowed the scene. It was cut from the negative before a 1949 reissue by order of the PCA.

ISLAND OF LOST SOULS

hanghai Express, Marlene Dietrich's first film of the year, was as eagerly awaited as Greta Garbo's *Grand Hotel*, and it had a similar plot—a group of disparate characters caught in an exotic setting. Josef von Sternberg used light, shadow, and sound to tell the story of Dietrich's newest character, Shanghai Lily. Surprisingly, the story of a regenerate prostitute chugged through the SRC without a hitch. *Shanghai Express* only had problems because of a religious fanatic named Dr. Carmichael (Lawrence Grant), who acts like an angry censor; a French officer named Major Lenard (Emile Chautard), who has been "discharged for a minor offense"; and a revolutionary named Chang (Warner Oland), who says: "I'm not proud of my white blood." Many boards cut Carmichael's ranting, France cut Lenard's line, and China banned the film altogether.

Shanghai Express was censored when it played in Hollywood, and, unfortunately for the theater manager, a famous actress brought Maurice Chevalier and Josef von Sternberg to view it. "Suddenly, the audience was startled to see a young woman bearing down upon the manager with a wild gleam in her eye!" wrote Cal York in *Photoplay*. "And they recognized her as the star

of the picture they had just seen, *Shanghai Express*. It was the glamorous Dietrich herself. And mad as a wet hen! It seems that certain scenes had been left out of

THIS PAGE: A self-portrait of Josef von Sternberg.

OPPOSITE: Erle C. Kenton's *Island of Lost Souls* was one of the most heavily censored and widely banned films of the entire pre-Code era. Charles Laughton played a sly, malevolent Dr. Moreau.

the picture. Dietrich wanted to know why. But it was confirmed that the theater ran the picture exactly as it came from the studio exchange."

Shanghai Express made a profit of $33,000, so Paramount gave in to Josef von Sternberg on his next script, *Blonde Venus*, which Dietrich had initiated in a treatment. As Jason Joy wrote Will Hays: "The argument started because the original script was too raw for Schulberg. A perfectly safe version of the script was developed, but now that von Sternberg and Schulberg have patched up their differences, the rewrite on the script seems to indicate that Schulberg has compromised pretty much with von Sternberg."

The film has Helen Faraday (Marlene Dietrich) sell her favors to a rich politician (Cary Grant) to pay for the medical treatment of her husband, Ned (Herbert Marshall). Joy explained to a Paramount executive why he had passed the film: "Never are infidelity and prostitution themselves made attractive." *Blonde Venus* was well received in all markets. "This is probably the best she has done since *Morocco*," wrote an Indiana exhibitor. "She certainly has that something that pleases the women. The picture was well liked, but with conditions as they are, it did average business, which means about forty per cent down from the happy days of 1929."

In May 1932, Paramount's situation turned critical. There was a coup. Unfairly blamed for everything from the star raid to theater losses, Jesse Lasky and B. P. Schulberg were pushed out of the company, and Adolph Zukor was pulled back east. Emanuel Cohen, an ambitious newsreel producer, ascended to power. He quickly signed Bing Crosby and Mae West. Then he bought Ernest Hemingway's *A Farewell to Arms*, hired

THIS PAGE: Helen Hayes and Gary Cooper in a scene from Frank Borzage's *A Farewell to Arms.* "Frank Borzage had a wonderful gift for intimacy," wrote Hayes in 1990. "He knew how to get inside an actor's heart and mind, and that rapport gives a special glow to his films." ◆ A montage image designed by Jean Negulesco for *A Farewell to Arms.*

OPPOSITE: In Josef von Sternberg's *Shanghai Express*, Marlene Dietrich's costume was designed by Travis Banton to make "Shanghai Lily" look like a bird of prey.

Frank Borzage to direct, cast Gary Cooper as Frederic Henry, and borrowed Helen Hayes from M-G-M to play Catherine Barkley. Trotti wrote Hays that the new executives were going to "live or die by this picture; and they are going to be as daring as possible."

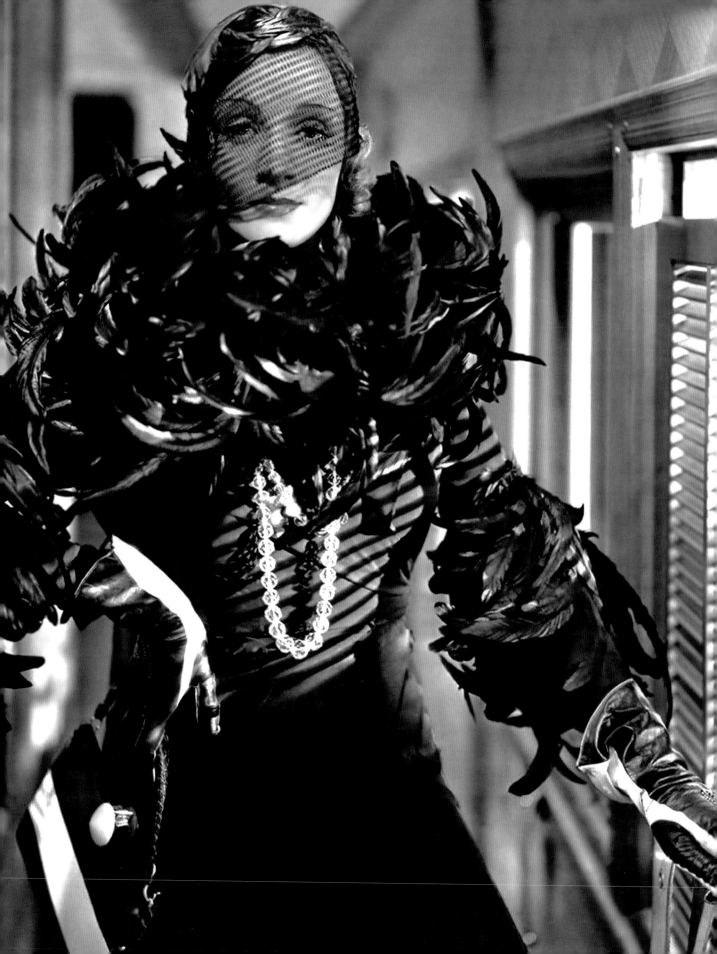

The production took two months and cost $900,000, but the result was worth it. Borzage had created an epic, and people wanted to see it. Before they could, though, there was the matter of the Code. The film had a scene of illicit love on the pedestal of a horseman's statue, a love scene in a hospital bed, an "unofficial marriage," scenes of childbirth, and the retreat of the Italian army, which could be the biggest problem of all. What would Jason Joy do?

Nothing; Jason Joy had already yielded to the blandishments of Fox Film, where Sidney Kent and Winfield Sheehan had been courting him for six months. He was now ensconced in a luxurious office, with Lamar Trotti as his assistant, making sure that Fox's scripts would be approved. His successor at the Studio Relations Committee was none other than Dr. James Wingate, the exacting New York censor. Assisted by new staff member Geoffrey Shurlock, Wingate reviewed *A Farewell to Arms*. True to form, he rejected it, then went to his quarters at the Hollywood Athletic Club. He was in for a rude awakening.

Paramount had already cooperated with the SRC to the extent of placating the Italian Embassy and shooting two endings. The company appealed Wingate's decision and presented the film to the AMPP jury. On December 7, 1932, Carl Laemmle Sr., Sol Wurtzel, and Joseph Schenck ruled in favor of Paramount, saying that "because of the greatness of the picture and the excellence of direction and treatment, the childbirth sequence was not in violation of Article II of the Production Code." *A Farewell to Arms* premiered a day later, and within weeks, it was making the money that most of the films in the Paramount calendar had not.

One of Paramount's last releases of 1932 was also its most heavily censored. *Island of Lost Souls* was adapted by Philip Wylie from the H. G. Wells novel *The Island of Dr. Moreau*. It was directed by Erle C. Kenton and photographed by Karl Struss, both of whom had been prominent portrait photographers. As Sternberg had made the American South a glistening backdrop for Dietrich in *Blonde Venus*, Kenton turned Catalina Island and the Paramount backlot into a foggy nest of horrors. "Luckily, we had a real fog," recalled Struss. When they did not, Struss gave the film the Paramount treatment, making hot light fall through bamboo slats onto steaming white stucco. What takes place in this dreamlike setting is not picturesque: Dr. Moreau (Charles Laughton) is trying to transform animals into humans. Laughton plays the blasphemous vivisectionist as an effete, purring host. When a young visitor to the island reviles Moreau for his experiments, he answers, ever so coolly: "Mr. Parker, spare me these youthful horrors."

That *Island of Lost Souls* was made at all shows how desperate Paramount was for product, especially since the *Freaks* controversy was still news. This film was not heavily cut by the censor boards; it was "rejected in toto by fourteen boards." The issue cited was that the film suggested bestiality: Dr. Moreau plans to mate the stranded visitor with a woman who has been vivisected from a panther. *Motion Picture Herald* wrote: "*Island of Lost Souls* will either write finis to the cycle of terror pictures or start a new vogue of super-shockers. This should be sold as a terror picture, the kind that starts audiences screeching and shuddering; the type that will make them afraid to go home alone after the show. The picture should not be shown to children. It

In *Blonde Venus*, Dietrich lets politician Cary Grant pay for her husband's medical treatment. ◆ The Panther Woman (Kathleen Burke) is reverting to bestial behavior, much to the annoyance of Dr. Moreau (Charles Laughton) in *Island of Lost Souls*.

is too gruesome and its main plot too vividly sexy for juvenile consumption."

When *Island of Lost Souls* played theaters in regions where it could be shown, reactions were unexpectedly diverse. Middleville, Michigan wrote: "Many women held their hands over their eyes, and the rest walked out." Stonington, Maine, wrote: "Was the first in this territory to play this one. Satisfied most of our audience." Garber, Oklahoma wrote: "Played this to the best business in months. People knock it, then come back and bring others to see it." Challis, Idaho, said: "I pulled fifty percent better than average business. I billed it 'Not recommended for children' and had only fourteen kids in the two nights that I played it."

"And they wonder why people have quit going to picture shows," wrote R. W. Hickman of Greenville, Illinois. "This is positively the most horrible picture ever released. A few more of this type and what little business there is left will be absolutely ruined. It's nothing short of a crime to release a thing like this one." When Charles Laughton returned to Great Britain to make *The Private Life of Henry VIII*, no one could tell him what they thought of *Island of Lost Souls*. It had been banned in that country. Laughton would do better with his next Paramount release, even though it created the most controversy of any film in 1932. For the next few months, Dr. Wingate and the SRC would be very busy.

"DECADENT IMAGINATIONS"

I n late 1931, when Clark Gable was a fast-rising actor, Paramount borrowed him from M-G-M for *No Man of Her Own*, Edmund Goulding's story of a gambler meeting a sexy librarian in a small town. A studio reader reviewed the script: "The story is essentially a brutal one—a sock on the nose—and we are going to sacrifice its best values if we try to soften it, make it nice, or whitewash it." The result was a light comedy with Carole Lombard in a couple of negligee scenes. A Georgia exhibitor wrote: "Like most pictures, it has its risqué moments; but it seems they like it, so why worry?"

On a Sunday afternoon in February, Daniel Lord dropped into a St. Louis theater to see *No Man of Her Own*. He rushed back to the rectory and "burned up the typewriter" with a letter to Will Hays, claiming that the film violated every tenet of the Production Code. He was incredulous that the people in the audience "seemed to thoroughly enjoy themselves" while he was "writhing." In his clerical opinion, seeing the film was "a sin." This belief was shared by Martin Quigley, who warned Hays that he was risking the wrath of "thousands of persons important in various religious, social, and educational activities." Apparently, it did

not occur to Hays that if a priest declared a film to be an occasion of sin, there could be consequences.

Meanwhile, *Photoplay* published a disturbing letter written by a prison inmate who signed his name only as "E.J.C." It said: "One of the greatest diversions the inmates of San Quentin Prison have is the weekly movie show. And may I inject a personal opinion from one not long confined behind these gray walls? One wearies of the never-ending sex pictures that are turned out with machine-like regularity by the picture companies."

In the late summer of 1932, Hays sent a letter to the studio heads. "I am not unmindful," he wrote, "of your constant stresses and pressures, to a point where it has been almost crushing. With these things in mind, I nonetheless urge a more strict compliance with the Production Code. There have been pictures that grossly violate the spirit and actually violate the letter of the Code. The great majority of folk in America refuse to be spattered with the spittle of decadent imaginations. Liberty of expression is not imperiled when protest is

OPPOSITE: Boris Karloff had his second great success as a Universal monster in Karl Freund's *The Mummy*.

made against playwrights who glean their plots from scribblings on latrine walls."

Joseph Breen had heard this rhetoric before. By late 1932 he had lost faith in Hays. And he had lost patience with Hollywood. Its attitude toward sex was the antithesis of his own. He was happily married, the father of six. From what he had seen in a year and a half, Hollywood was the divorce capital of America, and couples were less interested in making babies than in making love. He was devoutly Catholic, so Hollywood perplexed him. Jack Warner was ostentatious in his gifts to the construction fund for the Wilshire Temple. Thalberg was discreet. Yet neither man attended services there. Brunch at Louis B. Mayer's beachfront home was an executive's Sunday ritual, regardless of his religious affiliation.

Far from being irreligious, Los Angeles hosted numerous belief systems. "As always in such troubled times," wrote *Time* magazine, "there is a flourishing of cults, of religious novelties and new fashions in faith. Among them blossom the Rosicrucian Fellowship, the Theosophists, and the Besant Society." Other places of worship included Aimee Semple McPherson's Angelus Temple in Echo Park and the newly opened

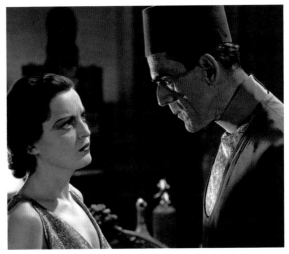

RIGHT, TOP TO BOTTOM: Edmund Goulding directs Billie Dove and Marion Davies in *Blondie of the Follies*. ◆ In *The Mummy*, Zita Johann plays the reincarnation of a princess whom Boris Karloff loved in ancient Egypt. He is a mummy who has been brought back to life by an incantation. When Karloff was asked his opinion of this project in 1932, he answered, "There is no future in being a mummy." ◆ Gloria Stuart and Eva Moore are two of the strange characters in James Whale's weird and wonderful film, *The Old Dark House*.

OPPOSITE: A portrait of Clark Gable and Carole Lombard for Wesley Ruggles's *No Man of Her Own*.

"DECADENT IMAGINATIONS"

Poster art of Ann Dvorak for Michael Curtiz's *The Strange Love of Molly Louvain.* ◆ Alison Skipworth and George Raft are upstaged by Mae West in *Night after Night.*

First Congregational Church of Los Angeles in the Westlake District. On the other hand, from what Breen had observed, Hollywood worshiped pleasure, wealth, and fame.

There were several centers of gossip in the film industry: publicity departments, editing departments, and the censor's offices. Every item came through them, so Breen heard gossip daily from his colleagues.

Mayer, Thalberg, Zukor, and Fox had happy marriages. By contrast, Jack Warner used his desk as a casting couch. Harry Cohn pulled starlets into projection booths so they could service him. Jesse Lasky left his wife in her paint studio while he pursued actresses. B. P. Schulberg's wife started an agency while he made Sylvia Sidney his mistress, and, incidentally, a Paramount star. If morality was malleable, was integrity, too?

The biggest scandal of 1932 involved the shooting death of M-G-M producer Paul Bern on Labor Day. It was called a suicide, but there was a sexual aspect to it. The middle-aged confidante of beautiful starlets was allegedly unable to consummate his marriage to Jean Harlow because of undersized genitals.

A few weeks later, there was another M-G-M scandal. It concerned the summary exile of a prominent director. "Eddie Goulding left here on twelve hours' notice," wrote Adela Rogers St. Johns, "after giving a party for eight girls which wound up with two of them having to be sent to the hospital. One of the newspapers told the studio people not to worry about the story itself being printed, as it was so filthy it couldn't be." Because film studios routinely paid district attorney Buron Fitts to have police and hospital records destroyed, history has not disclosed the details of the scandal, but the staff members of the Studio Relations Committee probably shared them over their morning coffee in Suite 408.

In the early twentieth century, Catholic schools taught students that "the Jews" were responsible for the death of Jesus. Many saw no difference between biblical Pharisees and Hollywood producers. Neither did Breen. His confidential reports to the Midwest

Catholics were rife with anti-Semitism. In a letter to Father Wilfred Parsons, the editor of *America*, Breen knocked Will Hays for believing that "these lousy Jews will abide by the Code's provisions." Breen went on to say: "These Jews seem to think of nothing but money making and sexual indulgence. The vilest kind of sin is a common indulgence hereabouts and the men and women who engage in this sort of business are the men and women who decide what the film fare of the nation is to be." And there was gossip.

> One very prominent lady star told a group of corre-spondents who were interviewing her that she is a lesbian. The head of a prominent studio was caught in bed fornicating with his neighbor's wife by his own wife, who came into the room, revolver in hand, and failed to kill both of the bedfellows simply because, in her excitement, she failed to quickly unfasten the lock on the pistol. Name cards at a birthday dinner were condrums [sic] for the men and cotex [sic], on which was a dash of ketchup, for the women. A studio head whom you and I know personally very well is just now the laugh of the town because of his conspicuous and public liaison with a star who is reputed to be the most notorious pervert in all Hollywood. And so it goes.

Breen's moral indignation found an obvious tar-get. "People whose daily morals would not be tolerated in the toilet of a pest house hold the good jobs out here and wax fat on it," he wrote. "Ninety-five percent of these folks are Jews of an Eastern European lineage. They are, probably, the scum of the earth."

Irving Thalberg was of German-Jewish descent and aware of the undercurrents of anti-Semitism in

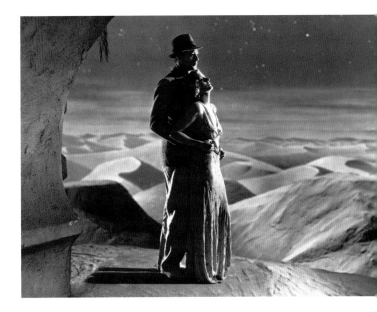

Gary Cooper and Tallulah Bankhead in a scene from Marion Gering's *Devil and the Deep.*

the American press. "Mr. Thalberg," said a reporter, "I realize that you are of the new order in films—a young man with ideals."

"If you mean," replied Thalberg, "that I think I'm superior to the so-called cloak and shoe and glove manufacturers who have really given their lives and their pocketbooks to this business in order to allow us something to build on, why then, you are wrong. I respect them very much. They had ideals also."

"DECADENT IMAGINATIONS"

THE SIGN OF THE CROSS

" I cannot find any inspiration at all in the type of pictures the producers want me to make," Cecil B. DeMille wrote Father Daniel Lord in 1931. "They are in a state of panic and chaos. They rush for the bedspring and the lingerie the moment the phantom of empty seats rises to clutch them. I cannot find a producer who is willing to do anything but follow the mad rush for destruction." At fifty, DeMille was the best-known producer-director in the world, whether for sex fables like *Male and Female* or biblical epics like *The King of Kings*, on which Lord had served as advisor. After seven supremely successful years at Paramount and five at his own studio, DeMille had tried producing as an independent at M-G-M. He was there for three years and three films; only the first had been successful. Irving Thalberg was polite but cold when he told him, "I'm sorry, C.B. There is just nothing here for you."

DeMille's wife Constance suggested that he travel to regain his bearings, so the couple toured Russia, Egypt, and Europe, seeing the latest films. When he returned in early 1932, no studio was interested in him, not even Paramount, which he had cofounded. It mattered not that DeMille had made Hollywood

Charles Laughton played the Roman emperor Nero in Cecil B. DeMille's *The Sign of the Cross*. Portrait by Eugene Richee.

the film capital of the world. "Nobody would even listen," said DeMille. "I was just like one of the Egyptian mummies we'd seen, a curiosity, something rather boring. I was through. I was dead. I was just dead."

D. W. Griffith had made his last film and was slipping into an ignominious retirement. This would not be DeMille's fate. He would persist in 1932, and his comeback film would be a milestone in cinematic technique. It would also be the most controversial film of the pre-Code period.

DeMille's mother was Jewish, and his father had been an Episcopal lay minister and a playwright. He was committed to continuing his father's work. He envisioned a trilogy. "*The Ten Commandments* was the giving of the law," he wrote. "*The King of Kings* was the interpretation of the law, the fulfillment of its promise. *The Sign of the Cross* will be the preservation of the law, the struggle of humanity to live up to it."

In March, before Lasky and Schulberg had been ousted, they had convinced Paramount Pictures to give DeMille a one-picture contract. DeMille's eminence meant nothing to Sam Katz and Emanuel Cohen, the most prominent members of the new regime. The industry had an unwritten rule: "You're only as good as your last picture." Paramount cared only that *The Sign of the Cross* be made economically. "Remember, Cecil," said Cohen, "you are on trial with this picture." DeMille's interest in the film was not purely aesthetic; he had raised half of its $650,000 budget.

The Sign of the Cross was a time-tested play by Wilson Barrett, a testament to Christian endurance in Nero's Rome. DeMille submitted the script not only to the SRC, but also to Daniel Lord, hoping to get an inside track with Will Hays. "You must not make your Christians into plaster saints who are dull, plodding, and uninspiring," Lord warned DeMille. "When your pagans are attractive, warm-blooded, alive human beings and are modern and almost night-clubbish, they make sin look as fascinating as it often seems to be."

To keep the film within its budget, DeMille enlisted art director Mitchell Leisen, whose reputation for outré pursuits was second only to Goulding's. Leisen lived with a pilot named Eddie Anderson, while married to an opera singer named Sandra Gale, none of which prevented him from approaching men at the studio; his behavior was excused because of his value to the company. As time grew shorter and the job more demanding, DeMille had Leisen design costumes and even co-direct scenes. Before long, they had turned a venerable play into a catalogue of Hollywood's private life.

Aware that stars filled theaters, DeMille cast Fredric March as Marcus Superbus, the womanizing Roman prefect, and Elissa Landi as Mercia, the Christian girl. He was delighted to get Charles Laughton for Nero but unsure who could play Poppaea. Claudette Colbert had been playing "bright young things" in lackluster comedies. "I think they've got you wrong," DeMille told her. "You should not be playing these little girls. To me you look like the wickedest woman in the world. Would you like to play her?"

"I'd love to!" replied Colbert.

"Claudette's test was the shortest on record," said DeMille. He set her and March in front of a camera. "You harlot," said March.

"I love you," said Colbert with a shrug and a half-smile.

"That's enough," said DeMille. "You have the part."

"Making the costumes for Claudette was a real pleasure," said Leisen. "I slit her skirts right up to the hip to show her marvelous legs. She didn't have a stitch on underneath."

For his obligatory bathtub scene, DeMille set Poppaea in a pool of asses' milk. "DeMille wanted the milk to just barely cover her nipples," said Leisen. "So the day before, I had Claudette stand in the pool and I measured her to get the level just right." When Colbert got in, she wondered what she had gotten herself into—literally. "That bath of 'asses' milk' was a powdered milk product called 'Klim,'" recalled Colbert. "That's 'milk' spelled backward. The Klim was so warm the bangs on my wig came uncurled. When the electricians turned off all the hot lights for an hour, it congealed, and the Klim turned to cream cheese." Cinematographer Karl Struss recalled: "Oh, boy! It smelled to heaven! And Claudette was really nude, so she couldn't get out too often." When she did, DeMille tried to get a free look; a technician inadvertently blocked it, and DeMille cursed him.

As sexy still photos started to emerge from DeMille's sets, studio head Sam Katz tried to keep the press from getting the wrong idea. "We have, in motion pictures, gone as far with sex as we are likely to go," said Katz. "The whole entertainment-seeking world has pondered and worried this last year until it

Christian boy Tommy Conlon is handed over to torturer Joe Bonomo by Clarence Burton, Nat Pendleton, and Ian Keith. "There is too much stress on agony," wrote an Indiana exhibitor. "Where they were torturing the boy, three women with children walked out." ◆ DeMille's gruesome re-creation of the arena games got past censors but not past exhibitors, many of whom cut these scenes.

has a permanent headache, so we avoid preaching, but the public likes a touch of the spiritual in times like these. *The Sign of the Cross* should be the answer."

Working at cross-purposes with management was a breathless publicist. "There are wild scenes in Nero's court," said Arch Reeve, "and the costumes spell sex. There's Claudette Colbert in a milk bath. And Fredric March using the sensuous dancer Joyzelle to break down the resistance of Elissa Landi—mentally, and how!"

"Charles Laughton asked DeMille if he was really strong for religious pictures," reported the *Los Angeles Times*. "DeMille went into a long rhapsody about the good they would do the people who saw them, the importance of spiritual uplift, etc. At the end of which Laughton commented whimsically and tersely, 'How cozy!'"

Neither Laughton nor Colbert took part in the orgy scene. In it, Marcus has failed to seduce the innocent Christian girl Mercia (Elissa Landi), so he asks Ancaria (Joyzelle Joyner), the "most wicked and, uh, *talented* woman in Rome," to perform a dance that will "warm her into life." As directed by DeMille and shot by Struss, the Dance of the Naked Moon was something that had never been done before, a narcotic ode to Sapphic sex.

DeMille was in the sands of the arena, filming assorted atrocities, when Roy Burns, his business manager, ran up to him. "We've just used up the budget," said Burns. "You haven't got a dime." DeMille stopped filming. He had managed to make his epic within budget. Next he had to get it past the Code.

Jason Joy was still at the SRC when *The Sign of the Cross* came up for approval, but James Wingate was

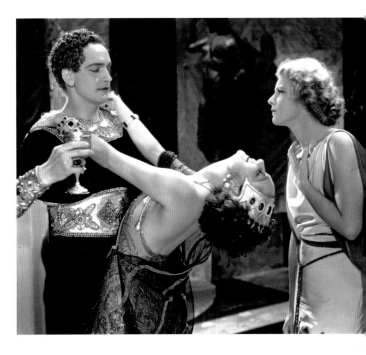

Elissa Landi is impervious to the sensuality emanating from Joyzelle Joyner and Fredric March.

there, too, newly installed. They screened the film and drafted a letter to Paramount. "Ordinarily we would have been concerned," said the letter, "about those portions of the dance sequence in which the Roman dancer executes the 'Kootch' Movement. But since the director obviously used the dancing to show the conflict between paganism and Christianity, we are agreed that there is justification for its use under the Code." This was not to be the last word on the subject.

The Sign of the Cross premiered at the Rialto Theatre in New York on November 30, 1932. It was apparent that DeMille had made a sound film that told its story in images, and that used both music and silence as effectively as dialogue. *Motion Picture Herald* ran a feature review by James O'Sullivan that analyzed the film's soundtrack and praised Rudolph Kopp's masterly score. The reviewer felt that DeMille

THE SIGN OF THE CROSS

had made the most totally integrated sound film yet. In the arena scene alone, he had mixed eleven tracks to achieve the depth he sought. If this film was the most aesthetically sophisticated of 1932, it was also the most provocative. Every review praised its epic vistas and the pathos of its martyrdom scenes. And every review criticized DeMille for including the most graphically violent and candidly sexual images ever committed to Hollywood gelatin.

"Mr. DeMille is in his happy hunting ground," wrote *Los Angeles Times* critic Edwin Schallert, "where color, blandishments of the flesh, and mad excesses of effect are virtually flung at the beholder. Maybe the religious-minded will be aghast at some of the frenzied revelry of an ancient licentious age, but against this is juxtaposed the victory of spirituality."

"Bige," the jaded *Variety* reviewer, was caught off guard by the arena scenes. "The attempts to horrify for theatrical effects and dramatic results are unprecedented on the screen. When it seems the limit in horror has been reached, on comes another exhibition of artistic and novel murder." Bige referred to the film's bisexual element as a "double action scenario, much of it being some of the boldest censor-bait ever attempted in a picture. Laughton manages to get over his queer character before his first appearance is a minute old."

The editor of the *Motion Picture Herald* was Terry Ramsaye, a former newsreel producer, and he felt that the standard review was insufficient coverage of *The Sign of the Cross*, so he wrote an editorial, saying that DeMille's combination of technical modernity and Victorian morality was being offered to a Depression audience that was "tired of sophistication, tired of too much authority that is not authority, tired of the

pursuit of riches that turn to ashes in the hand and in the bank alike, disappointed in all that has substance, and ready to turn to something of the spirit that holds promise." Having attended the premiere, though, Ramsaye evinced ambivalence about the great unwashed public. "They will shudder, they will gasp, they will cry, and they will love it—provided their sensibilities survive the odors of Lesbos and de Sade. It's that kind of picture, and they are that kind of people."

The Sign of the Cross was playing road-show engagements, complete with intermission music. The reviews had evidently not been frank enough. "At the Rialto, some women put their hands across their eyes to shut out the dreadful views; others fainted." Mordaunt Hall of the *New York Times* had something interesting to relate. "After the opening night, several scenes were deleted, including one in which an elephant is supposed to crush the skull of one poor fellow, but at least one flash remains of an Amazon beheading a dwarf and then impaling him on her spear."

Ramsaye wrote a follow-up article. "Enough scenes were left in to cause some women to become sick in the stomach. A flash picturing a next-to-nude Christian virgin lashed to a post to await the onslaught of a giant ape and a herd of hungry crocodiles waddling to an arena feast of edible, white-fleshed Christian girls disappeared from the picture after early runs at the Rialto. Before Harold Franklin opened the picture at the Music Hall, he cut almost every one of these scenes out, leaving only enough of them to suggest the cruelty of the Romans."

While conceding that *The Sign of the Cross* conveyed a message of faith, Catholic publications, including *Our Sunday Visitor*, *Commonweal*, and

DeMille instructed his writers to tell a story with images, not with words.

America, were outraged by Ancaria's dance. Daniel Lord told DeMille that it smacked of "sex perversion." Martin Quigley wrote: "The scene transgresses the limits of legitimate dramatic requirements and becomes an incident liable to an evil audience effect." Writing in *America*, Father Gerard B. Donnelly, SJ, declared: "The dance is explicitly aphrodisiac, and its deliberately erotic effect upon the spectators is shown in two or three camera shots that in context become the most unpleasant bits of footage ever passed by the Hollywood censors. And, incredibly, this dance is not only lascivious but also clearly suggestive of perversion."

DeMille had not expected this response from the usually well-disposed Catholic press. When Protestant and Jewish leaders also voiced disapproval, he asked Paramount: "Are there many people who will stay away from a theater today because of a sensational dance?" Before he got an answer, Will Hays called him. "I am with Martin Quigley," said Hays. "What are you going to do about that dance?"

"Will, listen carefully to my words, because you may want to quote them. Not a damn thing."

"Not a damn thing?"

"Not a damn thing."

Paramount shipped *The Sign of the Cross* to the censor boards. The few boards who made cuts concentrated on milk, gorillas, and crocodiles.

The film was rushed to smaller theaters to capitalize on the press, and regional exhibitors reported a range of audience reactions. "It is massive, gigantic, spectacular, awe inspiring, etc.," wrote Detroit.

"Business on this was very good." Texas wrote: "To my mind, DeMille's greatest, but advance word of mouth of the horrors of the arena scenes kept business below what it deserved. Many of our regulars refused to take a chance." Wisconsin wrote: "Wonderful from an artist's standpoint. Walkouts during gruesome scenes." Nebraska wrote: "The church going said it was too gruesome, and none of the ministers came to see it." Illinois wrote: "Brought out an element of churchgoers who seldom come, and they liked it." Kentucky wrote: "Drew better than we expected, a picture that people told their friends not to miss. Thank you, Mr. DeMille, for giving us something really worth showing."

Not one censor board cut the dance. Not one exhibitor mentioned it. *Harrison's Reports*, a conservative trade paper, was philosophical. "The average adult will not understand that it is a Lesbian dance,

and hardly any adolescent will know what is happening." Just plain folks may not have known what was happening, but Midwest Catholics knew impure love when they saw it. Hollywood had defiled their mythology of Christians versus lions, and they would not soon forget.

In spite of the Depression, or perhaps because of it, *The Sign of the Cross* was a major urban hit. To see Rome in soft focus, city patrons offered theaters handwritten IOUs. "Nearly every one of them was redeemed when cash began to flow again," wrote DeMille.

Behind the triumphant trumpets, there were ominous notes. The *Southern Messenger*, a Catholic magazine, urged an unprecedented measure: "The way of safety lies in putting *The Sign of the Cross* on a list of pictures which Catholics should avoid." Daniel Lord had his own magazine, the *Queen's Work*, and this got him thinking. Then he received a call. "An executive of the company told me that the picture was taking a large financial loss. Could I do anything to get young people to change their attitude about it? I answered that I was largely responsible for their attitude—and I hoped it would continue!"

THIS PAGE: Cecil B. DeMille used a whistle to direct a street fight in *The Sign of the Cross*.

OPPOSITE: Claudette Colbert was yet another player who became a star in the pre-Code era.

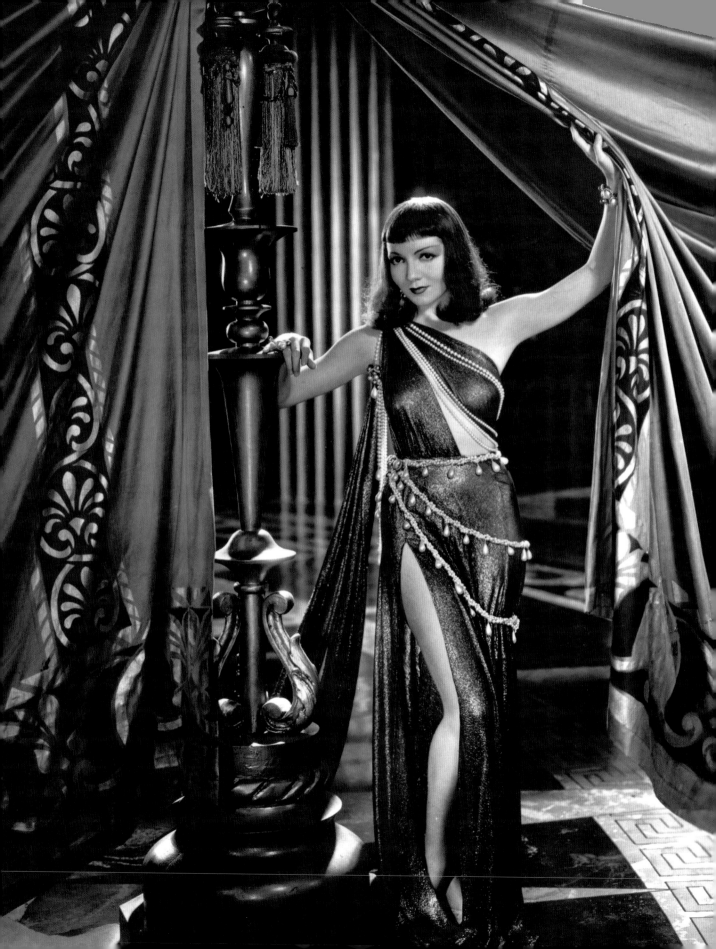

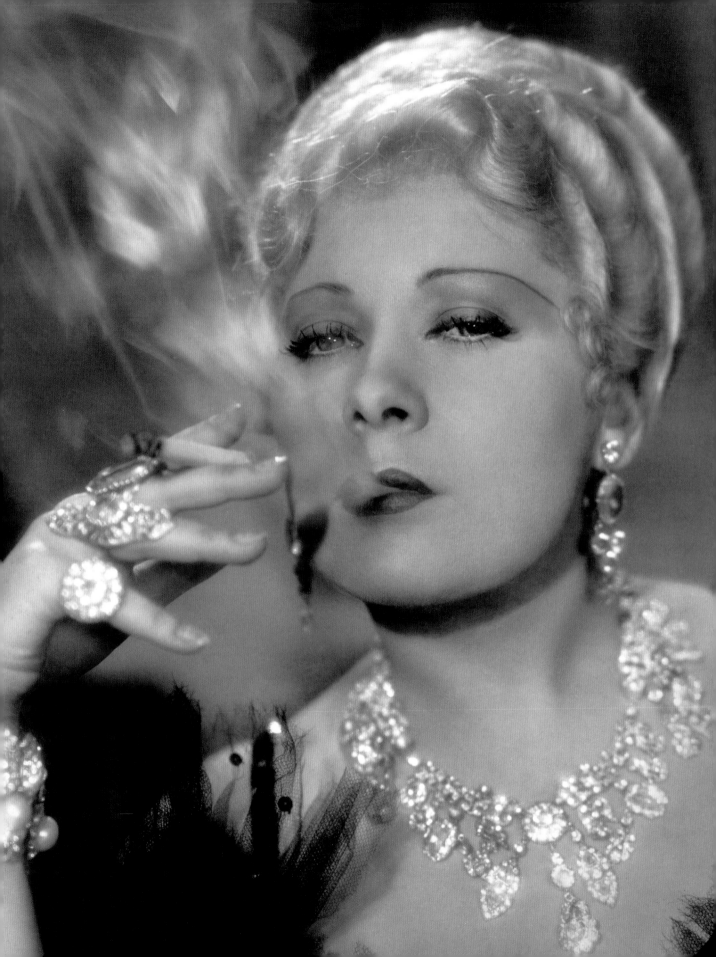

PART

———

1933

———

FIVE

SHE DONE HIM WRONG

Paramount held on through the grim Christmas of 1932 and into the anxious January of 1933. Although the company was functioning with grosses from *Horse Feathers*, *Blonde Venus*, *A Farewell to Arms*, and *The Sign of the Cross*, it reported a deficit of $15,857,544. On February 4, 1933, Paramount went into receivership. Six weeks later, it declared bankruptcy. Watching with no little interest was a plump thirty-nine-year-old from Brooklyn. Years later, Mae West recalled the Hollywood of 1933. "It was a world that came awake with an economic hangover, and instead of being thankful it was being saved, it tried to assault its rescue teams." Before the year was over, she would be credited with saving Paramount Pictures—and denounced as an evil influence.

Mae West had come to Hollywood in June 1932 at the invitation of Paramount producer William LeBaron. George Raft, a mutual friend from Broadway, was making his first starring vehicle, *Night after Night*, and wanted West for a supporting role. After waiting eight weeks for a script, she was let down. "My part was very unimportant and banal," she wrote. "The dialogue did nothing for me." LeBaron told her she could rewrite her lines, but Archie Mayo, the director,

tried to keep her from delivering her lines as she had written them. She resisted, argued, and got her way. "I was firm," she said, "as I always am when I believe I'm right."

"Mae West saved this picture from being mediocre," wrote an exhibitor. "Make no mistake. This Mae West is going places. She has a definite 'It' that is not seen on the screen in any other actress." Suddenly everyone remembered the playwright—and star—of the 1928 sensation *Diamond Lil*. Paramount had bought it, even though it was on the Will Hays "banned" list; its libidinous heroine made Catherine the Great look prim. In mid-October 1932, Paramount hired *Public Enemy*'s John Bright and Harvey Thew to adapt the play with West. The clever, accomplished Lowell Sherman would direct.

On October 19, Harry Warner telegraphed Hays: "Please wire immediately whether I can believe my ears that Paramount has arranged to make *Diamond Lil*. Recollect that it was absolutely not to be produced." The implication was that if Paramount could film a banned play, so could he. Hays assured Warner that there was no danger of Paramount violating the MPPDA agreement on banned titles. Yet the working

CLOCKWISE FROM TOP: Seated at the rehearsal table for *She Done Him Wrong* are (from left) Mae West, editor Alexander Hall, director Lowell Sherman, and associate producer William LeBaron. Standing are (from left) Noah Beery, Cary Grant, Owen Moore, and assistant director James Dugan. Photograph by Don English. ◆ "Always remember to smile," Mae West tells Rochelle Hudson.

"And you'll never have anything to worry about." ◆ Mae West's fascination with the 1890s flavored *She Done Him Wrong*. "I was always fascinated with the old photographs of that era," said West. "None of your boyish-figure stuff for them. They were all woman—busts, hips, hair, jewels, clothes."

titles announced in *Variety* for the Mae West project included *Diamond Lady* and *Queen of Diamonds*. On November 1, as Jason Joy was starting his new job at Fox Film, the *Los Angeles Times*'s Edwin Schallert wrote: "Of all the improvements in titles I have noted, the changing of *Diamond Lil* to *Honky Tonk* strikes me as the most momentous. And was this done at the behest of the Hays Office?"

James Wingate was not qualified to cope with this bombshell, so Hays wrote to Adolph Zukor: "By all means this ought to be stopped, as it is a direct violation by Paramount of its most solemn agreement." Next, the SRC's John Wilson wrote to supervisor Harold Hurley, "There is no objection to Mae West writing any story she wants, but they must stay away from the basic plot of *Diamond Lil*." By mid-November the title had been changed to *Ruby Red*. Filming commenced on November 23, 1932. On November 28, Hays called an emergency meeting in New York. Emanuel Cohen changed the title to *She Done Him Wrong* and pledged not to mention *Diamond Lil* in ads. He was told that Lowell Sherman could resume filming. He had never stopped.

"I am assuming that in making a picture of such a period," Wingate wrote to Hurley on November 29, "you will invest the picture with such exaggerated qualities as automatically will take care of possible offensiveness." All of West's Broadway shows were played for laughs; this had not saved them from being closed by the police. In 1927 West had served ten

OPPOSITE: The actual line of dialogue was: "Why doncha come up some time and see me?" It was quickly misquoted as "Come up and see me sometime." Mae West let it stand, and it became her catchphrase.

Russian Rita (Rafaela Ottiano) is jealous of the attention her kept man is paying to Lady Lou (Mae West).

days in jail for writing and appearing in a "wicked, lewd, scandalous, bawdy, obscene, indecent, infamous, immoral, and impure" play called *Sex*.

"Sure, I've been called rough," West told the *Los Angeles Times*. "But I get 'em into theaters, and from all classes, upper to lower. There isn't any woman in pictures doin' just exactly what I do. I got my own style. I give 'em the physical stuff. I guess you'd say I had an animal personality. Somethin' that's right out there. It appeals to the primitive in men. Somethin' that makes 'em want to love you. See? That's what they want. All my acting has got it, in my plays and my pictures."

It was obvious to everyone at Paramount that someone special had arrived. "Mae West would come out of her dressing room," recalled actress Frances Dee, "and all the other dressing-room doors would

open, just a little. Everyone wanted to see her. They just wanted to watch her walk as she went from her dressing room to the soundstage. That was the power of Mae West."

In mid-December *Variety* blew the whistle. "It is no secret around the Paramount headquarters that *She Done Him Wrong* is just another title for *Diamond Lil*." Wingate nervously wrote Hays: "I have advised Mr. Sherman that the whole picture be directed with emphasis on the comedy values so as to remove it from any feeling of sordid realism." Wingate had a tenuous grasp of the situation. A tightly scripted film could not be bent in one direction or another, and Sherman was known for sex comedies, not kiddie shows. The story was set in the 1890s because period gowns were becoming to West, not because the period was harmless; the Bowery setting was merely a backdrop for her sexy exploits.

She Done Him Wrong was previewed for the *Motion Picture Herald* in mid-January. "It is nothing more or less than *Diamond Lil*," wrote Leo Meehan. "If you happen to exhibit it in censors' areas, it is difficult to say what you are going to have left to show when the censors are through with it." He was more sanguine about the star. "Mae West is quite as spectacular on the screen as she is behind the footlights. She is an extraordinarily vivid personality."

From the moment Mae West swaggered across the screen, viewers knew they were in the presence of a master—a master of exaggeration, innuendo, and humor. The ribaldry she had flashed in *Night after Night* shone full force in *She Done Him Wrong*, the story of Lady Lou, a Gay Nineties saloon singer. "Always remember to smile," says Lou. "You'll never have anything to worry about." Lou is always smiling, and with good reason; admirers adorn her with diamonds, the true love of her life.

For three years the screen had been dominated by languid stars like Garbo and Dietrich. Garbo thrilled her fans by reacting to situations; she rarely initiated them. "The drama comes in how she rides them out," said Irving Thalberg. Dietrich was a stoic siren, sacrificing herself for an ideal love. Mae West was different. She wrote her stories, and in them she ran the show. "She was the strong, confident woman, always in command," said Adolph Zukor. "And that was the real Mae." In *She Done Him Wrong*, Lady Lou says: "Men's all alike, married or single. It's their game. I just happen to be smart enough to play it their way." She plays it with sex, but tempers it with humor, striding through every scene with a rhythmic gait, bursting out of a wardrobe so tight that she never sits, tossing one-liners with ingratiating aplomb.

"There was a time when I didn't know where my next husband was comin' from."

"Why, a boy with a gift like that oughta be workin' at it."

"When women go wrong, men go *right after them*."

There was, of course, the line that became a catchphrase, the endlessly quoted (and misquoted) "Why doncha come up sometime an' see me?" Two other lines were almost cut: "Say, you can be had," and "Hands ain't everything." James Wingate tried to delete them from prints after the initial release, but he only succeeded in cutting two verses from the song "A Guy What Takes His Time," including the lines: "A hurry-up affair I always give the air. / A hasty job really spoils a master's touch." What remained was enough.

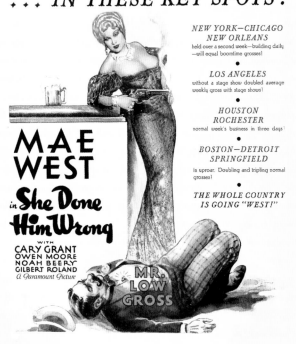

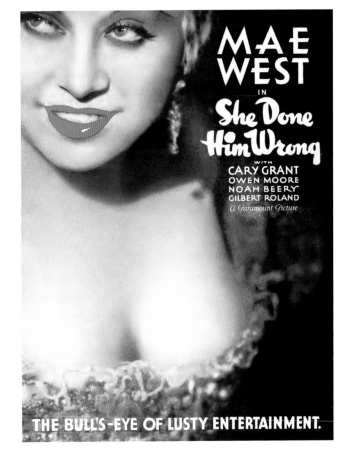

CLOCKWISE, FROM TOP LEFT: Mae West sings "I Wonder Where My Easy Rider's Gone." ➤ For once, the trade ads were not exaggerating. *She Done Him Wrong* was phenomenally successful.

"I went last night to see the Mae West picture," Fox's Sid Kent wrote Hays. "The time has arrived to stop talking and do something. *She Done Him Wrong* is the worst picture I have seen. I believe it is worse than *Red-Headed Woman* from the standpoint of the industry. It is far more suggestive in word, and what is not said is suggested in action. I cannot understand how your people on the Coast could let this get by. They promised that that story would not be made." Wingate sheepishly agreed: "We are not sure that this type of picture will do the industry any good."

She Done Him Wrong was released on January 27, 1933. "The statuesque Mae West is appearing in a pictorial sketch of the '90s," wrote Mordaunt Hall in the *New York Times*. "Miss West never raises her voice, never overdoes her peculiar walk, and her eyebrow lifting is unusually effective. Every time she struts across a room, the audience laughs at her individual swagger." Indeed, the film encouraged audience comment. "While I was gazing upon Mae's buxom curves," wrote Anita Cahoon of Huntington Park, California, "some woman sitting in back of me said, 'Why that's positively indecent!' I turned around and gave her the meanest look I could muster. My granddaddy said that scenes like those were absolutely true to life, and I guess he should know."

"Folks in the sticks," wrote *Variety*, "seeing Mae West for the first time in this flicker are likely to inquire as to what reform school Mae was brought up in. They may not know her from Joan of Arc, or the 1928 legit show, but they're seeing *Diamond Lil*. Deletions from its original form are few, with only the roughest of the rough stuff out. White slavery angle is thinly disguised, but don't tell Will Hays." Elizabeth Yeaman of the *Hollywood Citizen-News* described the film as "the most flagrant and utterly abandoned morsel of sin ever attempted on the screen, and I must confess that I enjoyed it enormously." Best of all was the item in the *Los Angeles Review*: "*She Done Him Wrong* has turned into a golden gusher for Paramount. Exhibitors can't pry it loose from their screens."

The exhibitor letters told the tale. From Robinson, Illinois: "Plenty ruff, but they liked it, with no howls from the bluenoses." From Morris, Illinois: "This was a smash hit in the cities, but only average in the tank towns. No wonder the producers have so many headaches trying to please the great majority. I personally enjoyed the flameproof West very much." From Winchester, Indiana: "We wished for pictures that are different, and Mae West came right out and gave us a different picture, and it proves to be a knockout." The rural response was unexpected. "I was doubtful about the small towns," said West. "But say, the small towns are just as fed up with hypocrisy as the rest of us—they're normal, all right."

She Done Him Wrong made $2 million in less than two months. With *A Farewell to Arms*, *The Sign of the Cross*, and now *She Done Him Wrong*, Paramount was out of the quicksand, but not out of the woods. Neither was Hollywood.

"SUCH THINGS ARE NOT FOR AMERICA"

The first week of March 1933 was the worst in memory. Two thousand studio employees were out of work. Franklin D. Roosevelt took office and discovered that banks were shipping gold out of the country. With economic collapse imminent, he declared March 6 a bank holiday. On Friday, March 10, as the moguls made speeches about salary cuts, nature provided an exclamation point: the Long Beach earthquake.

On Monday, March 13, the studios shut down until 50 percent cuts were agreed upon. The next morning, in studio after studio, the moguls broke the news. At M-G-M, Louis B. Mayer was unshaven and weeping. At Warner Bros., Darryl Zanuck promised to restore salaries within a month. "That night I went to the Brown Derby," recalled actress Aline MacMahon. "Waiters were carrying large bowls of caviar behind a screen. And behind the screen were the Warner families, celebrating. It was a great break for them." The crisis, however, was real; the bank holiday cost the studios $14 million. They had only enough finished films to last two weeks.

As if this were not enough, Will Hays was on a rampage. Worried by a rash of bad publicity, he made the MPPDA directors sign a document in which they promised to abide by the Code, and he then went to Hollywood. "There is no use referring to *She Done Him Wrong*," he told a group of executives, "and saying, 'See, look what *they* got away with! We can do the same!'" He warned them that this document was all that stood between them and federal censorship. But films had to

Diana Wynyard and John Barrymore scintillate in Sidney Franklin's *Reunion in Vienna*. Like *The Guardsman*, this film lets the audience decide if an adulterous affair occurred after the fade-out. Portrait by Clarence Bull.

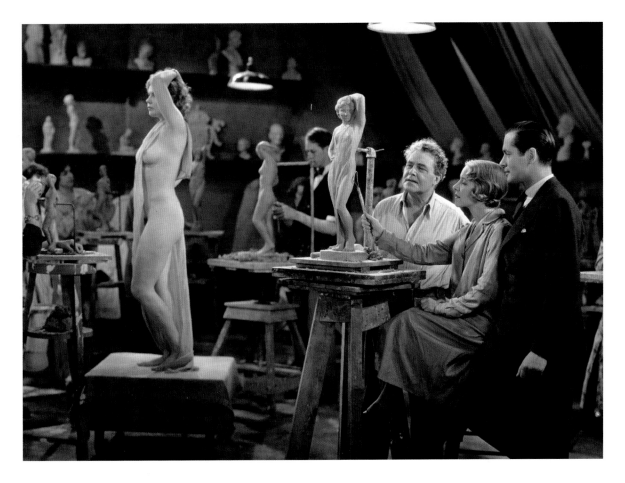

be made, and federal censorship was a distant threat,
about as likely as a boycott by Roman Catholics. All
that really stood between the producers and racier
movies was a nervous censor.

James Wingate had been a school administra-
tor since 1900, but not even the New York school
system could prepare him for the Studio Relations
Committee. He was sadly miscast. Morris L. Ernst
and Pare Lorentz described him: "Wingate has
the characteristics of his profession. Middle-aged,
slightly pompous yet evasive, and given to long-winded
and meaningless speeches. His spectacles and severe
garb give him the appearance of a clergyman or a
YMCA organizer."

Wingate tried to standardize SRC procedures as
if he were in a classroom. Producers were used to Joy's
thoughtful approach, but Wingate was pedantic, and
he labored over scripts. "Your reports are coming in
so slowly," Darryl Zanuck wrote him, "that very often
half of the picture is finished photographing when we
get it. Please give us as quick action as you possibly
can." Wingate's assistant, Geoffrey Shurlock, recalled:
"Wingate couldn't explain what needed to be done in a

"SUCH THINGS ARE NOT FOR AMERICA"

given script to make it acceptable to the Code. He was quite simple-minded and logical about things, really quite square, and he didn't get on very well with these emotional Jewish producers. They had wild ideas about doing it their way. He'd say, 'No, no! Cut it out!' And what they wanted was not to cut it out but to do it differently." Unable to justify major cuts, Wingate had passed *The Sign of the Cross*. Worse, he had let *Diamond Lil* slide through. And no one would let him forget it.

Mary Pickford was more than "America's Sweetheart." She had been Hollywood's uncrowned queen for two decades. Who could forget *Pollyanna* or *Sparrows*? She and Douglas Fairbanks were film-dom's first couple. As astute in her business dealings as she was in her filmmaking, she was one of the founding partners of United Artists. Terry Ramsaye of the *Motion Picture Herald* interviewed her at the Sherry-Netherlands in New York, where she was promoting her latest film, *Secrets*. The conversation turned to current film fare.

"The other morning I passed the door of my young niece's room," said Pickford. "Gwynne, she's only about seventeen and has been raised, oh, so carefully. I heard her singing bits from that song from *Diamond Lil*. I say, 'that song,' just because I'd blush to quote the title line even here." Since Pickford was actually referring to *She Done Him Wrong*, the song in question could have been "Easy Rider," "A Guy What Takes His Time," or "Frankie and Johnny." Pickford was perturbed. "Now what do you suppose I think about a production policy that puts on the screen things that can invade the

Jean Harlow in *Hold Your Man*.

home—things like the lyrics of *Diamond Lil*? Such things are not for America." Pickford wanted to make sure she was understood. "I am talking about America, not New York. New York is a country, a nation unto itself. And so is Hollywood. *America* is that great big land in between those two countries—and *America* is where the customers are."

Shrewd executive that she was, Pickford grasped one of the basic problems of the business: the film companies didn't know their market. *Variety* wrote: "Circuit managers, house managers, independent exhibitors, and others in the tall grass agree that what is needed is a better understanding between the sticks, New York, and Hollywood. There is probably no one combination that will produce a picture that's okay in New York, okay in Birmingham, and okay in Kansas

"SUCH THINGS ARE NOT FOR AMERICA"

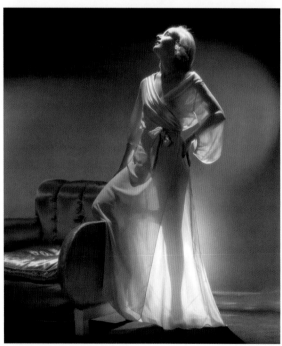

A portrait of Carole Lombard by Eugene Robert Richee.
◆ Loretta Young in William Wellman's *Midnight Mary*.
Portrait by Clarence Bull.

City. Boiled down to a pint of pure water, the sticks don't want sophisticated pix." William Fox had grown rich making homespun fables for the breadbasket of the country. But this was the conventional wisdom. *Variety* heard otherwise.

"The subjects that click," reported an Alabama exhibitor, "are sports, aviation, war, slapstick humor, and sex. The more vivid the sex, the more business it gets, providing that it escapes the blue noses and censors. The preachers are the biggest enemies of the pictures. If a real sexy picture isn't banned, the preachers ring the clappers off the bell of the mayor's phone. But where a sexy picture does get by and word gets around that it is sexy, then the young couples fly to the box office." Needless to say, studio executives read *Variety*.

At M-G-M, Louis B. Mayer took advantage of Irving Thalberg's absence to remove him from his post and make him one of a group of "independent producers" on the lot. Thalberg's recuperation stretched to nine months, and without him to guide them, the newly elevated producers turned to unconventional sexuality. Screenwriter Donald Ogden Stewart played a game with the SRC: "You would learn to put in incidents or bits of dialogue that the censors could take out to satisfy the Hays Office. And you'd get away with murder with what they left in." When Thalberg returned to M-G-M in August 1933, he was disappointed by the new crop of films, most of which had gratuitous sex. After a preview of one such film, a new producer crowed: "It's a smash!"

"Yes," said Thalberg coldly. "A few more like it and we'll smash the company!"

Perversion was the order of the day. In *Midnight Mary*, gangster's moll Loretta Young whispers in

Ricardo Cortez's ear what she will do with him when they are alone. "I didn't know she was living with that man," recalled Loretta Young. "I remember thinking, 'Why does he have to slap me?' And Bill Wellman said, 'Because you're his girl.' And I said, 'He doesn't have to slap me.' Poor Bill kept saying to me, 'Loretta, you're *his* girl.' But I didn't know what he was talking about. If I had, I think I would have put it out of my mind." Whether Young could or would understand the relationship, it was sadomasochistic, as was the "romance" shown in *The Barbarian*, where Myrna Loy and Ramon Novarro enjoy slapping, whipping, and kidnapping. This abuse is supposedly excused by the revelation that Loy is half Arab.

Perversion was not limited to M-G-M. The most offbeat project at offbeat Fox was Erich von Stroheim's *Walking Down Broadway*. Stroheim's filmmaking methods were extravagant even by filmdom standards, and he had been barred from directing since he lost control of both story and budget on *Queen Kelly* in 1928. Winfield Sheehan thought a small film would rehabilitate Stroheim, but according to screenwriter Leonard Spigelgass, Stroheim was "chiefly interested in the neuroses" of lower-class New Yorkers, and "turned these simple American characters into far more complicated ones, Vienna-oriented."

Jason Joy drew on his Montana youth when he reviewed the script: "Stroheim kicked like a steer about seeing us, but I was very much pleased yesterday to hear that he thinks we aren't so bad. This man has always been a hard one to handle." Stroheim's actors would agree. When Boots Mallory could not cry after working for more than twenty hours, Stroheim slapped her. "Terrance Ray was supposed to laugh, and

he couldn't," recalled cameraman Charles van Enger. "And Stroheim had a guy tie a string around the end of his pecker, so when Stroheim wanted him to laugh, he would pull this string, saying, 'Reaction! Reaction!' And that made the guy laugh." Just as he had in his silent films, Stroheim sought grotesque realism. "In directing the love scenes," wrote historian Richard Koszarski, "Stroheim instructed the couple to visit the lavatories prior to each take and masturbate almost to the point of completion."

Hollywood could not tolerate Stroheim for long. When Sheehan previewed *Walking Down Broadway*, he decided it was too twisted even for Fox Film. He fired Stroheim and reshot almost the entire film, releasing it as a shambles called *Hello, Sister!*

RKO Radio Pictures was in receivership, too, but it saved its hide with the strangest love story of all. *King Kong* was the saga of a super-simian and his love object, Fay Wray. "Working with Kong was quite an experience," Wray told *Photoplay*. "It was something new in the way of screen lovers!"

Tonight Is Ours was adapted from Noël Coward's *The Queen Was in the Parlour*, and its perversion took place in a Ruritanian flashback. Claudette Colbert marries the King of Kroya, only to discover that he is a bit kinky. "You pretend that you're my slave," he tells her. "And I'll chase you around the room! And then!" *Girl without a Room* featured a dance by the notorious Joyzelle. In it, she wears nothing but a coat of metallic body paint. Its setting is a Paris bistro, but it could be any dive in the "twilight world" of Manhattan. Denizens of that world were turning up more and more in Hollywood films.

SO THIS IS AFRICA

In early 1933 the *Hollywood Reporter* was one of several trade journals reporting on the sudden prevalence of "lavender men" and "mannish" women on the screen. "Take a look at the pictures produced recently," a screenwriter was anonymously quoted. "There is *Sailor's Luck*, with pansies all through it. There is the Lesbian dance in *The Sign of the Cross*. There were the dance instructor in *Our Betters* and the nance cook in *Hell's Highway*. There are innumerable examples and they are increasing." This was true. *Call Her Savage* had a scene where Clara Bow goes slumming in Greenwich Village. The restaurant she visits has a floor show of two young men dressed as chambermaids, singing these lyrics:

> If a sailor in pajamas I should see
> I'm sure 'twould scare the life out of me!
> But on a great big battleship we'd like to be
> Working as chambermaids!

In his 1995 book *Gay New York*, historian George Chauncey describes the "pansy craze" that swept New York in the early 1930s. Coming as it did on the heels of the so-called "Negro craze," it captured the attention of novelists such as Tiffany Thayer and Carl Van Vechten, and then of Hollywood. Flouting Article II, Section 4 of the Code, screenwriters began to insinuate "sex perversion" into their work. They began with the "nance comedy" of Grady Sutton, Ferdinand Gottschalk, and Franklin Pangborn. In Paramount's

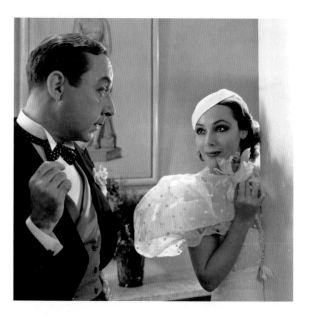

THIS PAGE: In *Flying Down to Rio*, Franklin Pangborn finds Dolores Del Rio beautiful but not desirable.

OPPOSITE: The title says it all for Elissa Landi and Ernest Truex in *The Warrior's Husband*, a Walter Lang production for Fox Film.

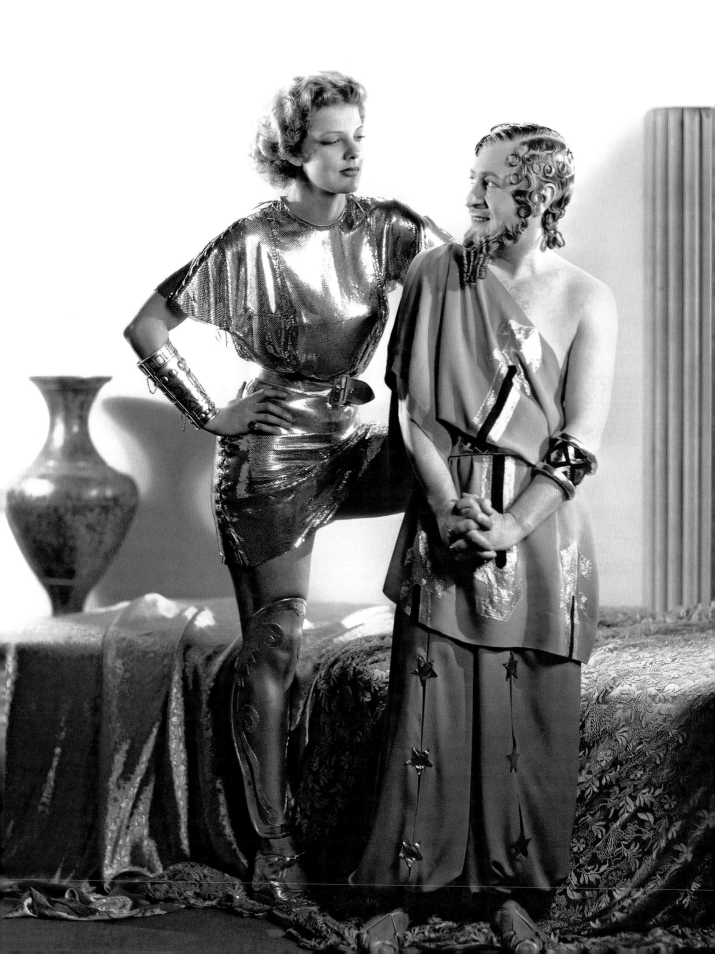

Hot Saturday, Sutton plays a bank teller whom any girl can safely date because he is *so* harmless. In *Female*, Gottschalk plays a wicked, mocking little man who can say with prissy insolence: "The dominant *male*, my dear." In Paramount's *International House*, Franklin Pangborn plays a hotel manager who has nerves of steel, provided he gets his cup of tea.

In 1933, the studios turned a corner, transforming caricatures into characters. In Warners' *42nd Street*, the show's director is conspicuously unmarried and invites one of his assistants to visit him because he is lonely. In *Footlight Parade*, Francis (Frank McHugh) asks Kent (James Cagney) to audition a special friend: "I simply had to tell you. This boy, Scott Blair. He's a discovery. Just loads of talent and personality."

"He sounds fascinating," replies Kent. "Bring him up some time. Maybe the three of us could knit some doilies." Wingate wrote Warner: "You should be very careful to avoid characterizing Francis as a 'pansy.' It seems to us that it is all right to show him as being rather fluttery and temperamental, but the various remarks made about him by Kent are likely to over-emphasize the characterization."

Universal's *Only Yesterday* has Franklin Pangborn as a vivid but respectable interior designer who brings a handsome young man (Barry Norton) to a party at a penthouse he has decorated, on the way admiring a painting in a shop window: "Look! That heavenly blue against that mauve curtain. Doesn't it *excite* you? You know, blue like that does something to me!"

The Fox Film Corporation had the distinction of being the first studio to use the word *gay* to denote homosexuality in a film. In *My Weakness*, Charles Butterworth and Sid Silvers are both hopelessly in love with Lilian Harvey. Butterworth suggests a solution: "Let's be gay!" The SRC mandated that the line be muffled in the soundtrack of all release prints. At the same studio, *Sailor's Luck* included a splashily effeminate swimming pool attendant (Frank Atkinson). Sailor Jimmy (James Dunn) spies him and says to his pals: "Et-gay the ansy-pay!" The attendant waves at them: "Bye, sailors!" *The Warrior's Husband* went further. It told the story of Pontus, an ancient country where women are warlike, and men are sylphlike, raised only to procreate. *The Warrior's Husband* used role reversal to get its pansy past the SRC, but films showing lesbians were more direct.

At Warner Bros., *Ladies They Talk About* put Barbara Stanwyck in prison. In a neighboring cell is a beefy gal who delights her cellmate with the size of her biceps. "You're just always exercising!" coos the cellmate. In UA's *Blood Money*, a tough nightclub owner named Ruby (Judith Anderson) advises her brother, Drury (Chick Chandler), against going out with trashy women; he defends his new girlfriend. "This one is nothing but class," says Drury. "Wears a monocle and a man's tuxedo."

"Then you're safe," laughs Ruby.

"That's just where you're wrong. She dresses that way for laughs. Got a great sense of humor." The girlfriend, played by Kathlyn Williams, is waiting at the bar, and, when a woman sits down next to her, she looks her up and down.

As the year wore on, this type of scene became more prevalent. Fox's *Cavalcade* had a "vice orgy" montage where the camera tracks across the floor of an Art Deco London flat, showing young women in bias-cut satin gowns and young men in full dress suits. However, the couples consist of one brassy woman wooing another, and one willowy young man affixing a slave bracelet to the wrist of another. Martin Quigley wrote to Will Hays: "It may be noted that the angle of perverted sex has crept so broadly into several items of recent product that it will be fortunate indeed if it escapes notice in the newspapers." It did not. "Producers are going heavy on the panz stuff in current pix," *Variety* reported, "despite the watchful eye of the Hays office, which is attempting to keep the dual-sex boys and lesbos out of films. With a queer flash in *Cavalcade*, the attitude is that if a picture of that type can get away with it, why not in the programmers?"

What concerned Hollywood's critics was how matter-of-factly it presented homosexual characters. In Preston Sturges's script for *The Power and the Glory*, a railroad magnate (Spencer Tracy) endures for years the unspoken love of his best friend (Ralph Morgan). The script got resistance from both the Hays Office and Fox Film. "If there is in this story a sex relationship such as Mr. Hays mentions, it will have to come out," wrote Sidney Kent to Winfield Sheehan. "I think the quicker we get away from degenerates and fairies in our stories, the better off we are going to be, and I do not want any of them in Fox pictures." Nevertheless, Fox Film was the only studio besides M-G-M that showed a profit in 1933; the queer folk remained.

The most tasteless transgressor of 1933 was a low-budget, low-profile, lowbrow comedy called *So This Is Africa*. It came into being because its stars, Bert Wheeler and Robert Woolsey, felt underpaid by RKO Radio. Promised more money and more freedom, they moved to Columbia Pictures, where they worked with writer Norman Krasna to concoct a super-spoof of the jungle cycle, spraying disrespect on *Trader Horn*, *Tarzan the Ape Man*, and on the documentary film-makers Martin and Osa Johnson.

Columbia had a fairly clean record in the SRC files, so the National Board of Review and the New York State Censor Board were shocked that Columbia would make such a mud bath of vulgarity. While rattling off one-liners of stupefying crudeness, Wheeler and Woolsey dally with: (1) a buxom explorer named Mrs. Johnson-Martini; (2) a female Tarzan; and (3) a gorilla of indeterminate gender. They are kidnapped by a tribe of Amazons, which is suddenly overrun by lustful cannibals. Wheeler and Woolsey are then forced into a marriage ceremony with the cannibals. Fade out.

Fade in. A year later, Wheeler and Woolsey emerge from a hut dressed as native housewives—complete with infants on their backs, discussing the most effective brand of laundry detergent. This utterly bizarre transition is revealed as yet another gag—their native wives emerge from the hut and remove the babies. For a shocked moment, though, the viewer is forced to wonder if a fade-out has imposed on Wheeler and Woolsey some unknown permutation of orientation, gender, or sanity.

OPPOSITE: Mrs. Johnson-Martini (Esther Muir) romances Robert Woolsey in Edward Cline's *So This Is Africa*. ◆ In *Blood Money*, "The Mannish Woman" (Kathlyn Williams) is more interested in the unbilled blonde at right than in George Bancroft.

"This is an amusing burlesque," wrote James Wingate. "It has been handled, we believe, in such a way as to cause little or no anticipation of censorship difficulties." The board was not amused. "Nothing as salacious has ever come before the National Board in eight years of reviewing. This outrages every common standard of decency. It is a salacious burlesque with absolutely nothing to recommend it. The Board would harm itself if it were to pass such a picture."

So This Is Africa nearly cost Wingate his job. As it transpired, prints had been shipped to theaters—just as Nebraska was embroiled in a censorship debate. "A bill is pending in Nebraska to establish a State Board of Censors," Carl Pettijohn wrote the SRC on February 20. "Our representative, Arthur Mullin Jr., told me today that if *So This Is Africa* is released in its present form, nothing can stop the censorship bill from passing. He says it is the rawest picture he has ever seen. He asks the company not to release it while the Nebraska legislature is in session." Fortunately for Wingate, not to mention Nebraska, the escaped prints were found and retrieved.

So This Is Africa was hastily recut, without benefit of sound remixing, and all previously struck prints were destroyed. More than twenty negative cuts were made, some of them running over a minute in length. Columbia still expected trouble with the version that was shipped. It might be a complete loss, savaged by word of mouth. The company shipped it, and executives waited anxiously.

Word came from an exhibitor in Selma, Louisiana: "The papers had several accounts of an exhibitor being in jail in Mississippi for having shown this. I held my breath on the first showing. I've never heard such roars of laughter, and never have I known of as much mouth-to-mouth advertising." Mason, Michigan wrote: "I played it to adults only (over fifteen years old). Kids who have been twelve for the last ten years aged rapidly on their way to our box office." From Robinson, Illinois: "It drew well on the first day of our nationwide bank moratorium, and they seemed to laugh aplenty, so Will Hays can close one eye."

Of course, there were the inevitable complaints. "Where are we headed?" wrote Harrisburg, Illinois. "If pictures like this and *She Done Him Wrong* are what small town exhibitors are to offer their patrons, we will have federal censorship and even the mighty Hays office will not be able to block it."

THE WARNER BROS. FLASH

n early 1933, there were two schools of thought. One said that poor box office was caused by the Depression. The other held that poor box office was caused by sexy pictures. "Off-color productions have probably hung up box office in many places," wrote a Colorado exhibitor in a trade editorial. "They are killing the steady, dependable family trade. How can we build a lasting business if we show stuff that appeals to the baser instincts of mankind, to the animal side of his nature?"

To appease both exhibitors and Will Hays, the studios offered uplifting films: *Alice in Wonderland*, *Little Women*, *State Fair*, and *Pilgrimage*. The so-called "clean pictures" were well received, but there were too few of them, and "dirty pictures" still had a following. What was really "dirty"?

Community standards varied so much between regions that harmless elements could become bones of contention. For example, dialogue that included the line "I'm going to have a baby" had become an issue. For years, films had suggested this plot development by having one woman whisper into the ear of another, but some audiences snickered at this, so studios had begun using the actual words. "There must be

Dance director Busby Berkeley and chorus girls.

a sweeter phrase for motherhood in pictures," wrote B. P. McCormick of Canon City, Colorado. "Don't say a mother is 'having a baby.' Let's get above the level of the cow having a calf. Motherhood is worthy of a sweeter expression."

There were also variations of a community standard *within* the community. Rural audiences tended to cold-shoulder films with theatrical pedigrees like

When the censor-bashing *Footlight Parade* grossed $1.75 million, it was obvious that Hollywood spoke only one language: box office.

Reunion in Vienna—unless an envied neighbor was attending. "John Barrymore is a losing proposition for me," wrote a Pennsylvania showman, "but the 'better class of people' invariably attend, and this is wonderful advertising to the masses. 'Ah! He must be showing the best picture, or else Mrs. Jones wouldn't go.' Masses follow classes!" Of course, it helped that *Reunion in Vienna* was glamorous, funny—and sexy.

"Love stories and sex stories make very good headlines," said Darryl Zanuck. "Sometimes they make very good pictures." In late 1932, Zanuck broached the subject of musicals to Jack Warner. "Oh, Christ, no!" responded Jack Warner. "We can't give 'em away!" Zanuck had a hunch. He quietly put a backstage story into production on the Burbank lot, while dance director Busby Berkeley shot intricate, flashy musical numbers at the Vitagraph lot in East Hollywood. Without tipping off Warner, Zanuck previewed *42nd Street* for him. "Jack went out of his mind!" said Zanuck. "He never knew until it was screened that it was a musical!"

The SRC suggested a few deletions, including: "The reference to Any Time Annie: 'She only said "no" once, and then she didn't hear the question.'" The line stayed in, and *42nd Street* was a hit. "What a box office baby this is!" wrote an Idaho theater. "This is by far the greatest box office attraction I've had in two years. It's a home run, a complete knockout."

In Warner Bros.' next musicals, *Gold Diggers of 1933* and *Footlight Parade*, Berkeley's production numbers offered abstractions of female anatomy that were both lyrical and lewd. "We wore very scant

OPPOSITE: A vista of chorus girls in Lloyd Bacon's *Footlight Parade*.

attire," recalled chorus girl Gwen Seeger. "We were covered with a few feathers and beads. It was nudity, but it wasn't vulgar. And yet, when I got off the set, I'd run and cover myself with a robe. I felt like I was too undressed to be wandering around."

Gold Diggers of 1933 was one of the first films with "alternate footage." The state boards had become so troublesome that a number of studios were shooting slightly different versions of censorable scenes. When the film was edited, the toned-down reels were labeled according to region. In this way, one version could be shipped to New York City, another to the South, and another to British territories. In one version of *Gold Diggers*, the rocky romance between Warren William and Joan Blondell is resolved backstage after the "Forgotten Man" number; in another, the film ends with the number. Other films with alternate scenes were M-G-M's *Strange Interlude* (to delete a monologue justifying adultery) and Paramount's *Too Much Harmony* (to make a prostitute's solicitation less obvious).

Zanuck told Wingate that the New York executives made him reserve 20 percent of the year's calendar

THE WARNER BROS. FLASH

for "women's pictures, which inevitably means sex pictures." The best of these starred Ruth Chatterton, who brought her clipped diction and slinky elegance to *Female*, in which she runs an auto factory and emulates Catherine the Great. Wingate wrote: "It is made very plain that she has been satisfying a too definitely indicated sex hunger by frequently inviting any young man who may appeal to her to her home and there bringing about a seduction. After having satisfied her desires with these various males, she pays no further attention to them other than to reward them with bonuses. And in the event that they become importunate, she has them transferred."

Another unconventional film was *Ex-Lady*, the story of a career woman who wants a trial marriage. "Well, what she wants, of course, is freedom," said Bette Davis. "She never will be satisfied until she has every right that a man has. The exceptional woman should have the same opportunities and the same freedom to develop them that the exceptional man has."

Joseph Breen watched film after film slither out of the SRC, but there was little he could do. He tried to help with *A Man's Castle*, which had Loretta Young living in sin with Spencer Tracy, but was hamstrung by irresolute policies. He turned to the Midwest Catholics for moral support. "Nobody out here cares a damn for the Code or any of its provisions," he wrote Father Wilfred Parsons. He wrote Father FitzGeorge Dinneen that the Hollywood producers were "a foul bunch, crazed with sex, dirty-minded and ignorant in

A portrait of Margaret Lindsay.

all matters having to do with sound morals." He wrote Father Daniel Lord that the March crisis had caused the studios to go after "quick money."

Martin Quigley heard from Breen that Will Hays was in "abject fear" of the moguls, and from Lord that Wingate was a "complete washout," so Quigley traveled to Hollywood. "I never saw him so down in the mouth about anything," said Breen. Hays tried to rekindle Quigley's enthusiasm but failed. For Quigley and the Midwest Catholics, there was only one conclusion: they'd been had.

The first defection was a painful one. Daniel Lord told Hays that Hollywood could go "merrily to hell." The next was Dinneen, who began naming indecent films from the pulpit. In his opinion, what the movies needed was a "legion of decency." Alice Ames Winter of the General Federation of Women's Clubs also resigned, but Hays talked her into remaining. Then he sent Breen to work on a troublesome Warners project.

OPPOSITE, CLOCKWISE FROM TOP LEFT: Barbara Rogers publicizes Lloyd Bacon's *42nd Street*. ◆ Lynn Browning strikes a pose. ◆ Toby Wing adjusts her fur. ◆ Renee Whitney models fabric.

THE WARNER BROS. FLASH

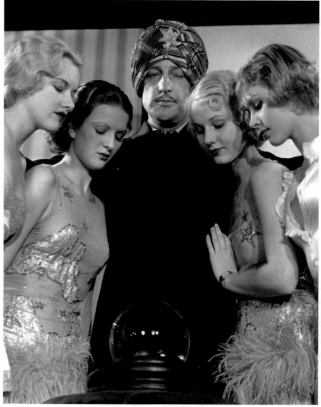

CLOCKWISE FROM TOP LEFT: James Cagney and chorus girls from the "Shanghai Lil" number in *Footlight Parade*. ◆ Warren William and his assistants in Roy Del Ruth's *The Mind Reader*. ◆ An opium den in the "Shanghai Lil" number.

OPPOSITE: The "By a Waterfall" number in *Footlight Parade*.

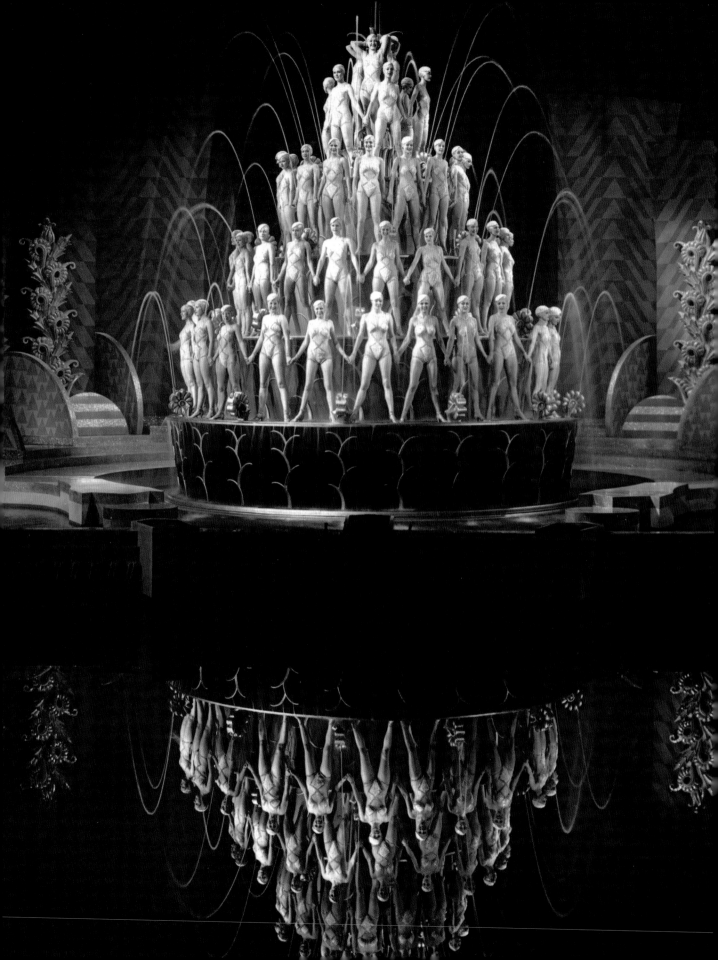

BABY FACE

aby Face was Darryl Zanuck's answer to *Red-Headed Woman*. He wrote the treatment and sold it to Warners for a dollar, using the pseudonym of Mark Canfield. (Zanuck was earning $3,500 a week and hardly needed the money.) In a story conference with Barbara Stanwyck and screenwriter Howard Smith, Zanuck established the characters. "Following up the conference with Stanwyck," Zanuck wrote Smith, "I am sending you this note to remind you of the things she suggested. The idea of Baby Face's father forcing the girl to dance at stag parties and to have affairs with the different men at the start of the story, and how her father forces her to dance in the almost nude for the few shekels which the men give her, and which shekels the father immediately, brutally takes away from her."

The script of *Baby Face*, by Gene Markey and Kathryn Scola, was tougher than anything Warners had submitted to James Wingate. "The theme is sordid and of a troublesome nature," Wingate told

In 1933 there were rules of etiquette, written and unwritten, and these applied to movie theaters. The exception to the rule of silence occurred when a scene moved an audience to cheer, which happened more often than one would suspect, according to accounts quoted in this book.

Hays. "However, we will do our best to clean it up as much as possible, and the fact that Barbara Stanwyck is destined for the leading role will probably mitigate some of the dangers in view of her sincere and restrained acting."

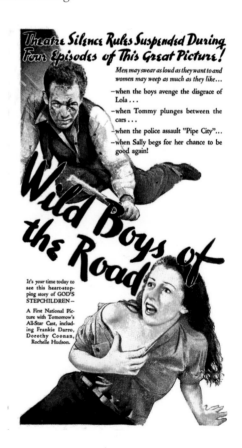

Baby Face was Lily Powers, an ambitious girl who wants to escape her degrading existence in a steel town. The only trustworthy man she knows, an old cobbler, advises her.

> "A woman, young, beautiful like you, can get anything she wants in the world. Because you have power over men. But you must use men, not let them use you. You must be a master, not a slave. Look here—Nietzsche says, 'All life, no matter how we idealize it, is nothing more nor less than exploitation.' That's what I'm telling you. Exploit yourself. Go to some big city where you will find opportunities. Use men! Be strong! Defiant! Use men to get the things you want!"

Wingate ingenuously asked Zanuck to downplay the "element of sex" and to punish Lily by having her lose both her money and her husband, the bank president whom she genuinely loves. "That is, if Lily is shown at the end to be no better off than she was when she left the steel town, you may lessen the chance of drastic censorship action by this strengthening of the moral value of the story." Zanuck agreed, but told the screenwriters otherwise: "We go as far in this scene as the censors will allow." To show Lily sleeping her way to the top, the script has the camera crane up a skyscraper to the saxophone wail of "St. Louis Blues." (The W. C. Handy song was often used to create a whorish ambience.) Alfred E. Green finished directing *Baby Face* just in time for Will Hays's emergency visit to Hollywood.

Hays looked at *Baby Face*, and for once, he was speechless. He could only tell Wingate to mandate changes. Wingate fumbled, so Hays borrowed Jason

Bert Longworth makes a portrait of Barbara Stanwyck as Lil Powers for Alfred E. Green's *Baby Face*.

Joy from Fox—again. Supervisors, who were now called "producers," were bucking Wingate's "narrower considerations." They preferred Joy, who was reasonable and helped them preserve "the general flavor of pictures." Finally, Joy declined to work in two places, so Wingate turned to Joseph Breen. This was the opportunity Breen had been waiting for.

Breen wrote an exigent letter to Zanuck, and Wingate signed it. Zanuck made the changes and

shipped the film to the New York board. Wingate's successor, Irwin Esmond, rejected it. Zanuck lost patience: "I deleted and altered the lines you objected to—such as 'Is it your first?' and 'I know you have had many lovers before.' Elimination of both these lines weakened both situations. I shot a new ending to the picture, which gave it a more wholesome and brighter finish."

Zanuck was determined to keep *Baby Face* as uncompromising as his original treatment, but in early April, he suddenly had more pressing concerns. Jack Warner had reneged on the studio's promise to restore the salary cuts to its employees, making Zanuck look like a first-class liar. Zanuck restored the cuts, only to have Warner cancel his action a day later. On April 14, he wrote a letter to Warner: "For many reasons with which you are cognizant, I hereby offer my resignation from all capacities in which I am employed by you." Hal Wallis succeeded Zanuck as head of production, and *Baby Face* became his problem.

This was when Joseph Breen made the decision to lift the concept of "morally compensating values" from the "Reasons Supporting the Code" and make it his broadsword. As historian Leonard Leff points out, this phrase is found nowhere in the Code: "Breen normally justified his use of the concept by citing a clause that allowed the 'presentation of evil' provided that in the end, 'the audience feels that evil is wrong and good is right.'" So armed, Breen wrote Warner: "Nowhere is the heroine denounced for her brazen method of using men to promote herself financially. We would suggest

OPPOSITE: Arthur Hohl tries to have his way with Barbara Stanwyck. ◆ Barbara Stanwyck plays banker Henry Kolker for a fool.

an attempt to use the cobbler in a few added scenes as the spokesman of morality."

The cobbler's dialogue was rewritten by Breen: "A woman, young, beautiful, like you are, can get anything she wants in the world. *But there is a right and a wrong way. Remember, the price of the wrong way is too great.* Go to some big city where you will find opportunities. *Don't let people mislead you.* You must be a master, not a slave. *Be clean, be strong, defiant, and you will be a success.*" [Emphasis added to indicate Breen's new lines.] Wallis dubbed the new lines onto over-the-shoulder shots of the cobbler, and Esmond passed the film. "Warner insiders figure," wrote *Variety*, "that it has cost between $75,000 and $125,000 to remodel *Baby Face* to conform to the stricter Hays code."

"Three Cheers for Sin!" cried a review in *Liberty* magazine. "If you don't think it pays, get a load of Barbara Stanwyck as she sins her way to the top floor of Manhattan's swellest bank in *Baby Face*." Somewhat apologetically, Stanwyck told a reporter: "I'm rather nervous over it. All my other roles have had sympathy. I hope the public likes me in it."

In late June, the *Variety* reviewer known as Bige saw the film with an audience at the Strand Theatre, and neither he nor the audience was taken in. "*Baby Face* is blue and nothing else," wrote Bige. "Story is that of a girl who goes tramping through life for seventy minutes of nothing but affairs with a flock of men. The Strand audience gave it the snick in the wrong spots, especially when Lily starts to bowl 'em over with just a look and a flash at the gams. This is reputed to be a remake on the first print, which was considered too hot. Anything hotter than this would call for an asbestos audience blanket."

After using and destroying a dozen men, Barbara Stanwyck has finally fallen for one, but she refuses to sacrifice her freedom for him.

The Ohio and Virginia boards declined to pass the film, but it played in more territories than anyone expected, even though it was not advertised as heavily as the average Warners film. Breen's use of "morally compensating values" had set a precedent. Even Will Hays was emboldened.

"If you Hollywood producers make a picture that violates the code," said Hays, "we will send it back to you to change. If you do not change it, I shall go over your heads to your New York executives, and if they fail to satisfy us, we shall go to your bankers. If they do not see our point, I shall carry my complaint to the American public, telling by name the company that persists in dealing in dirt." Only time would tell if threats carried more weight than platitudes.

THE STORY OF TEMPLE DRAKE

"If you want to get a job today in pictures at big money," an unnamed writer told *Variety*, "all you have to do is to write a dirty book. Look what has happened recently. One of the most revolting novels ever published is William Faulkner's *Sanctuary*, but Paramount is making it under *The Shame of Temple Drake*. Another major company has hired Faulkner for its writing staff. Tiffany Thayer wrote *Thirteen Women* and *Call Her Savage* and was hired to write for pictures." The writer could also have mentioned Elinor Glyn (*Three Weeks*), Vicki Baum (*Grand Hotel*), and Mae West.

When the Ohio censor Beverly O. Skinner visited the MPPDA offices in September 1933, Skinner's wife told officer Vincent Hart a bit too much about Ohio. "Mrs. Skinner praised Mae West to the nth degree," wrote Hart. "She has seen *She Done Him Wrong* three times, and is awaiting *I'm No Angel* with great interest."

I'm No Angel was West's next film, and in it she realized her lifelong ambition of playing a lion tamer. She also tamed every man in sight, cracking one-liners like whips. Martin Quigley wrote: "This is a scarlet woman whose amatory instincts are confined exclusively to the physical. There is no more pretense here

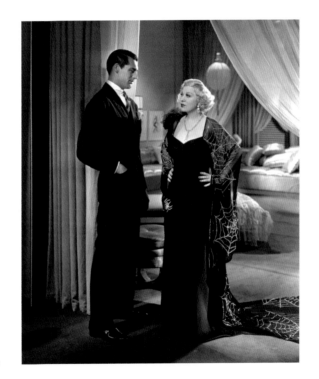

Wesley Ruggles's *I'm No Angel* was an even bigger Mae West hit than *She Done Him Wrong*, grossing $2.25 million. The "stud-farm" saga co-starred Cary Grant.

of romance than on a stud farm. Its sportive wise-cracking tends to create tolerance if not acceptance of things essentially evil." Surprisingly, its critics were in the minority, and *I'm No Angel* surpassed *She Done Him Wrong* at the box office. A Louisiana exhibitor

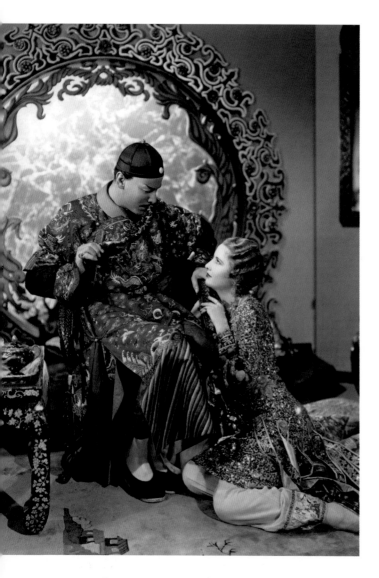

Frank Capra's *Bitter Tea of General Yen* failed because of racial prejudice, so his sensitive direction of Nils Asther and Barbara Stanwyck was seen by few.

Studios at a time when the studio was considering selling out to M-G-M, and when Paramount theaters—1,700 of them—thought of closing their doors and converting their theaters into office buildings."

Radio City Music Hall opened its doors on January 11, 1933. If the world's largest indoor movie theater needed a hit for its opening, *The Bitter Tea of General Yen* was an odd choice. It told the offbeat story of a missionary (Barbara Stanwyck) who falls in love with a Chinese warlord (Nils Asther). Director Frank Capra was enamored of the concept, so he ignored the miscegenation laws of thirty states, including California. According to Barbara Stanwyck: "The story was far ahead of its time in that the missionary comes to respect the 'heathen' attitudes of the Oriental. Before the general drinks his poisoned tea, she touches him in farewell—and worse—actually kisses his hand. His hand! Women's groups all over the country protested, wrote letters to exhibitors, saying we were condoning miscegenation." The film was pulled after eight days for lack of attendance.

Joseph Breen could do little with *The Story of Temple Drake*. Lamar Trotti had reviewed *Sanctuary* in 1931: "This is a sadistic story of horror—probably the most sickening novel ever written in this country. Important because of its brilliant style, it has had quite a large sale." It was the fable of a Southern society girl whose rebellious streak runs her afoul of inbred mountaineers and an impotent bootlegger named Popeye. He rapes her with a corncob and makes her work in a brothel, which she eventually enjoys. Trotti could not finish the book, declaring it "utterly unthinkable as a motion picture."

When Paramount's Emanuel Cohen attempted

affirmed: "The church people clamor for clean pictures, but they all come out to see Mae West."

"In the middle of the Depression," stated William LeBaron, "*She Done Him Wrong* and *I'm No Angel* broke box-office records all over the country, and broke attendance records all over the world. *She Done Him Wrong* must be credited with having saved Paramount

the unthinkable in early 1933, Will Hays told Breen: "We simply must not allow the production of a picture which will offend every right-thinking person who sees it." Cohen assigned Oliver H. P. Garrett to write the screenplay and Stephen Roberts to direct.

Harrison's Reports soon charged Cohen with doing "the greatest harm to the motion picture industry that has ever been done in its entire history." Cohen cast George Raft as the twisted bootlegger, renamed Trigger. Raft refused to appear in the film. "That part was plain suicide for a fellow with my face," said Raft. "Any other actor might play it and maybe get away with it, but I look like that kind of a guy. There'd be just one thing for the public to think: 'George Raft, himself, is like Trigger.' Listen, do you know what I would have had to do in that picture? First I had to kill a feeble-minded boy. And then I had to rape a girl—in a corn crib, see. Then I take her to a sporting house. That's the part they asked me to play. That's the part I refused to play."

Paramount put Raft on suspension and cast Jack LaRue as the bootlegger. Cohen cast Miriam Hopkins as Temple Drake, who still goes to "Miss Reba's house," not as an inductee but as a sex slave to Trigger, whom she ultimately murders. In Garrett's script, Trigger is no longer impotent, so the infamous corncob was struck from the plot. Jean Negulesco, fresh from designing *The Big Broadcast* and *A Farewell to Arms,* made storyboard sketches and was then awarded the dubious distinction of "technical adviser on the rape scene." He alluded to the unique rape with stray corncobs around its perimeter. Negulesco then carefully set up each shot, fielding such questions from Miriam Hopkins as "Jean, are my legs open at the right angle? Shouldn't

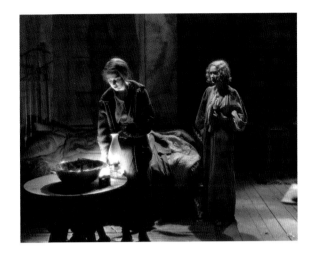

Ruby Lemarr (Florence Eldridge) does as little as possible to shelter Temple Drake (Miriam Hopkins) from the storm in Stephen Roberts's *The Story of Temple Drake.* Karl Struss's soft-focus photography saved the film from being completely nightmarish.

my dress be up higher? Do I scream?" As shot, the scene ends with Trigger moving out of a close-up, and, as the image of the wall behind him fades out, there is one scream.

Breen previewed *The Story of Temple Drake* in mid-March and pronounced it "sordid, base, and thoroughly unpleasant." He told Cohen to make changes in it before submitting it to any censor board. Cohen ignored him and submitted it to the New York board in mid-April. Irwin Esmond promptly rejected it, and the other state boards found out. For the first time in the history of the Code, it appeared that a film might be rejected by all eight boards.

In May, a nervous Cohen worked with Breen to make such changes as Esmond deemed necessary. Jump cuts, overly loud background music, and claps of thunder muffled lewd dialogue, but the rape remained. Though it was only suggested by the fadeout and the scream, it was unprecedented.

Jean Negulesco painted a storyboard for the rape sequence. Roberts and Struss followed it fairly closely.

The Story of Temple Drake received mixed reviews. Many critics condemned it, but just as many conceded that it was powerfully written, directed, and acted. Its aesthetic merits could not silence the bad publicity. Breen had predicted that it would earn the "wrathful condemnation of decent people everywhere."

"Everywhere" did not include Ellinwood, Kansas: "Advertised it for adults only and did better than average business. Not nearly as bad as some would have you to believe." Or Cogswell, North Dakota: "A picture so fraught with sex as this becomes morbid. Mind you, this show does not merely suggest sex, but paints it in big red letters across the screen from start to finish. By the end, our cooling system was exhausted." Or even Detroit: "This picture could almost be shown to a Sunday school class. It is true that a rape is indicated, but it was shown so delicately, and the villain is properly punished, and the heroine shows heroic qualities. All in all, a worthwhile picture. Its drawing power is above average." The thousands of people who disapproved of *The Story of Temple Drake* did not have to sit through it to disapprove of it. Just seeing its lurid posters drove them to write outraged letters. And those letters were read.

CONVENTION CITY

or all the box office benefits of *She Done Him Wrong*, *So This Is Africa*, and *The Story of Temple Drake*, many exhibitors in Mary Pickford's America were too embarrassed to greet their patrons as they left the theater. After all, they lived in small communities. The theater manager sitting next to his patrons in church on Sunday had run an "immoral" film the night before. His children and their children went to school together. It was an awkward situation.

George Skouras was one of a family of theater owners, and he was canvassing the exhibitor community as President Franklin D. Roosevelt implemented the National Recovery Act. "During the last six months," wrote Skouras, "each time I have visited any theater, the managers have had a unanimous complaint—that some woman that same day had objected to the filthiness of the picture they had run. Unfortunately, in spite of how our executives may feel on this matter, I can say sincerely that I agree with the woman. If we should ever be in a position where we

Guy Kibbee and Joan Blondell in Archie Mayo's *Convention City*. ◆ Adolphe Menjou and Joan Blondell in *Convention City*.

are dominated by politically appointed censors, God have mercy on us!"

While assisting James Wingate, Joseph Breen tried to squelch RKO's *Ann Vickers*, which was based on a Sinclair Lewis novel forbidden to Catholics because its feminist heroine had two affairs and one abortion. When he read the script in May, he wrote: "This script simply *will not do*." Producer Merian C. Cooper countered that the script had already cleaned up most of the book's problems and that it did not "pander to cheap sex, nor to cheap and vulgar emotions." This was not enough for Breen. He insisted that the script have a "spokesman for accepted morality."

At this point, John Cromwell was already directing *Ann Vickers*, and RKO president B. B. Kahane was less than willing to abide by precepts that were not in the text of the Code. After three weeks of revisions and an investment of $300,000, he wrote: "We cannot afford to risk this amount of money with a chance that after we finish the production, Dr. Wingate will renew his objections or make new ones." Kahane went on to say that RKO was "frankly doubtful that Wingate had a broad enough viewpoint regarding the Production Code." He then called Will Hays's bluff by asking for an AMPP jury to judge not the film, but its script. Would Hays defend Breen's "voice for morality"?

Hays dodged the issue, mouthing platitudes about the studios' responsibility "to establish in the minds of the audience that adultery is wrong, unjustified, and indefensible." Kahane then questioned the ability—indeed, the *authority*—of Wingate or Hays to interpret the Code in such a way that RKO would have to "affirmatively establish" that a character's actions were wrong. Hays did not respond directly. Instead he sent letters to all the studios, telling them that "illicit sex relationships" were not to be filmed, regardless of taste. The standoff between him and RKO ended, predictably enough, with token cuts, but its lesson to Joseph Breen was invaluable. Morally compensating values were needed, and Will Hays was not going to fight for them.

Ann Vickers was one of a dozen 1933 films with sexual elements. What Breen failed to acknowledge was that some of them—*King Kong*, *The Story of Temple Drake*, *The Song of Songs*, *The Bitter Tea of General Yen*, *Dancing Lady*—were works of art. Breen was as skilled a story editor as Jason Joy, but he did not share Joy's respect for cinematic accomplishment. Joseph I. Breen only had one goal—to impose his moral values on the film industry. "The mainspring of his vitality," wrote Jack Vizzard, "was the fact that he nurtured not the slightest seed of self-doubt regarding his mission or his rectitude. He was right, the moviemakers were wrong, and that was that."

In September, Breen was a bystander as Warner Bros. prepared a comedy that could eclipse *So This Is Africa*. A contract writer named Peter Milne had spun a wild yarn about conventioneers in Atlantic City, and Hal Wallis assigned Henry Blanke to produce it. Years later Blanke said to Jack Vizzard: "Me. I was the one. Single-handedly I brought on the whole Code. Yeah. Ask Joe Breen. He'll tell you. Ask him about *Convention City*."

Robert Lord's script was nominally set in Atlantic City, but it took place in a universe devoted to two activities: drinking and fornicating. When Wingate read it, he and Joy immediately called a meeting with Hal Wallis, telling him that the script "seemed to

indicate a pretty rowdy picture, dealing very largely with drunkenness, blackmail and lechery, and without any particularly sympathetic characters or elements." Wallis hastened to assure them that the script would incorporate all thirty of their suggested changes.

Convention City comprised a series of indelicate episodes occasioned by a convention of the Honeywell Rubber Company. In one, salesman Ted (Adolphe Menjou) tries to edge salesman George (Guy Kibbee) out of a promotion by seducing Claire (Patricia Ellis), the boss's teenage daughter. Salesperson Arline (Mary Astor) disapproves: "Ted, she's only a child. You want to go to the pen?"

"She's old enough," laughs Ted. "Almost, anyhow. I remember the year she was born."

Lord made every change suggested by Wingate and Joy, including "a comedy bit about a drunk who was chasing a sheep around the lobby of the hotel, trying to lure it up to his room." Lord changed the sheep to a goat and moved the chase out of the hotel. In one day, he rewrote twenty-nine pages. At the top of one, he noted: "Mr. Wingate suggests that we handle the following drunken scenes with extreme delicacy." One character summed up these scenes: "I'm stinkin'—and I love it!"

Director Archie Mayo was apparently having a great time on the set of *Convention City*, judging from a Jack Warner memo: "We must put brassieres on Joan Blondell and make her cover up her breasts because, otherwise, we are going to have these pictures stopped in a lot of places. I believe in showing their forms but, for Lord's sake, don't let those bulbs stick out."

"That is the raunchiest thing there ever has been," recalled Joan Blondell. "We had so many hysterically

In the 1960s, Joan Blondell told film historian John Kobal: "*Convention City* was so blue that I heard that they had to end up using it for stag shows."

dirty things in it. No dirty words or anything like that, just funny, burlesque-y." One line involved the conventioneers' product. A Honeywell Rubber Company employee says: "Let's place our goods in convenient slot machines. You never can tell when an emergency may arise!"

When Wingate reviewed *Convention City*, he wrote to Hays: "While not as rough as the script indicated, it is nevertheless somewhat low-tone entertainment, long on drinking and rowdiness, but is fortunately free from any actual sex situations." The state boards disagreed. The film averaged twenty cuts per board.

Censored or not, *Convention City* made a strong impression, and it was not what the reformers expected. From Greenville, Michigan: "One of the best comedies we ever played. People laughed at this

that had not grinned in years." From Browns Valley, Minnesota: "Patrons emphasized their satisfaction with the picture." From Cooper, Texas: "Did nice business on this one. Some of our patrons were laughing for a week after seeing it." From Avon Park, Florida: "Created more talk than any picture we've run since *Footlight Parade.*"

Joseph Breen stood at the edge of the SRC, seemingly powerless as Wingate passed one filthy film after another. Still, Breen's public relations job had made him some powerful allies. One was Bishop John J. Cantwell of Los Angeles. At Breen's urging, Cantwell visited each of the studios, contacted other bishops, and spoke with banker A. H. Giannini, chairman of the Bank of America. Breen thought the threat of a financial boycott would frighten Hollywood into compliance, so he brought Giannini to an AMPP meeting on August 1. He also invited a powerful Catholic lawyer, Joseph Scott, who was affiliated with the Los Angeles Chamber of Commerce.

After Will Hays introduced them to the assembled executives, Giannini said he would no longer underwrite films that were "prostituting the youth of America." Scott, whose wife was Jewish, warned against a backlash of anti-Semitism, contending that communists and film moguls were "serving to build up an enormous case against the Jews in the eyes of the American people." The implied threat was a Catholic boycott, which could in turn spawn a Christian revolt against Hollywood, the last thing the industry needed in this year of crisis.

Once again, the studio heads pledged cooperation, resolving to cleanse themselves of what Adolph Zukor admitted was "dirt and filth." Breen did not believe them. Nor did he know that Joseph Schenck had called his own meeting—to denounce Scott and the reformers as "narrow-minded and bigoted," and to convince his fellow moguls that they had the right to film mature subjects. Seeking solidarity, Breen rallied the original Code group behind him: Dinneen, Mundelein, Parsons, Lord, and Quigley. For two months, they threw ideas back and forth. Then, in late 1933, they had a brainstorm. Hollywood, regardless of race or creed, spoke only one language: box office. That would be their target.

OPPOSITE: An Ernest Bachrach portrait of Ginger Rogers for William Seiter's *Professional Sweetheart*.

QUEEN CHRISTINA

Reformers, women's clubs, and churchmen were not the only voices raised in protest in late 1933. Industry people were speaking, too. A screenwriter who wished to remain anonymous spoke to *Variety*. "The Hays Code is not even a joke anymore;

OUR MOVIE MADE CHILDREN

Hollywood's critics said that movies were harming children, but there was no way to prove it. Then this book appeared. Never mind that its research methods were unscientific; people believed it. Meanwhile, the M-G-M publicity department thought the whole idea was a joke.

it's just a memory. The industry yells its head off about the terrible things that are done by censors and then produces pictures which are a stench in the nostrils of every decent man and woman."

Martin Quigley and Joseph Breen approached the Reverend Amleto Giovanni Cicognani, a representative of the pope, to speak to American Catholics on their behalf. At this time, the Roman Catholic population of the United States was 20,322,594. On October 1, the apostolic delegate spoke to the National Conference of Catholic Charities in New York, enjoining clergy and laity alike: "Catholics are called by God, the pope, the bishops and the priests, to a united and vigorous campaign for the purification of the cinema, which has become a deadly menace to morals." He was especially solicitous about young movie fans: "What a massacre of innocent youth is taking place hour by hour!"

More than forty secular organizations had already voiced disapproval of 1933's films, galvanized by a sensational new book, Henry James Forman's *Our Movie Made Children*. First serialized in *McCall's* magazine, it was the culmination of the Payne Foundation Study, a three-year series of interviews and experiments

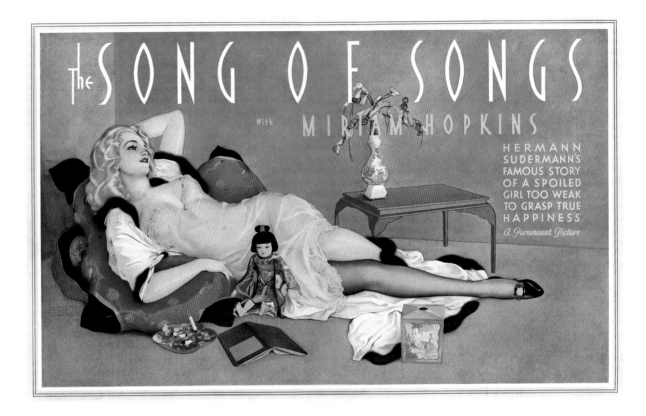

A trade ad for a film that was obviously given to another star.

conducted to measure the effect of films on children. That this study was backed by the pro-censorship Motion Picture Research Council did not faze Forman or the factions who cited it. All that mattered were its shocking statistics.

The book claimed that the weekly film audience was one-third children, and mostly unsupervised. In the films they watched, 87.5 percent of the characters smoked, 66 percent drank, 43 percent were drunk, and 43 percent enacted a bedroom scene. According to Forman, these films portrayed an unreal world where "apparently every human being over forty has been chloroformed. In that world, where few toil, and none spin, these movie characters play their roles preponderantly in full accoutrements of formal dress." Since

the book claimed that youth retained 70 percent of what they viewed, that retention increased as time went by, and that sleep (and other nighttime activities) were severely affected, it relied heavily on adolescent testimony:

"When I see a fellow and a girl in a passionate love scene . . . I just have a *hot* feeling going through me and I want to do everything bad."

"After I have seen a romantic love scene, I feel as though I couldn't have just one fellow to love me, but I would like about five."

"When I see these movies, I go out to some roadhouse or an apartment with my man and get my wants satisfied. Especially when I get all stirred up and my passion rises, I have a feeling that can't be expressed with words but with actions."

Another best seller was Herbert Blumer's *Movies and Conduct*, which quoted an articulate high school girl: "I imagined myself caressing the heroes with great passion and kissing them so they would stay osculated forever, and I practiced love scenes either with myself or with a girlfriend. We sometimes think we could beat Greta Garbo, but I doubt it." Both Forman and Blumer blamed the film industry for America's erotomania, never admitting that the public paid cash to make Garbo a star. At M-G-M, Walter Wanger was preparing a new Garbo film for this same eager public.

Garbo had been off the screen for a year. Her friend Salka Viertel was researching a screenplay, *Christina*, based on the life of the seventeenth-century Swedish monarch. Hollywood sophisticates wondered if she would hint at the queen's bisexuality. Irving Thalberg asked Viertel if she had seen a German film, *Mädchen in Uniform*, which had a lesbian subtext: "Does not Christina's affection for her lady-in-waiting indicate something like that?" Viertel recalled: "He wanted me to 'keep it in mind,' and perhaps if 'handled with taste it would give us some very interesting scenes.'" M-G-M submitted the script to the SRC, and Wingate promptly replied: "We assume that you will be careful to avoid anything in the portrayal of this scene which might be construed as lesbianism."

In the script, which was written by playwright S. N. Behrman, Christina travels her country dressed as a man, and must share a cozy room in a snowbound inn with a Spanish ambassador (John Gilbert). He, of course, discovers her true sex, and they spend idyllic

OPPOSITE: An Irving Lippman portrait of Marlene Dietrich in Rouben Mamoulian's *The Song of Songs.*

days together. In August, when Rouben Mamoulian had already started shooting, Wingate asked Jason Joy to speak with Wanger. The producer agreed to shoot the scene at the inn several ways.

Mamoulian had conceived the morning-after scene as a lyric poem, and he shot it so it could be cut only one way: "Garbo strokes the bedroom where she has been with her lover, so that she will remember every detail. The scene was choreographed. She played it to a metronome. She had to roll over a bed, and move around the room in what was a kind of sonnet in action." Years later, Garbo told her friend, the actor Robert Arthur, "When I acted that scene, I pretended that the pieces of furniture I was stroking were my lover's legs." Indeed, every aspect of the sequence had a warm, erotic quality. Cinematographer William Daniels recalled: "All the light in the room came from the fire—or seemed to." The three artists had created a masterpiece of sensuality, and Mamoulian was not about to have it tampered with.

Jason Joy, meanwhile, was busy at Fox, and Wingate was losing ground. "Wingate took refuge in the Hollywood Athletic Club," wrote Jack Vizzard. "where all he was allowed to do was work out on the barbells. He was not to be faulted if he took a second cup of cheer at cocktail time." Breen saw the SRC falling apart, unable to stop another "perverted" film. He became a man possessed. He rushed from diocese to diocese, asking each bishop to work with him. Then he wrote a speech for Cantwell to deliver at the annual bishops' meeting in November. His impassioned speech attacked such "vile and nauseating" films as *The Sign of the Cross*, and exhorted the bishops to organize against Hollywood: "The pest hole that infects the

entire country with its obscene and lascivious moving pictures must be cleaned and disinfected." The bishops concurred.

On November 15, they elected the "Episcopal Committee on Motion Pictures." Its head, the Most Reverend John T. McNicholas, archbishop of Cincinnati, worked with Bishop Cantwell, Bishop John Noll of Fort Wayne, Bishop Hugh Boyle of Pittsburgh, and Martin Quigley to create a "Catholic Legion of Decency." The Legion would function in three ways: pressure tactics, boycotts of proscribed films, and enforcement of the Code. Breen's barnstorming ended in New York, where he met with Will Hays. Hays told him that he was sending Wingate on a "vacation." Hays then asked Breen to head the Studio Relations Committee. Breen accepted, and returned to California to assume his new post. His first challenge was the M-G-M film now called *Queen Christina*.

Mamoulian knew that Breen would go after the scene in the inn. Mamoulian later said: "I always divide the world into two: those who like the scene and those who don't." Wingate had liked it, and advised cutting only two of Christina's lines from it: "Do you think the old saints would approve of us? Will we have their blessing?" and "This is how the Lord must have felt when He first beheld the finished world, with all His creatures—living, breathing, loving." Mamoulian removed the first, but retained the second. Breen was taking office at the SRC as the film was being edited. But M-G-M was too fast for him.

According to Garbo biographer Karen Swenson, a studio representative worked with the New York board's Irwin Esmond to cut the film for its

premiere—without Breen's approval. Esmond passed it and *Queen Christina* opened on December 26. Most reviews were highly laudatory. A dissenting review came from Martin Quigley, who singled out the scene in the inn, "which registers with voluminous and unnecessary detail the fact of a sex affair. The sequence is emphasized and dwelt upon beyond all purposes legitimate to the telling of the story, thereby assuming a pornographic character."

Breen fumed to Mayer: "I know that the picture has been playing in New York for some days without our approval." Then he got down to business. The idea that the queen should invoke God's name on the morning after an illicit affair was repugnant. He planned to cut most of the scene at the inn: "I think Miss Garbo should be kept away from the bed entirely. The scene should be cut from the action at the spinning wheel, at least, and the business of lying across the bed fondling the pillow is, in my considered judgment, very offensive."

Wanger and Mamoulian thought otherwise. They bypassed Breen and presented the film to an AMPP jury. Three days later, the secretary of the jury sent M-G-M its decision: "This jury, consisting of Messrs. B. B. Kahane, Jesse L. Lasky, and Carl Laemmle, Jr., saw this picture in your projection room yesterday afternoon and decided unanimously that the picture be approved as exhibited yesterday." *Queen Christina* was vindicated, the sixth SRC decision to be overturned by the jury in three years.

Breen had lost the battle, but not the war. The state boards in Kansas, Maryland, Ohio, and Pennsylvania cut parts of the scene, and Virginia cut it entirely. The Detroit Council of Catholic Organizations

condemned *Queen Christina* in the *Michigan Catholic*, describing Garbo as a "perverted creature."

Reports from city theaters were glowing; from the towns, less so. "There's life in the old gal yet," wrote Pearl River, New York. "I got the history students in there, but the teachers were kind of shocked. Still, it did the business, and that's what counts." An exhibitor in Mellen, Wisconsin, wrote: "This is another choice bit of meat for the League of Decency. One of my Catholic patrons remarked to my wife: 'Garbo is playing such a loose woman!' When will the producers wake up? When it's too late?" In dioceses across the country, Catholics were talking. In the Midwest, bishops were mobilizing. A Catholic crusade was beginning.

THIS PAGE: King Kong was the longest-playing, highest-grossing film of 1933.

PAGE 224–225: Greta Garbo and John Gilbert enjoy an idyll in *Queen Christina*.

QUEEN CHRISTINA

PART

———

1934

———

SIX

TARZAN AND HIS MATE

In early 1934, film companies noted an increase in box-office receipts. Franklin Roosevelt's New Deal policies were taking hold, and seventy million Americans a week were attending the movies, which continued to be racy. No one in Hollywood believed that an attack on the movies could come from the same people who had fostered the Production Code: the Midwest Catholics. Father Daniel Lord wrote: "I was only one of the many who had had hopes for the Code and was mad through and through."

At first, the attack was more rhetorical than real, since the Episcopal Committee was still debating strategies. "We can settle on a common plan later," said Bishop Hugh Boyle of Pittsburgh. "In the meantime, it's best to swarm upon the enemy from all sides with all kinds of weapons." These weapons included boycotts of local theaters, letters to local film exchanges, and letters to the studios. Lord published a pamphlet, *The Movies Betray America*, which accused the industry of "faking observance of the Code." It listed statistics of seduction, rape, murder, brutality, and vulgarity filmed since 1930. Although Martin Quigley and Will Hays considered Lord's pamphlet rash, it was cited by priests in most of the country's 103 dioceses.

Catholics were being forced to question what was playing at their neighborhood theaters.

The massive success of *Tarzan the Ape Man* mandated a sequel, and the expensive project took two years to complete. When previewed in early 1934, *Tarzan and His Mate* had 116 minutes of nonstop action. The *Hollywood Reporter* said: "New *Tarzan*, packed with showmanship, needs cuts." It did indeed. It showed Tarzan and Jane in bed, and Jane in a very skimpy costume. "They tried different things to make Jane look pretty sexy," recalled Maureen O'Sullivan. "First of all they had the idea of wearing no bra, no brassiere at all, and that she would be always covered with a branch. They tried that, and that didn't work. So then they made a costume, and it wasn't that bad." There was, however, a nude swimming sequence. Because of it, Breen rejected the film. Louis B. Mayer appealed his decision. An AMPP jury composed of B. B. Kahane, Carl Laemmle Jr., and Winfield Sheehan met at M-G-M to watch the film.

PAGE 226: A George Hurrell portrait of Norma Shearer made for Edmund Goulding's *Riptide*.

OPPOSITE: A portrait of Johnny Weissmuller and Maureen O'Sullivan made by Ted Allan for *Tarzan and His Mate*.

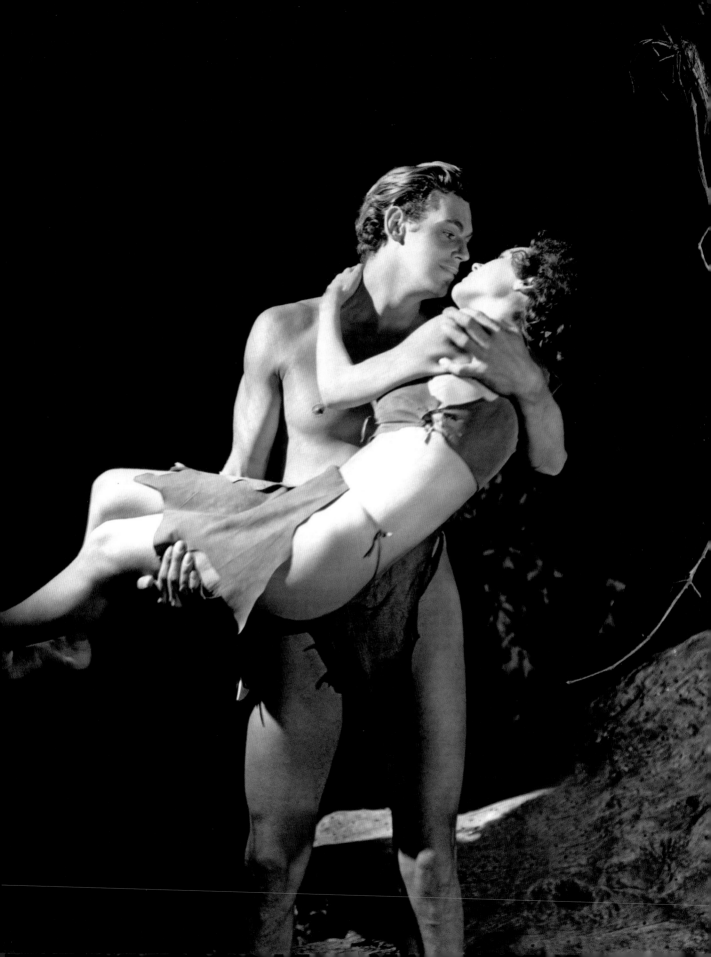

"After a rather animated discussion between the jurors," Breen reported, "the verdict of this office was sustained by the jury." The discussion included protests from Mayer and Thalberg that *Common Law* had gotten away with less tasteful nudity. When a print of it was delivered from RKO, it revealed Constance Bennett's nude stand-in in the far corner of a very wide shot. Breen had won the battle, but not the war. Scenes were reshot, recut, and eleven minutes were snipped from *Tarzan and His Mate*—but which version?

According to historian Rudy Behlmer: "From all evidence, *three* versions of the sequence eventually went out to separate territories during the film's initial release. One with Jane clothed in her jungle loin cloth outfit, one with her topless, and one with her in the nude." Even the territories that didn't see the nude scene thought that Jane's costume (which at one point popped open to reveal her groin) was disgraceful. O'Sullivan said: "It started such a furor that the letters just came in. So it added up to thousands of women that were objecting to my costume. I was offered all kinds of places where I could go in my shame, to hide from the cruel public who were ready to throw stones at me." The film was condemned by the Legion of Decency, but not even O'Sullivan took the drubbing that the First Lady of M-G-M received.

Norma Shearer's first film after her return to M-G-M was *Riptide*, a tasteful trifle about a woman driven to adultery by her husband's lack of faith in her. The film was passed without problems, and no one expected the vicious review that appeared in the June issue of the *Queen's Work*. "*Riptide* is unfortunately typical of the pictures that have been built around Norma Shearer, the much-publicized wife of Irving Thalberg. It seems typical of Hollywood morality that a husband as production manager should constantly cast his wife in the role of a loose and immoral woman. That the picture is beautifully mounted and the heroine elaborately gowned makes the plot that much more insidious. We advise strong guard over all pictures which feature Norma Shearer. They are doing more than almost any other type of picture to undermine the producers' Code."

Father Lord's article enraged Thalberg, and he complained volubly. Bishop Cantwell, backed by Quigley, told Archbishop McNicholas to rein in Lord: "His unwise and irresponsible statements are doing us harm in Hollywood, and creating much confusion." Indeed, Lord had allied himself with a contingent of Protestant owners who favored the abolition of block-booking.

In 1934 Lord was but one of many factions raging at the movies. Quigley and Breen looked at the big picture. Quigley acknowledged that "our ideas of morality in entertainment differ radically from those held by the vast majority of the public in this country." Breen admitted: "I have no real authority to stop the dirty pictures." They agreed that these pictures had to be stopped at the script level, and that only box-office pressure would make the studios cooperate.

OPPOSITE, CLOCKWISE FROM TOP: *Sadie McKee* was one of the films condemned by the Legion of Decency. Portrait of Joan Crawford by George Hurrell. ◆ Anna Sten plays a prostitute in Dorothy Arzner's *Nana*. Portrait by Hurrell. ◆ Norma Shearer was a convenient target when *Riptide* displeased Daniel Lord. Portrait by Hurrell. ◆ Carole Lombard and John Barrymore flouted the Production Code in Howard Hawks's *Twentieth Century*.

The first diocese to formally blacklist films was Detroit. Monsignor John Hunt proscribed sixty-three films in *St. Leo* magazine, including *Convention City*, *The Story of Temple Drake*, *Queen Christina*, and *Flying Down to Rio*. Of the films blacklisted by the diocese of Detroit, twelve were Paramount's and twelve were Warner Bros.' Fox was known for racy films and had recently pushed one called *Bottoms Up* to the AMPP jury (and won), but no studio irked Breen more than Warner Bros. In his opinion, the typical Warner product was a "cheap, low-tone picture with lots of double-meaning wisecracks and no little filth."

Wonder Bar was an all-star project submitted to the SRC by story editor Robert Lord in October 1933. When Wingate recommended thirteen cuts, producer Hal Wallis made a few cuts, submitted them to Wingate, and then charged ahead. After Breen took over the SRC, he received a worried report from counsel Vincent Hart that *Wonder Bar* contained "one item which the audience did not seem to relish, the ballroom scene where a man and a woman are shown dancing. Into the scene comes an effeminate-looking youth who taps the dancing man on the shoulder and asks, 'May I cut in?' whereupon the man dancing with the girl smiles, leaves her, and the two men dance off together."

Breen fired off a letter to Warner, asking for a screening of the entire film. A week passed; he heard nothing. "It is quite evident that this gentleman is giving me the run-around," said Breen. "He evidently thinks that this is the smart thing to do." Breen would have to change the way he dealt with producers. He later told Jack Vizzard: "When I spoke to them

politely, they thought I was a sissy. I had to show them that I meant what I said."

"Joe was not a big man, about five foot eight," said Vizzard. He was chesty, with an athletic spring in his legs. When he looked at you, it was as if he was saying: 'You wouldn't like to knock this chip off my shoulder, would you?' He was an intelligent man, so this was no dummy act. He was physically fearless."

Before long, the trade papers and even the *New York Times* were commenting on his pugnacious new approach. "Mr. Breen knew how Hollywood liked to argue. He adapted his Gaelic voice and temperament to the situation. He pounded desks as hard as any producer in town. His voice could be heard, on occasion, for miles, while theirs carried but for blocks. The studios were amazed. Could this be a Hays man? He didn't win all his arguments, but his average was excellent."

On one occasion, Breen went to visit Harry Cohn at Columbia. He presented Cohn with his portfolio. Cohn was not impressed. "What's all this shit?"

"Mr. Cohn, I take that as a compliment."

"What does that mean?"

"My friends inform me that if there's any expert in this town on shit, it's you. So if I have to be judged, I'm glad it's by professionals."

Having bested another filmland dragon, Breen returned to the SRC, where scripts were piling up, and there was news from the Episcopal Committee.

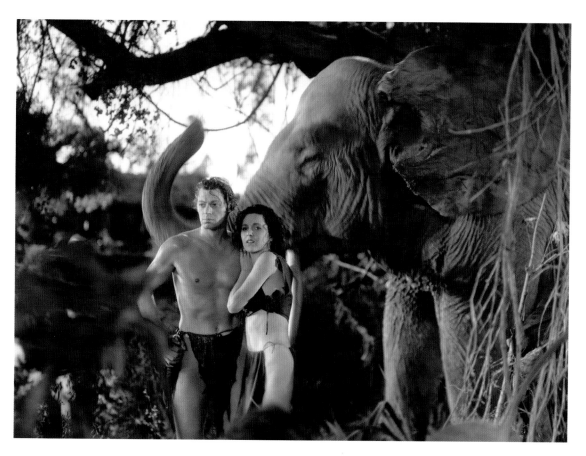

"PURIFY HOLLYWOOD OR DESTROY HOLLYWOOD!"

The Catholic crusade began in earnest on April 28, 1934, when the Legion of Decency was incorporated. The Legion was not so much an organization as it was a manifestation of Catholic will. By joining it, American Catholics showed their support for the Episcopal Committee. They did not have to attend meetings or vote. They only had to sign a pledge card placed in the pew at Sunday Mass, and recite the pledge written by Archbishop John McNicholas. It read in part: "I wish to join the Legion of Decency, which condemns vile and unwholesome moving pictures. I unite with all who protest against them as a grave menace to youth, to home life, to country and to religion."

A number of cities were ready for the Legion: Chicago's Cardinal George Mundelein had joined with Father FitzGeorge Dinneen to educate their flock; Boston's Cardinal William O'Connell was using radio broadcasts to urge boycotts; and Detroit Catholics were displaying signs in their cars: "We

Demand Clean Movies." With the Legion, bishops had a focus for their zeal and a tool for recruitment. Within a month, the Legion collected 300,000 signatures in each of the dioceses of Brooklyn, Philadelphia, and Los Angeles; 500,000 in Cleveland; 600,000 in Detroit; a million in Boston; and a million in Chicago. Meanwhile, Martin Quigley got the signal from Bishop McNicholas to formulate a plan for control of the movies, and he immediately consulted Joseph Breen.

Though the Catholics were unanimous in their contempt for indecency, they disagreed on how to quash it. Over this issue, says historian Gregory Black, they broke into two camps. The first camp comprised Archbishop McNicholas, Bishop John J. Cantwell, the

OPPOSITE: While Catholic bishops railed against "immoral" movies from their pulpits, Hollywood offered its own kind of liturgy. In this scene from Edgar G. Ulmer's *The Black Cat*, Boris Karloff officiates at a Black Mass.

FILM PRODUCERS SHAKEN BY CLEAN-UP CAMPAIGN

Industry Facing Its Most Serious Crisis and Period of Extreme Uncertainty in Prospect

(This is the first of three articles on the "clean-up" campaign of the screen, written by Edwin Schallert, drama critic of The Times. The film producers have many problems to solve in changing the class of pictures produced in recent years, and these will be discussed at length. Also the makers wonder what the public reaction will be when the "better class" entertainment is offered. Mr. Schallert's articles cover a wide field and are interestingly handled.)

BY EDWIN SCHALLERT

"Hold me in your caress/Sweet Marahuana!" sings Gertrude Michael (in a verse from "Marahuana" by Johnston and Coslow), as topless chorines cover their breasts with their hands in Mitchell Leisen's *Murder at the Vanities*. ◆ Joseph I. Breen in his offices at the Production Code Administration.

Episcopal Committee, and Quigley. They believed that a show of strength and the mere threat of a boycott would force Will Hays to accept Joseph Breen's interpretation of the Code. They favored the abolition of the AMPP jury, but opposed national boycotts, censorship, and blacklists.

The second camp comprised Cardinal Mundelein and his followers: Dinneen, Cardinal Dougherty of Philadelphia, Cardinal William O'Connell of Boston, and Daniel Lord. They, in turn, favored boycotts, letter-writing campaigns, and wildcat blacklists. That was where Lord went out on a limb. In May, he began printing lists of "Code Violators" in his magazine, the *Queen's Work*. His review of *The Trumpet Blows*, for example, ended with: "It is unfit for any decent person to see or approve, and it violates the Code in a dozen different ways. Protest to Paramount Studios,

Hollywood. Protest to George Raft, same address." Neither his blacklist nor any of the dozen others in circulation had been cleared by the Episcopal Committee, and they created confusion. Even so, they fanned the flames of indignation, contributing to what had become a national crusade.

Breen sent a letter to Cardinal Dougherty in Philadelphia, proposing that the Cardinal use the Legion to institute a boycott of films in the city where Warner Bros. had substantial holdings. This was the same Cardinal Dougherty who in 1927 had thrown *The Callahans and the Murphys* out of circulation because it mocked Irish Americans.

On May 23, the axe fell. Dougherty declared from the pulpit that Catholics in his diocese were to boycott *all* motion pictures, and that this was a "positive command, binding all in conscience under pain of sin." Box-office receipts immediately fell 40 percent. Geoffrey Shurlock remembered: "Harry Warner, who owned the Stanley chain of theaters in Philadelphia, was losing $175,000 a week."

Daniel Lord brought up the rear, asking five thousand high school students in Buffalo: "How would you like to clean up the movies?" *Variety* told of thousands of letters pouring in from children, teenagers, and church groups. More telling was their financial impact. Within weeks, Hollywood had lost several million dollars. Lord wrote: "Hollywood knew it was licked—to its own salvation."

Frightened moguls turned to Will Hays. Harry Warner pleaded: "Will, you've got to save us. I'm being ruined by the hour. If anybody else does this thing, we're out of business." The potential loss of 20 million Catholic customers was bad enough, but it now app-

Only Universal would see paternal connotations in a gruesome, perverted horror film.

eared that Protestant and Jewish groups might join the crusade. The Federal Council of Churches made it known that its 22 million members were willing to join the Legion of Decency. The Catholic Church had Hays backed against a wall. He called Breen: "Joe, look! For the love of God, come over here! What can you do?"

"I've been telling you guys it's coming," Breen answered.

On May 28, Hays held a secret meeting with Quigley and Breen. Hays capitulated, saying: "The Catholic authorities can have anything they want." Breen relayed a message from Archbishop McNicholas: "You have a Code. Apply it. Implement it. You will have no problem at all with the Catholics if you do that simple thing." Hays agreed to let Quigley and Breen negotiate on his behalf with the Episcopal Committee. A meeting was planned for June 19 in Cincinnati. Meanwhile, the Legion of Decency, which had already collected three million pledges, held its first rally. Addressing fifty thousand people, Cleveland Bishop Joseph Schrembs exhorted them: "Purify Hollywood or destroy Hollywood!" The stage was set for Joseph Breen's ascendance.

THIS PAGE: Wallace Beery whips Fay Wray in Jack Conway's *Viva Villa!* Photograph by James Manatt. ◆ In Lloyd Bacon's *Wonder Bar*, Dick Powell and Al Jolson grin as John Marlowe leaves his partner and dances off with Demetrius Alexis. Photograph by Bert Longworth.

OPPOSITE: In Michael Curtiz's *Mandalay*, Kay Francis is the star attraction in a dive of dubious nature. "Make it more of a night club and gambling house than a hook shop," wrote producer Hal Wallis in a cautious memo. A month later, such scenes were outlawed.

THE PRODUCTION CODE ADMINISTRATION

I n June 1934, the Catholic Crusade roared on, gathering momentum and force. Will Hays likened it to an "avenging fire, seeking to clean as it burned." Pledges were signed, speeches were delivered, and hundreds of editorials were flung at Hollywood. The Hays Office counted more than two hundred editorials in one week.

In the *Los Angeles Times*, film critic Edwin Schallert wrote a three-part article that began: "Hollywood is in the most serious crisis of its history." Its most telling passage dealt with the transitory appeal of film. This was the argument that motion pictures were indefensible as art, and unworthy of protection from censorship. "Making pictures is not like writing literature or composing music or painting masterpieces," wrote Schallert. "The screen story is essentially a thing of today and once it has had its run, that day is finished. So far there has never been a classic film in the sense that there is a classic novel or poem or canvas or sonata. Last year's picture, however strong its appeal at the time, is a book that has gone out of circulation." He was apparently unaware that many "strong" films—*Grand Hotel*, *Red-Headed Woman*, *She Done Him Wrong*—had never gone

A CODE

TO GOVERN THE MAKING

OF MOTION AND TALKING

PICTURES

the

Reasons Supporting It

And the

Resolution for Uniform

Interpretation

by

Motion Picture Producers and Distributors of America, Inc.

JUNE 13, 1934

The amended Production Code took effect on July 1, 1934. Thus, the term "pre-Code" refers to films made before this strictly enforced document.

out of circulation. But this was a crisis, and the air was filled with half-truths.

In Chicago, Cardinal George Mundelein claimed credit for the 1930 Code, and charged the film companies with deception: "To them it was just another scrap of paper." Father Daniel Lord used the same metaphor in the *Queen's Work*: "This is the story of a great betrayal. It is the story of signatures written on scraps of paper. It is the record of words given and instantly violated, of men who made solemn pledges that they did not keep beyond the moment when the ink dried on the paper." In St. Louis, the Lord camp continued to foment ill will, gaining coverage in the *Saturday Evening Post* and the *New York Times*. In Chicago, Martin Quigley worked with Joseph Breen to formulate a document that would avoid the pitfalls of the Code. Before they could pitch it to the bishops, though, they had to be sure the film companies would back it.

A meeting of the MPPDA was convened in New York on June 13. Breen unveiled a modest pamphlet titled: "A Code to Govern the Making of Motion and Talking Pictures, the Reasons Supporting It and the Resolution for Uniform Interpretation." The new Code required that evil be identified as such by a major character in the film, and that it be punished, promptly and thoroughly. The meeting's most important accomplishment was to take the Studio Relations Committee away from the AMPP. It was henceforth answerable only to the MPPDA and could halt a film at the script stage. The AMPP jury was abolished, and replaced by the New York board of directors, a more impartial body. Would these changes be enough to make the Catholics call off their attack? Breen and Quigley

went to Cincinnati for a June 19 bishops' meeting. They were the only ones present who were without clerical collars, but Archbishop John McNicholas made them welcome; neither Daniel Lord nor Will Hays had been invited.

"The meeting lasted three days," remembered Hays. "None of us in the Association knew what was going on in Cincinnati. There was nothing to do but wait." While they waited, Breen and Quigley worked to convince McNicholas and the Episcopal Committee that their plan was worth backing. Besides the concessions of the MPPDA meeting, this plan offered theaters the option of canceling 10 percent of their block-booking if they didn't like all the films in the block. It also intended to pull offensive films such as *She Done Him Wrong* and *Convention City* from circulation. Theaters could even cancel contracts for films released before July 15, provided the films had been publicly condemned.

Most importantly, the plan gave Breen absolute authority: (1) a film could not be produced if he did not approve its script; (2) it could not be released if he did not give it a seal; and (3) if a company tried to release it without a seal, no MPPDA theater could play it.

Breen and Quigley told the bishops that the Catholic Crusade should continue, but that wildcat boycotts and blacklists must cease. Father FitzGeorge Dinneen disagreed, but was outvoted. He returned to the rival camp, where he prevailed upon Daniel Lord, Cardinal Mundelein, and Cardinal O'Connell to break with the Episcopal Committee. This schism was ill-advised; it caused momentary confusion and long-term bitterness.

On June 22, the MPPDA board of directors assembled in the Hays Office to wait for Breen and Quigley. A late train made them wait four hours. Among the executives waiting with Will Hays was Harry Warner, who had been hit hardest by the Philadelphia boycott. When Breen and Quigley made their entrance, wrote Hays, "I knew everything was all right from the cat-ate-canary expressions on their faces. Everyone crowded around them anxiously, but they, being Irish, could not resist having a little fun with us." Breen later described the scene for Jack Vizzard:

> There was Harry Warner, standing up at the top of the table, shedding tears the size of horse turds, and pleading for someone to get him off the hook. And well he should, for you could fire a cannon down the center aisle of any theater in Philadelphia, without danger of hitting anyone! And there was Barney Balaban of the Paramount Theatre chain, watching him in terror, wondering if he was going to be next in Chicago, and Nick Schenck of Loew's, wondering when he was going to be hit by a bucket of shit in New York.

Breen moved to the back of the room to await his cue. Quigley took the floor and announced that "The war had been called off." Effective July 1, the SRC would become the Production Code Administration (PCA). There was applause. "At last we have a police department," said Hays. There was more applause. But who would run it? "Gentlemen, we have the very man right here in our midst." Breen was brought to the front of the room, and he accepted the post of production code administrator; still more applause. He held up his hands: "But on one condition. And the condition is that you understand that I come from a race of people who have a long history of committing suicide—on the other guy!" To strengthen his assaults on "the other guy," another provision was added to the Code: a $25,000 fine that would be levied against any producer who dared to produce a film without PCA approval or to release a film without the PCA seal.

On July 11, 1934, the Production Code Administration opened for business in the Mayer Building, in the same suite the SRC had occupied. On that day, the PCA awarded the first seal, "Certificate of Approval No. 1," to an important Fox film directed by John Ford. *The World Moves On* was the three-generation saga of a family that learns to hate war. The film was, unfortunately, not a success. The Code, on the other hand, was a resounding success. It became effective on July 15, 1934, and it endured until 1968.

OPPOSITE: Madeleine Carroll and Franchot Tone in John Ford's *The World Moves On*; this was the first film to earn a Certificate of Approval from the newly empowered Production Code Administration (PCA). ◆ Some New York audience members booed and hissed when they saw this seal flash on the screen for the first time in July 1934.

FORBIDDEN HOLLYWOOD

When the smoke cleared and the anger subsided, no one stopped to consider the significance of what had just occurred. A Catholic minority had wrested control of a Protestant market from a Jewish-controlled industry. As if this were not sufficient cause for amazement, there was another issue to consider. Since 1922, this industry had been paying good money to a trade protection agency, the MPPDA, to protect it from a government takeover—yet the industry had constantly challenged that agency to do its job. If the studios had respected the deal, there would have been no Production Code, no Catholic Crusade, no PCA. This is human nature. There may not be a serpent, but there is always an apple. The industry had to live and learn. It escaped federal censorship, but it gained an in-house conscience.

The crusade had created excitement and, at times, confusion. It kept Breen out of the SRC for long stretches in April and May. As a result, certain films slid through the Code machinery. Two of these exhibited the most egregious flouting of the Code yet. They

could have been made examples of, yet they were not. A convergence of events conspired to save them.

Search for Beauty was a sexy comedy that surpassed *Convention City* in humor, irreverence, and sex. Based on a play called *Love Your Body*, it starred Robert Armstrong and James Gleason as con artists who dupe Olympic medalists (Ida Lupino and Buster Crabbe) into editing a near-defunct health magazine. Before long, the crooks have turned *Health and Exercise* into a skin-and-confession magazine. "So hot you could fry an egg on it!" says Armstrong. When Lupino objects to its "reeking" articles, Armstrong says: "My dear young lady, there can be no virtue without a knowledge of vice. You don't know a stove is hot until you touch it, do you? These stories all point a moral."

"Yes," she snaps. "Just enough moral to sneak them through the mails."

Armstrong reminds her that a board of censors must approve each story. In a scene that should have tweaked Breen, the film shows the censors as clubwomen who are titillated by the stories they review: "'I Loved an Artist' . . . Oh, those poets! What thrilling love lives they lead! Just leaping from one bed—of flowers—to another!"

"Don't you think it points a moral?" asks Armstrong.

"About 1 percent moral," answers a censor. "And 99 percent sex."

"There's nothing wrong with sex," says Armstrong. "As long as it leads to, uh, what it leads to."

"I got nothin' against sex," pipes up Gleason. "Either ya got it or ya go lookin' for it."

The script thumbed its nose at Breen when teenagers Sally (Toby Wing) and Susie (Verna Hillie) compare notes on "I Loved an Artist." Sally says: "I sure wish I could meet a guy like that 'dark, mysterious artist.' Of course, you get a bill for it in the end."

"Bill?" sneers Susie. "Baloney! That 'paying the price' stuff is the bunk. They just put that in to make the yarn moral. I'll bet that dame is living on Park Avenue, riding around in an imported oil can, and splashing mud in the faces of pure working girls."

Oddly, Breen did not bristle at this insult to his "voice for morality." He only warned Paramount about certain visual problems. "The shot of Crabbe seen through the woman's binoculars, concentrating on his loins, and the shot in the locker room, in which a couple of men run through naked." The film was released without cuts, but it only got through Chicago and New York in the same condition. Every other board cut it, loins, locker room, and all.

Yet *Search for Beauty* had gotten past Joseph Breen. Perhaps Marlene Dietrich and Josef von Sternberg could, too. In late 1933, they had been completing their sixth film, *Catherine the Great*. This fantastic biography of Russia's oversexed sovereign was slated for release in April, but in December the British producer Alexander Korda announced that he was releasing his own version, starring Elizabeth Bergner. *The Rise of Catherine the Great* was scheduled for a London release in January and for New York in February. Rather than have Sternberg accelerate the pace of his meticulously planned production, Paramount delayed its release until the British film could play its limited engagements in the United States. Publicity photos of Dietrich as Catherine were recalled and new slugs were glued to them: "The title of this film has been changed to *The Scarlet Empress*."

Sternberg could not resist opening *The Scarlet Empress* in London, which would spite Korda. To do this, he had to rush the film through the SRC. When Breen saw the most adult, depraved, sex-obsessed film of the entire pre-Code period, he brought in Hays, ran the film again, and called an emergency meeting with Sternberg and Paramount executives. But the Catholic Crusade required his attention more than one movie, and Sternberg was insistent about the opening. When Breen left to consult with Quigley, someone let *The Scarlet Empress* slip under the wire. It premiered at the Carlton Theatre in London on May 9, 1934.

In July, when Breen was putting PCA seals on Paramount films, for some reason he did not look at *The Scarlet Empress*, perhaps because it had already premiered. Someone gave it a seal and sent it out.

In September, the Legion of Decency got as far as the first reel, where an eight-year-old girl dreams of three beheadings, a naked woman falling out of an "iron maiden," three topless women being burned at the stake, and a "human clapper" swinging inside a huge bell. The Legion slapped a "condemned" rating on *The Scarlet Empress*, but Breen paid no attention. Nor did anyone else. In spite of guardedly positive reviews, no one went to see the film. No one understood it,

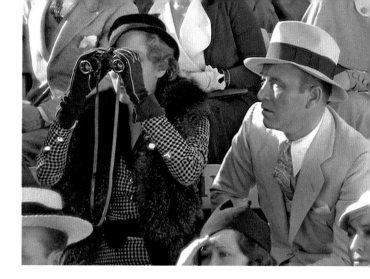

and word of mouth killed it. Everyone, including Mae West, dismissed it as "an arty disaster." What was possibly the best-scripted, best-photographed, and best-directed film of the period was written off as a waste of celluloid. But its PCA seal saved it from the fate that awaited a hundred other films.

Breen had promised to pull objectionable films from circulation, so in the fall of 1934, with the PCA humming along, he turned to the task of reclassifying films already in release. Class I films would be pulled and never rereleased. They included *She Done Him Wrong*, *I'm No Angel*, *George White's Scandals*, *The Story of Temple Drake*, *Baby Face*, and *Convention City*. A 1932 film that was still trying to recoup its cost was Ernst Lubitsch's *Trouble in Paradise*. The Legion of Decency had recently condemned it, so Breen put it in Class I. Class II films would complete their exhibition contracts, never to be rereleased. These included *Riptide*, *Search for Beauty*, and *Queen Christina*. Class III films would be reviewed and then resubmitted for PCA seals. *Tarzan and His Mate* was a typical Class III film.

By mid-1935, Breen had begun to inspect the Class III films. In case after case, he found scenes and lines that could no longer be screened, let alone filmed. To reissue these films as they were would undermine the mission of the PCA. He also believed that these films were "dangerous" to any unknowing person who might see them. But these films represented potential income to the studios; their stars were still popular

These scenes from *Search for Beauty* show how brazen films had become by the spring of 1934. *Search for Beauty* only got past Breen and the SRC because they were preoccupied with the Catholic campaign.

FORBIDDEN HOLLYWOOD

and their titles were still known. Breen acknowledged this problem with a regrettable solution. For the next nineteen years, if the studios wanted to rerelease a film, he made them cut scenes—not from prints, not from fine-grain positives, not from dupe negatives—but *from master camera negatives.*

Victims of Breen's extensive, jarring cuts included: *All Quiet on the Western Front*, *Animal Crackers*, *Morocco*, *Mata Hari*, *The Public Enemy*, *Frankenstein*, *Dracula*, *Dr. Jekyll and Mr. Hyde*, *Shopworn*, *Horse Feathers*, *Blessed Event*, *A Farewell to Arms*, *Blonde Venus*, *Love Me Tonight*, *The Mask of Fu Manchu*, *Shanghai Express*, *The Sign of the Cross*, *The Bowery*, *The Eagle and the Hawk*, *King Kong*, *Counsellor-at-Law*, *Manhattan Melodrama*, *Tarzan and His Mate*, *The Merry Widow*, and *Viva Villa!*

To call these films "victims" is to assert that they, though only made of imagination and chemicals, were works of art with souls. No one believed that films were art. They had no legal protection. Then came the *Miracle* case. In May 1952, the US Supreme Court overturned a lower court decision banning Roberto Rossellini's film *The Miracle*, and in the process threw out *Mutual Film v. Ohio.* As quoted in the May 31, 1952 issue of *Boxoffice*, Justice Tom Clark wrote: "The importance of motion pictures as an organ of public opinion is not lessened by the fact that they are designed to entertain as well as to inform. Nor should film be subject to censorship because it is an industry conducted for profit, as such a category would also include the press. Finally, the medium's supposed capacity for evil, if it existed at all, was not sufficient justification for substantially unbridled censorship such as we have seen here."

This decision came too late for the pre-Code films. A hundred titles had been cut, and the nitrate "trims" had been thrown away.

Joseph Breen's tenure ended in 1954. When he retired, the Academy of Motion Picture Arts and Sciences presented him with the coveted Academy Award for Lifetime Achievement. The award was inscribed: "To our industry's benevolent conscience." This was a long way from the contentious days of 1934. Breen, who had railed against the immorality of the Hollywood Jews, had learned from them—and they from him. They would not have asked him to run RKO Pictures in 1942 if he had been truly anti-Semitic. They would not have flown him here and there. They would never have invited him into their homes. (Producer Sam Spiegel accepted a cash loan from Breen to buy a home.) They certainly would not have given him an Academy Award. Breen had convictions. He had a temper. He was a fighter, but he did not hate.

According to Jack Vizzard, who worked with Breen from 1944 to 1954: "Towards the end of his career, I asked Joe why he didn't write the story of the Code. He waved off the suggestion with a touch of irritation. 'Jack,' he said, 'I have too many friends in the industry, and I wouldn't want to say anything to embarrass them.' I think the same thing happened to him as happened to me. I came running down out of the theological hills, where I was studying for the priesthood, to save the world from the Jews. They reciprocated by saving me from myself."

OPPOSITE: Josef von Sternberg's *The Scarlet Empress* was the most libidinous film of the entire pre-Code period, yet it survived the Breen regime to become an acknowledged classic. Portrait of Marlene Dietrich by Don English.

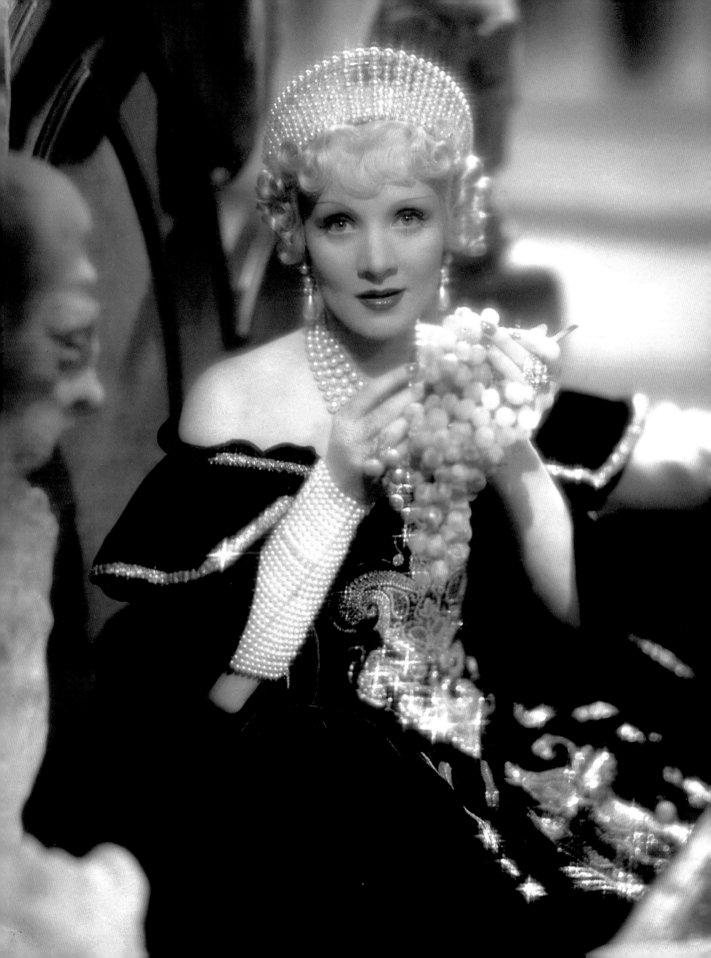

EPILOGUE

There was no television in the pre-Code era. For many reasons, the 1920s invention did not become a commercial entity until the late 1940s. John Golden, the prominent Broadway producer, told a class of Columbia University students in 1932: "Television will do to films what pictures did to the stage, taking its stars, its authors, and its audience." It took its movies, too.

Starting in the mid-1950s, television started buying libraries of pre-1948 sound films from the majors. "Packages" of 16mm prints arrived at local TV stations, where they were scheduled between network programming and local fare. The Production Code was still in force but did not apply to television, so the brash and breezy movies of the early thirties were aired where Baby Boomers could see them, and in their original uncensored versions. By 1965, vintage movies accounted for 25 percent of local programming, and a new generation fell in love with Joan Crawford, Clark Gable, and the Marx Brothers. Since

The *Oakland Tribune* ran a syndicated but uncredited cartoon in July 1934.

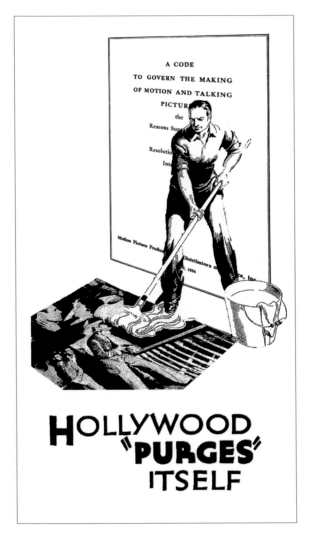

the reissue policies of most studios were limited to recent product, few of these films had been seen since their initial release. Yet a national magazine described an incident in which a late-night broadcast of *The Thin Man* brought angry calls to a TV station because an employee, when splicing commercials into the film, had put the reels out of order.

It was possible, in the span of a week, to see films from every year of the Golden Era, and to make judgments previously limited to professional critics. It was at this time, for example, that film fans realized that 1932 had yielded a cornucopia of classics: *Shanghai Express*, *Tarzan the Ape Man*, *Grand Hotel*, *Love Me Tonight*, *The Sign of the Cross*, *Trouble in Paradise*, *The Mummy*, and *Red Dust*.

The article did not call *The Thin Man* a "pre-Code movie." In the quarter century since that period, only one book had written about it. *The Movies* by Richard Griffith and Arthur Mayer was a pictorial history published in 1957. With section headings like "The Grim Thirties," "Decency," and "The Gathering Storm," it told the story accurately but did not use the term *pre-Code*. In 1983, the PCA files were given to the Margaret Herrick Library at the Academy of Motion Picture Arts and Sciences. Researchers found the correspondence between censors and producers quaint but engrossing. Books drawing on this material began to appear, but there was still no designation of the pre-Breen era.

When did *pre-Code* come into the lexicon?

In the '60s and '70s, when boomers were attending college, America rediscovered its film heritage, and repertory cinemas became popular. A programmer named Bruce Goldstein cut his teeth at venerable

houses like the Thalia. When he began programming at the Film Forum in 1987, he redefined repertory with previously unthought-of genres such as widescreen. In 1988, he coined the term *pre-Code*. For the first time, films of the early '30s had a category. The concept was borrowed for programs at the Castro Theatre in San Francisco and the Nuart in Los Angeles, and it was only a matter of time before pre-Code movies joined the home entertainment market. In 1993, MGM-UA Home Video launched a "Forbidden Hollywood" series on VHS and laser disc.

Pre-Code became so popular in the '90s that, with the help of Mick LaSalle—film critic of the *San Francisco Chronicle*—I was able to restore the critical view of Norma Shearer, the foremost pre-Code star. We began with sold-out retrospectives at Elliot Lavine's Roxie Theatre and continued with my book, *Hurrell's Hollywood Portraits*, and with LaSalle's book, *Complicated Women*. A scholarly pre-Code work was published by Columbia University Press in 1999, *Pre-Code Hollywood* by Thomas Doherty. Appearing at the same time was my book for Harry N. Abrams, *Sin in Soft Focus*. Doherty analyzed the genre. I told the story of the Code, film by film, with a detailed, illustrated narrative. After my book was reviewed by Robert Gottlieb in the *New York Times*, it sold out its first printing.

In the decades since, pre-Code has merited a *Vanity Fair* article by James Wolcott, a documentary of *Complicated Women* by Timeline Films, and a dozen other documentaries. Pre-Code discs are released on a regular basis by Warner Archive, Sony, Universal, and Twentieth Century-Fox, all in partnership with Turner

Classic Movies. Pre-Code film festivals are as popular as those for film noir, and many more pre-Code films are available on DVD, on cable, and via streaming.

The story of pre-Code Hollywood is one of living history. Even as the motion picture industry has made a transition from gelatin-based film to digital formats, home entertainment companies and archives have also found new ways to make their holdings available. Where I once plopped myself into a theater seat at the Vagabond on Wilshire and Carondelet to see the uncensored vault print of *Blonde Venus*, I now slide a disc into a Blu-ray player to see a restored version of the film, free of scratches, splices, dust, dirt, and other artifacts. I don't wish to engage in an apples-and-oranges debate of film quality versus digital quality. I know the merits, and drawbacks of each technology—intimately so. The important thing to me, whether I'm watching 16mm or streaming high-definition content, is that I am able to see the film, in as close an approximation of its original presentation as possible.

A question remains: What would Daniel Lord, Martin Quigley, James Wingate, Joseph Breen, Jason Joy, Cecil B. DeMille, Irving Thalberg, Norma Shearer, Joan Crawford, Darryl Zanuck, Mae West, Hal Wallis, Jean Harlow, Marlene Dietrich, Josef von Sternberg, and all the other characters of this saga think of the status that pre-Code films have attained? Was the struggle for nothing? Were they misguided—the producers, who wanted more sin, or the censors, who wanted none?

Community standards change. Acting styles change. Cinematic techniques change. And yet, there are constants. If not, how could we look at a film from last year, let alone from ninety years ago? I know there are people who have never watched a black-and-white Hollywood classic. And there are people in 2019 who have never read a book. Yet pre-Code Hollywood continues to share its delights.

Lest we forget, the era made stars of the Marx Brothers, Wallace Beery, Marie Dressler, Kay Francis, Maurice Chevalier, Jeanette MacDonald, Clark Gable, Jean Harlow, Robert Montgomery, Katharine Hepburn, Johnny Weissmuller, Barbara Stanwyck, Fredric March, Dick Powell, Marlene Dietrich, James Cagney, Constance Bennett, Boris Karloff, Irene Dunne, Edward G. Robinson, Bette Davis, Paul Muni, Cary Grant, and Mae West. Their pre-Code films are watchable, and this book will direct you to the best of them. When you see *She Done Him Wrong*, you can watch for the place where James Wingate cut two stanzas. There is a jump cut.

I was not alive in 1933 to witness the first audience response to *She Done Him Wrong*, but in my lifetime I have seen a range of presentations. I saw it for the first time in 1966 on late-night San Francisco TV. The announcer introduced it with a condescending disclaimer: "This was quite a controversial movie back in '33. Let's see how it stacks up against the new movies." He could have saved his breath. The 16mm print was censored. Most of the best lines had been cut. Splice, splice, splice!

Later that year, the *San Francisco Chronicle* put Mae West on the cover of the Sunday entertainment section. I promptly pinned the page to the front archway of my homeroom at St. Joseph's High School in Alameda. The principal walked in and told me to take it down. Censorship was alive and well in 1966, at least in the Bay Area.

In 1970 another local station broadcast *She Done Him Wrong*, this time uncensored, so I finally got to hear Mae West say, "Aw, you can be had." In 1984 I saw the nitrate vault print of *She Done Him Wrong* at Berkeley's Pacific Film Archive with an audience full of women. I wondered if they'd like it. They screamed with delight. The same thing happened at the Los Angeles County Museum of Art during the Cary Grant series a few years back. Mae West hijacked the series from Grant. Nearly ninety years after its release, in a world of perishable substances and evanescent taste, *She Done Him Wrong* still exists. It glows from a digital transfer and its soundtrack is rich and clear. A film that should be barely watchable, that some would dismiss as a creaky relic, has life, breath, energy, and, yes, sex.

Cary Grant and Mae West in *She Done Him Wrong*.

SELECTED BIBLIOGRAPHY

BOOKS

Amory, Cleveland, and Frederick Bradlee. *Cavalcade of the 1920s and 1930s.* New York: Viking Press, 1960.

Barrios, Richard. *Screened Out: Playing Gay in Hollywood from Edison to Stonewall.* New York: Routledge, 2003.

Barrymore, John. *We Three.* New York: Saalfield Publishing Company, 1935.

Bawden, James, and Ron Miller. *Conversations with Classic Film Stars: Interviews from Hollywood's Golden Era.* Lexington, Kentucky. University Press of Kentucky, 2016.

Baxter, Peter. *Just Watch! Sternberg, Paramount, and America.* London: British Film Institute Publishing, 1993.

Behlmer, Rudy. *Inside Warner Bros. (1935-1951).* New York: Viking Penguin, Inc., 1985.

Behrman, S. N. *People In A Diary.* Boston: Little, Brown and Company, 1972.

Berg, A. Scott. *Goldwyn: A Biography.* New York: Alfred A. Knopf, 1989.

Black, Gregory D. *Hollywood Censored: Morality Codes, Catholics, and the Movies.* Cambridge: Cambridge University Press, 1994.

Chauncey, George. *Gay New York: Gender, urban culture, and the making of the gay male world, 1890-1940.* New York: BasicBooks, 1994.

Chierichetti, David. *Mitchell Leisen: Hollywood Director.* Los Angeles: Photoventures Press, 1995.

Crowther, Bosley. *The Lion's Share.* New York: E. P. Dutton and Company, 1957.

Curtis, James. *James Whale.* Metuchen, New Jersey: Scarecrow Press, 1982.

_____. *James Whale: A New World of Gods and Monsters.* Boston, Faber and Faber, 1998.

DeMille, Cecil Blount. *The Autobiography of Cecil B. DeMille.* Englewood Cliffs, New Jersey: Prentice-Hall, Inc., 1959.

Doherty, Thomas. *Pre-Code Hollywood: Sex, Immorality, and Insurrection in American Cinema, 1930-1934.* New York: Columbia University Press, 1999.

_____. *Hollywood's Censor: Joseph I. Breen & the Production Code Administration.* New York: Columbia University Press, 2007.

Durgnat, Raymond, and John Kobal. *Greta Garbo.* New York: E. P. Dutton, 1965.

Eels, George. *Ginger, Loretta and Irene Who?* New York: G. P. Putnam's Sons, 1976.

Ernst, Morris L., and Pare Lorentz. *Censored: The Private Life of the Movie.* New York: Jonathan Cape and Harrison Smith, 1930.

Eyman, Scott. *Ernst Lubitsch: Laughter In Paradise.* New York: Simon and Schuster, 1993.

Facey, Paul W. *The Legion of Decency: A Sociological Analysis of the Emergence and Development of a Social Pressure Group.* New York: Arno Press, 1974.

Forman, Henry James. *Our Movie-Made Children.* New York: MacMillan, 1933.

Gatiss, Mark. *James Whale.* London: Cassell, 1995.

Greenberg, Joel, and Charles Higham. *The Celluloid Muse.* New York: Signet, 1972.

Gussow, Mel. *Don't Say Yes Until I Finish Talking.* New York: Doubleday and Company, 1971.

Hamann, G. D. *Mae West in the '30s.* Los Angeles: Filming Today Press, 1997.

Hays, Will H. *The Memoirs of Will H. Hays.* Garden City, New York: Doubleday and Company, 1955.

Higham, Charles. *Cecil B. DeMille.* New York: Charles Scribner's Sons, 1973.

_____. *Hollywood Cameramen.* Bloomington, Indiana: Indiana University Press, 1970.

Jacobs, Lea. *The Wages of Sin: Censorship and the Fallen Woman Film, 1928-1942.* Madison, Wisconsin: The University of Wisconsin Press, 1991.

Keats, John. *Howard Hughes.* New York: Random House, 1966.

Kobal, John. *People Will Talk.* New York: Alfred A. Knopf, 1985.

Koszarski, Richard. *The Man You Loved to Hate: Erich von Stroheim and Hollywood.* New York: Oxford University Press, 1983.

Kotsilibas-Davis, James, and Myrna Loy. *Being and Becoming.* New York: Alfred A. Knopf, 1987.

Lawrence, Jerome. *Actor: The Life and Times of Paul Muni.* New York: G. P. Putnam's Sons, 1974.

Lasky, Jesse L. with Don Weldon. *I Blow My Own Horn.* Garden City, New York: Doubleday, 1957.

Lasky, Jesse L. Jr. *What Ever Happened to Hollywood?* New York: Funk & Wagnall's, 1973.

Leff, Leonard J., and Jerold L. Simmons. *The Dame in the Kimono: Hollywood, Censorship, and the Production Code from the 1920s to the 1960s.* London: Weidenfeld and Nicolson, 1990.

Lord, Daniel A., S. J. *Played by Ear.* Chicago: Loyola University Press, 1956.

Loos, Anita. *Kiss Hollywood Good-by.* New York: Viking Press, 1974.

Madsen, Axel. *Stanwyck.* New York: HarperCollins, 1994.

Mank, Gregory William. *It's Alive! The Classic Cinema Saga of Frankenstein.* New York: A. S. Barnes & Company, 1981.

_____. *Karloff and Lugosi: The Story of a Haunting Collaboration.* Jefferson, North Carolina: McFarland and Company, 1990.

McBride, Joseph. *Hawks on Hawks.* Berkeley: University of California Press, 1982.

McCarthy, Todd. *Howard Hawks.* New York: Grove Press, 1997.

McGilligan, Pat. *Backstory 1: Interviews with Screenwriters of Hollywood's Golden Age.* Berkeley: University of California Press, 1986.

Marx, Samuel. *Mayer and Thalberg, the Make-Believe Saints.* New York: Random House, 1975.

Miller, Frank. *Censored Hollywood: Sex, Sin, and Violence on Screen.* Atlanta: Turner Publishing, 1994.

Moley, Raymond. *The Hays Office.* New York: Bobbs-Merrill, 1945.

Mosley, Leonard. *Zanuck: The Rise and Fall of Hollywood's Last Tycoon.* Boston: Little, Brown, 1984.

Negulesco, Jean. *The Things I Did and the Things I Think I Did.* New York: Linden Press/Simon and Schuster, 1984.

Parish, James Robert, and Mank, Gregory William. *The Best of MGM.* Westport, Connecticut: Arlington House Publishers, 1981.

Pizzitola, Louis. *Hearst over Hollywood: Power, Passion, and Propaganda in the Movies.* New York: Columbia University Press, 2002.

Quigley, Martin. *Decency in Motion Pictures.* New York: MacMillan, 1937.

Quirk, Lawrence J. *Norma.* New York: St. Martin's Press, 1988.

Savada, Elias and David Skal. *Dark Carnival: The Secret World of Tod Browning.* New York: Anchor Books, 1995.

Schulberg, Budd. *Moving Pictures: Memoirs of a Hollywood Prince.* London: Alison & Busby, 1993.

Shorris, Sylvia and Marion Abbott Bundy. *Talking Pictures.* New York: The New Press, 1994.

Stenn, David. *Clara Bow: Runnin' Wild.* New York: Doubleday, 1988.

Thomas, Bob. *Thalberg: Life and Legend.* Garden City, New York: Doubleday and Company, 1969.

Vasey, Ruth. *The World According to Hollywood, 1918-1939.* University of Wisconsin Press, 1997.

Viertel, Salka. *The Kindness of Strangers.* New York: Holt, Rinehart and Winston, 1969.

SELECTED BIBLIOGRAPHY

Vizzard, Jack. *See No Evil: Life Inside A Hollywood Censor.* New York: Simon and Schuster, 1970.

Walker, Alexander. *Joan Crawford, The Ultimate Star.* New York: Harper and Row, 1983.

Walsh, Frank. *Sin and Censorship: The Catholic Church and the Motion Picture Industry.* New Haven: Yale University Press, 1996.

West, Mae. *Goodness Had Nothing to Do With It.* Englewood Cliffs, N. J.: Prentice-Hall, Inc., 1959.

Zukor, Adolph. *The Public Is Never Wrong.* New York: G. P. Putnam's Sons, 1953.

SIGNED ARTICLES

Babcock, Muriel. "Burlesque Days' Buxom Figure Comes to Films." *Los Angeles Times*, January 29, 1933, p. A1.

_____. "Freaks Rouse Ire And Wonder." *Los Angeles Times*, February 14, 1932, p. 8.

Ball, Cecil. "Call Her Savage." *The Daily Texan*, February 16, 1933, p. 3.

Behlmer, Rudy. "Tarzan, Hollywood's Greatest Jungle Hero." *American Cinematographer* 68, no. 11 (January 1987), pp. 38-48.

Biery, Ruth. "The New Shady Dames of the Screen." *Photoplay*, August 1932, p. 27.

Bige. "The Sign of the Cross." *Variety*, December 6, 1932, p. 11.

Black, Gregory D. "Hollywood Censored: The Production Code Administration and the Hollywood Film Industry, 1930-1940." *Film History* 3, no. 3 (1989), pp. 167-189.

Brown, Robert H. "Stix vs. City on Pix." *Variety*, December 6, 1932, p. 5.

Chrisman, J. Eugene. "Jean Harlow and Judge Ben Lindsey Discuss Sex." *Hollywood*, March 1934.

Donnell, Dorothy. "Will His First Big Break Be His Last?" *Movie Classic*, May 1933, pp. 31, 58.

Everson, William K. "Film Treasure Trove." *Films in Review* 25, no. 10 (December 1974), pp. 595-610.

Eyles, Allen. "Donald Ogden Stewart." *Focus on Film* no. 5 (Nov./Dec. 1970), pp. 49-57.

Green, Abel. "Rain." *Variety*, October 18, 1932, p. 14.

_____. "Rasputin and the Empress." *Variety*, December 27, 1932, p. 15.

Hall, Gladys. "Has Hollywood Turned a Cold Shoulder on Tallulah Bankhead?" *Motion Picture*, September 1932, p. 47.

_____. "Norma Shearer Tells What A 'Free Soul' Really Means." *Motion Picture* 12, no.11 (November 1931), pp. 48-49, 96.

_____. "Norma Shearer, a Heroine to Others." *Motion Picture*, January 1933, p. 27.

Hall, Mordaunt. "Clara Bow as a Termagant." *The New York Times*, November 25, 1932, p. 19.

_____. "Mae West's Film." *The New York Times*, February 19, 1933, p. X5.

_____. "Mr. DeMille's Sign of the Cross." *The New York Times*, December 11, 1932, p. X7.

_____. "Sadie Thompson Again." *The New York Times*, October 13, 1932. p. 18.

Hullinger, Edwin W. "Free Speech for the Talkies?" *North American Review* 8, no.6 (June 1929), n.p.

Jacobs, Lea. "Industry Self-Regulation and the Problem of Textual Determination." *The Velvet Light Trap* 23 (Spring 1989), pp. 6-15.

Kingsley, Grace. "Mummy—Player Stars in Own Story." *Los Angeles Times*, October 31, 1932, p. 9.

Klumph, Helen. "Broadway Film Fates Skittish." *Los Angeles Times*, July 10, 1932.

Koszarski, Richard, and William K. Everson. "Stroheim's Last 'Lost' Film: The Making and Remaking of 'Walking Down Broadway'." *Film Comment* 11, no. 3 (May-June 1975), pp. 6-19.

Leff, Leonard J. "A Farewell To Arms: Unmaking the 1932 Version." *Film Comment* 31, no. 1 (January/February 1995), pp. 70-73.

Lewis, Charles E. "Susan Lenox—Passing in Review." *Motion Picture Herald*, October 24, 1931, p. 27.

Lord, Daniel, A., S. J. "Code Violators." *The Queen's Work* 26, no. 9 (June 1934), p. 1.

_____. "Hollywood Treats Own Code As 'Scrap of Paper' in Great Public Betrayal." *The Queen's Work* 26, no. 9 (June 1934), pp. 1, 10-11.

Lusk, Norbert. "DeMille Again the Old Master." *Los Angeles Times*, December 5, 1932, p. B17.

Maltby, Richard. "*Baby Face,* or How Joe Breen Made Barbara Stanwyck Atone for Causing the Wall Street Crash." *Screen* 27, no. 2 (March/April 1986), pp. 22-45.

_____. "The Genesis of the Production Code." *Quarterly Review of Film and Video* 15, no. 4 (March 1995), pp. 5-57.

McGoldrick, Rita C. "Your Public." *Motion Picture Herald*, January 30, 1932. p. 50.

Meehan, Leo. "DeMille, the Master of Spectacle." *Motion Picture Herald*, December 3, 1932, p. 22.

Meehan, Leo. "Musicomedy Comeback." *Motion Picture Herald*, January 21, 1933, p. 28.

_____. "Passing in Review." *Motion Picture Herald*, November 14, 1931, pp. 39, 42.

Merrick, Mollie. "Hollywood in Person." *Los Angeles Times*, September 10, 1932, p. A7.

_____. "Film Official Tells Outlook." *Los Angeles Times*, September 30, 1932, p. 12.

Mitchell, Charles P. "Marilyn and the Monster." *Films of the Golden Age,* Winter 1997/98, pp. 44-48.

Morris, Ruth. "Sinful Girls Lead in 1931." *Variety*, December 31, 1931, p. 5.

O'Sullivan, Joseph. "Music as a Spiritual Symbol." *Motion Picture Herald*, December 17, 1932, p. 17.

Parry, Florence Fisher. "I Dare Say." *Pittsburgh Press*, July 17, 1932.

Parsons, Louella. "Flagg and Quirt Win Acclaim in Film at Chinese." *Los Angeles Examiner*, September 25, 1929.

Peet, Creighton. "Possessed." *Outlook and Independent* 159 (December 2, 1931), p. 439.

Poff, Tip. "Nero Laughton—That Certain Party." *Los Angeles Times*, February 4, 1933.

Pryor, Nancy. "No More Nighties for Jeanette," *Motion Picture*, February 1932, pp. 27, 97.

Ramsaye, Terry. "Lust, Horror, Faith." *Motion Picture Herald*, December 3, 1932, p. 8.

_____. "Mistress Mary Asks Producers to Try Discovering America Again." *Motion Picture Herald*, August 19, 1933, p. 10.

_____. "The Money The Sign of the Cross Has Lost." *Harrison's Reports*, February 18, 1933, p. 25.

Schallert, Edwin. "Film Producers Shaken by Clean-Up Campaign." *Los Angeles Times*, June 10, 1934.

_____. "The Sign of the Cross Effective." *Los Angeles Times*, January 23, 1932.

Scheuer, Philip K. "Beast of City Thriller." *Los Angeles Times*, April 5, 1932, p. A8.

_____. "Freaks Film Side Show." *Los Angeles Times*, February 15, 1932, p. 7.

_____. "Harlow Surprises." *Los Angeles Times*, June 25, 1932, p. A7.

_____. "Joan Crawford's Mouth Smeared Up to the Limit." *Los Angeles Times,* September 11, 1932, p. B15.

_____. "Scarface Gangland Epic." *Los Angeles Times*, April 23, 1932, p. A7.

Sherwood, Robert. "This Is What They're Saying." *Kalamazoo Gazette,* October 6, 1929.

Sime. "Front Page—Film Reviews." *Variety*, March 25, 1931, p. 17.

Whitaker, Alma. "Mae West Loves to Shock 'Em." *Los Angeles Times*, April 16, 1933, p. B6.

Wilkerson, W.R. "Howard Hughes Scarface—Tradeviews." *The Hollywood Reporter*, April 30, 1946, p. 1.

Williams, Whitney. "Coming Films Previewed." *Los Angeles Times,* October 23, 1932, p. B7.

ANONYMOUS ARTICLES

"As Seen by Marlen Pew." *The Churchman, October 26, 1929,* pp. 16-17.

"Baby Face." *Variety,* June 27, 1933, p. 15.

"Banned from Bathroom." *Variety,* February 2, 1932, p. 6.

"Big Films Got Big Loop Business." *Variety,* July 10, 1929, p. 8.

"Breen Gives Voice." *Motion Picture Herald,* April 21, 1934, p. 21.

"California Cults." *Time,* March 31, 1930.

"Censors—Letters from Our Readers." *Motion Picture,* September 1932, p. 6.

"Clara Bow's OK Film Comeback." *Variety,* November 15, 1932, p. 3.

"Cock Air Cleared But at Cost of $100,000." *Variety,* January 12, 1932, p. 7.

"Cycle Wheels Right Over Hays' Code." *Variety,* September 9, 1930.

"Dealing with Capone." *Time* 18, no. 6 (August 10, 1931), p. 1.

"Dirt Craze Due to Women." *Variety,* June 16, 1931, p. 5.

"Easiest Way." *Harrison's Reports,* February 21, 1931, p. 30.

"Editorial." *The New York Telegraph,* September 22, 1930.

"Grand Hotel—Brickbats." *Photoplay,* July 1932, p. 8.

"Grand Hotel—Letters from Our Readers." *Motion Picture,* September 1932, p. 6.

"Grand Hotel—Box Office Critics." *New Movie,* March 1932, p. 80.

"Here's a Censoress's Cinematic Dislikes." *Variety,* November 29, 1932, p. 1.

"Hollywood Promises." *Commonweal* 16, April 1930, p. 668.

"In Chicago." *Outlook and Independent,* July 3, 1929, p. 378.

"Letty Lynton—The Audience Talks Back with Brickbats and Bouquets." *Photoplay,* August 1932, p. 6.

"Miss West Talks Shop." *The New York Times,* February 3, 1935, p. 5.

"Morals for Profit." *The New York World,* April 1, 1930.

"Movie Censors Hear Their Master's Voice." *Christian Century,* July 13, 1932.

"News and Gossip of the Studios." *Motion Picture* 43, No. 1 (February 1932) p. 39.

"No Publicity Is Academy Policy." *Variety,* November 1, 1932, p. 2.

"The Norma Shearer Irving Thalberg Loves." *New Movie* 9, no. 5, (May 1934) pp. 32-33, 70-72.

"Philadelphia—Box Office Critics." *New Movie,* March 1932, p. 80.

"Picture Don'ts for '30." *Variety,* February 19, 1930, p. 9.

"Producers Sadly Quit Gang Cycle." *Variety,* August 11, 1931. p. 6.

"Production Code Scrap of Paper Says Mundelein." *Motion Picture Herald,* June 9, 1934, p. 40.

"Public Enemy—Letters to the Editor." *Motion Picture* XLIII No. 2 (March 1932), p. 6.

"Public Enemy." *Time* 17, no. 18 (May 4, 1931), p. 44.

"San Quentin—The Audience Talks Back," *Photoplay,* October 1932, p. 6.

"Steffey Prize Winner." *Motion Picture Herald,* February 11, 1933, p. 54.

"Susan Lenox—Looking 'Em Over." *Motion Picture Daily,* July 13, 1931, p. 3.

"Television—News from the Dailies." *Variety,* July 19, 1932, p. 46.

"What the Press Says." *Motion Picture Herald,* December 26, 1931.

"Writers War on Filth." *The Hollywood Reporter,* February 27, 1933, p. 2.

UNPUBLISHED DOCUMENTS

"Norma Shearer Arrouge Memoir Notes." Unpublished document, author's collection.

"Popular Arts Project: Ben Hecht, 1959." Columbia University Oral History Collection.

Wall, James M. "Oral Interview with Geoffrey Shurlock." Louis B. Mayer-American Film Institute Film History Program

AUDIOTAPE

Knight, Arthur. "Oral Interview with Lawrence Weingarten." Recorded March 5, 1974, in Knight's Cinema 305 Class, History of the American Sound Film, University of Southern California

DOCUMENTARY FILM

MGM: When The Lion Roars. Turner Broadcasting, March 1992.

INTERVIEWS

Ted Allan, March 2, 1986

Clarence Sinclair Bull, November 2, 1975

David Chierichetti, December 3, 1995

George Hurrell, November 1, 1975

Jack Vizzard, January 16, 1998

Bill Pace, September 12, 2012

WEBSITES

https://supreme.justia.com

https://mppda.flinders.edu.au/

http://digitalcollections.oscars.org/cdm/

https://pureentertainmentpreservationsociety.wordpress.com/

INDEX

ACKNOWLEDGMENTS

To find new information on the pre-Code era for *Forbidden Hollywood*, I built on the research I did in the late 1990s for *Sin in Soft Focus*. I must briefly thank those institutions and individuals who were not involved in the new project. I thank Linda Mehr of the Margaret Herrick Library at the Academy of Motion Picture Arts and Sciences, where I was able to study the Code correspondence for 100 films. I thank Paul Meienberg for introducing me to *Search for Beauty*. I thank Joel Gotler and Alan Nevins of Renaissance for taking on the book.

I'm sorry that a number of individuals who helped me with *Sin in Soft Focus* are no longer living: Roger Mayer of Turner Entertainment; Rex Bell, Jr., of the Clara Bow Estate, and Clare Cameron. I remember the help I received from Carole York in the days of Memory Shop West. I remember researching pre-Code films with Harvey Stewart. I wish to acknowledge years of support from David Chierichetti. All my books have benefited from the generosity of Ben Carbonetto. Lastly, the retired censor Jack Vizzard became a mentor, taking me back in time, yet making sure I kept my scholarly feet in the present.

For helping me begin research on this book, I thank Ned Comstock, Senior Library Assistant, Cinematic Arts Library at the University of Southern California.

For help with Production Code research, I thank Richard Maltby and the MPPDA Digital Archive at Flinders University. I thank David Pierce and the Media History Digital Library. I thank Tiffany Brannan of the Pure Entertainment Preservation Society for new information about Joseph Breen and Geoffrey Shurlock. I thank Danny Reid of precode.com for marshaling his resources on my behalf. Thanks also go to Mary Mallory; Richard Barrios; Anthony Carrillo; Eugene Kenourgios; Jeff Mantor of Larry Edmunds Cinema Bookshop; and Michael Ribak at Universal Home Video.

For access to photographs and archival documents in the Cinematic Arts Library at the University of Southern California, I thank Ned Comstock; Sandra Garcia-Myers, Director of the Archives of the Cinematic Arts; and Steve Hanson, Head Cinematic Arts Librarian. I thank Art Flores, Guy Abrahams, and the Digital Imaging Specialists at Iron Mountain in Hollywood for excellent scans. I thank Matt Severson of the Margaret Herrick Library. For help with photographs at Turner Brand Central, I thank Eileen Flanagan. I thank Helen Cohen of the De Mille Office.

I thank these individuals for photographs: Robert Cosenza; John McElwee of Greenbriar Picture Shows; Bill Nelson; Rob McKay; James Mahoney; Jack Allen; Tim Malachosky; Darrell Rooney; Karl

Ruddy; Ron and Margaret Borst; Marc Wanamaker; Lou Valentino; and Roy Windham.

I acknowledge the education I received from my teachers at St. Joseph High School: Anthony Aiello; Robert Sickenger, Stanley Murakami; and Patrick McCormick.

I thank Victor Varela for building a new computer for me. I thank Angel Cortez for computer help. For sustenance during editing sessions, I thank my friends at Casita del Campo Restaurant: Florentino Martinez; Baldo Mendoza; Jay Richards; Rigo Benitez; and the late Nina del Campo. I thank Antonio Marroquin for a smoothly functioning studio and for the pets who sit by me as I write.

For generous assistance and support, I am deeply grateful to: Mike Chambless; Cathy Phillips; Matias A. Bombal; Kenton Bymaster; Jane Child and Cat Gray; Helen Cohen; John Connolly; Darin Barnes; Jon Davison; Vincent Estrada; Kim Hill; Robert L. Hillmann; Alan J. Jarvis; Peter Koch; Eugene La Pietra; Garrett Mahoney; Howard Mandelbaum; Ann Meine; Andrew Montealegre; Katherine Orrison; Bruce Paddock; Mark Penn; Connie Parker; Felix Pfeifle; Dana Sherman; Leonard Stanley; Bronni Stein; P.R. Tooke; Joseph Wallison; and Horalia Way.

I thank Cyndi Mortensen, Patrick Loughney, and David W. Packard.

I thank Cecilia de Mille Presley for her patronage.

For guidance and counsel, I thank Suzanne McCormick; Kathleene Labby; Pat Tooke; Jann Hoffman; Ruben Alvarez, M.D.; Rev. Tom Eggebeen; Rev. Laura Fregin; and the Rev. Dr. R. Scott Colglazier, First Congregational Church of Los Angeles.

I thank Running Press and my editor Cindy De La Hoz for this project. I thank my designer, Jenna McBride. The artists at 1010, Ltd., deserve a round of applause for peerless lithography. And working with Turner Entertainment means a great deal to me. No company has done more to preserve America's film heritage—and to make it available. Writing this book would have been impossible without viewing the films in it.

I thank Deborah Warren of East-West Literary for her steadfast, resourceful work on my behalf.

For ongoing encouragement, I thank my family: Joan Semas; Barry Gutfeld; Beverly Ferreira Rivera; Sue Costa; Julie Chambless; Michael and Cindy Chambless; Lenore Griego; Matthew Griffiths; John and Julie Vieira; Guy and Shannon Vieira; and Steve and Janine Faelz.

Lastly, I wish to thank all the Internet friends, seen and unseen, who wrote letters of support for this project. Every time I found new information to share, I silently thanked you for helping me and my publisher tell the full story of pre-Code Hollywood.

Marlene Dietrich in *The Scarlet Empress*.

CHECK OUT
OTHER TITLES
IN THE

LIBRARY

RUNNING
PRESS